COMPLETE
CALLIGRAPHY
SKILLS

COMPLETE
CALLIGRAPHY
SKILLS

VIVIEN LUNNISS

BARRON'S

COMPLETE CALLIGRAPHY SKILLS

A QUARTO BOOK

Copyright © 2015 Quarto Inc.

**First edition for North America
published in 2015 by
Barron's Educational Series, Inc.**

All inquiries should be addressed to:
Barron's Educational Series, Inc.
250 Wireless Boulevard
Hauppauge, New York 11788
www.barronseduc.com

ISBN-13: 978-1-4380-0589-8

Library of Congress Control No.:
2014935423

QUAR.CASK

Conceived, designed, and produced by
Quarto Publishing plc
The Old Brewery
6 Blundell Street
London N7 9BH

Senior editor: Katie Crous
Art editor: Emma Clayton
Designer: Karin Skånberg
Art director: Caroline Guest
Photographer: Phil Wilkins
Picture research: Sarah Bell
Proofreader: Claire Waite Brown

Creative director: Moira Clinch
Publisher: Paul Carslake

Color separation by PICA Digital
Pte Ltd, Singapore
Printed in China by Toppan Leefung
Printing Ltd

10 9 8 7 6 5 4 3 2 1

Contents

Welcome

I could not have foreseen the journey started by the gift of a simple fountain pen set, or the world that it would open up for me, a world which continues to fascinate 30 years later.

I have touched manuscripts that are over 1,500 years old and marveled at manuscripts with gorgeous gold leaf illumination and exquisite, finely detailed painting. I have visited Rome and seen inscriptional letters in all their forms, much as they were when they were made by the craftsmen hundreds of years ago. I have taught scores of students and been taught by skilled and generous masters of the craft, both of which are represented here.

There is a sensual pleasure in the subtle scrape of the nib across the paper when drawing the letterforms. This gives me an oasis of calm in this often frenetic modern life. We may all have our favorite scripts, but it is often the act of writing rather than the writing itself that gives the most pleasure.

No study of calligraphy is complete without historical antecedents, and these are included for each script, as well as contemporary examples that show the exciting direction in which calligraphy is evolving.

Calligraphy may have a practical purpose in the form of invitations and certificates, yet there is also so much more for us all to discover, so enjoy.

Vivien Lunniss

About This Book

Complete Calligraphy Skills **is organized into two chapters: the first looks at the practicalities of getting started and the theory behind some of the fundamental rules of the craft; the second chapter contains 21 script alphabets, with an informative overview and an in-depth look at individual letters.**

THE SCRIPTS: BACKGROUND AND INTRODUCTION

Enlarged versions of three sample letters show key details of the script and how they are applied to construct the letters.

Where relevant, a historical example shows the script's origins.

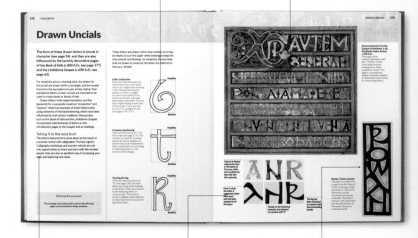

The background to each script gives an understanding of its origins, development, and modern usage.

Where relevant, three letters are compared from the historical and contemporary exemplars, which highlight key differences and/or similarities.

A contemporary exemplar by a modern calligrapher highlights how the script is, or can be, used today.

Expert movie tutorials

In addition, this book contains links to free online tutorials, in which the author and other contributors guide you through writing specially selected letters from each script. Simply scan the QR code with your smartphone or type the URL address into your web browser to link to the relevant web page.

THE SCRIPTS: ALPHABET

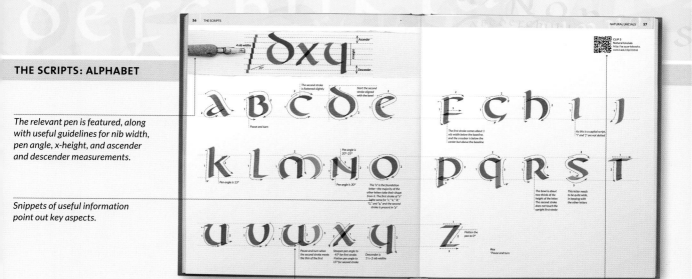

The relevant pen is featured, along with useful guidelines for nib width, pen angle, x-height, and ascender and descender measurements.

Snippets of useful information point out key aspects.

The full alphabet is featured. In most cases (where possible and useful), a color system is used to define the strokes: red = stroke 1; blue = stroke 2; green = stroke 3; purple = stroke 4.

Scan the QR code or type the URL address into your web browser to access the online tutorials.

THE SCRIPTS: BASIC STRUCTURE, IN DETAIL, AND IN PRACTICE

A sample word is used to illustrate letter spacing.

The main pen angle/position is shown.

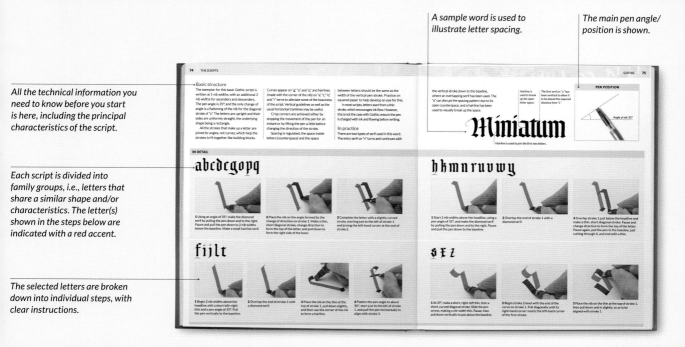

All the technical information you need to know before you start is here, including the principal characteristics of the script.

Each script is divided into family groups, i.e., letters that share a similar shape and/or characteristics. The letter(s) shown in the steps below are indicated with a red accent.

The selected letters are broken down into individual steps, with clear instructions.

The
Basics

Covering the fundamentals of calligraphy for pointed and broad-edge pens, this section begins by explaining how these pens work—along with the hidden secrets of letters when used as an art form—and closes with stunning examples of artwork undertaken by skilled practitioners, to excite and inspire all who wish to explore this craft, whatever their level.

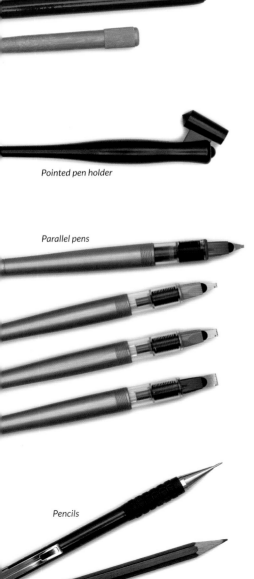

Pen holders

Pointed pen holder

Parallel pens

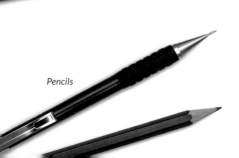

Pencils

Calligrapher's Tool Kit

Whether you are doing broad-nib calligraphy, which is what comprises most of the examples in this book, or pointed-nib calligraphy, such as Copperplate and Spencerian, your basic equipment to start includes pens, paper, and ink, along with deadly sharp pencils (HB) and a ruler for drawing guidelines, a suitable work surface, and a comfortable writing position.

Calligraphy dip pens
Dip pens are preferred for calligraphy not only for their unique interaction with the paper surface and wide range of sizes, but also because you can tailor your writing medium to suit its purpose. Calligraphy dip pens are usually in three parts: the holder, the nib, and its reservoir. The nib has a broad edge similar to a chisel, and the slip-on reservoir usually fits under the nib. The holder and the reservoir are interchangeable, and the nibs are available in a variety of sizes. Left-oblique nibs are available for left-handed calligraphy either in sets or singly.

Fountain pens
Fountain pens are designed for Italic handwriting and do not give good results with formal calligraphy. Lettering is not as sharp as with a dip pen, the range of sizes is limited, and the inks tend to fade over time. However, fountain pens are useful if you are doing calligraphy on the move.

Parallel pen
Unlike other fountain pens, the Pilot Parallel pen has a nib composed of two parallel metal plates on top of each other. The ink feeds between them and is delivered across the writing edge. This removes the frustration of ink flow, which can be troublesome with dip pens, and may help overcome early teething problems. The pen will write easily with the broad edge or corner.

The Parallel pen is available in four sizes: 6 mm, 3.8 mm, 2.4 mm, and 1.5 mm. Beware that the ink supplied can bleed (feather) on some papers and is not lightfast.

Which nib?
The variety of nibs available can be confusing. However, a good starting point is with a No. 2 Mitchell Roundhand nib.

Specialist suppliers sell nibs singly, and it is worth experimenting to find the best one for you. As you progress with your calligraphy, your preferences may change depending on what you are writing.

Other nibs to try are Manuscript, Brause, and Speedball.

Mitchell Roundhand nib
The Mitchell Roundhand nib is a good nib to start with. Available in 10 sizes from 0 (the largest) to 6 (including sizes 1.5, 2.5, and 3.5).

Manuscript nib
Manuscript nibs are similar to the Mitchell, although "Leonhardt" is stamped on the nib. These nibs are narrower, so the reservoirs are not interchangeable with Mitchell nibs.

Brause nibs
Brause nibs are less flexible, which can be an advantage when pen manipulation is needed, and they are right-oblique. They have an integral reservoir on the top of the nib and are available in nine sizes from 5 mm to 0.75 mm.

	Specialist pens	
Technical drawing pen	**Chisel brush**	**Folded ruling pen**
Waterproof and lightfast, these pens are useful wherever fine lines or drawing are required, such as for the Drawn Uncials on pages 172–179.	Available for brush lettering (see pages 156–163) in a wide range of sizes.	Used for expressive and dynamic lettering, the line width of this pen varies depending on how much of the curved edge is in contact with the paper (see pages 142–155).

Speedball nibs

Speedball nibs are right-oblique, although left-oblique nibs are available. They have an integral reservoir and are available in seven sizes. The nibs have two slits so the ink flow is improved, particularly with the larger sizes.

Pointed nibs

The pointed nibs used for Copperplate and Spencerian come to a fine point and are very flexible. The end spreads when pressure is applied to make thicker lines—the greater the pressure, the thicker the line. The pressure applied can be gradual, creating a swelling line, or it can be immediate, so that the stroke is weighted at its beginning or end.

Pen holders

Although we may choose a pen holder on the basis of its color or attractive marbled finish, the important thing about pen holders is how they feel in the hand. The cork holders are thicker to hold and comfortable in hot weather. Speedball holders (they fit all the nibs above) are slightly waisted so as to keep the fingers in a good position. The Mitchell School pen holder is quite slender and lightweight. If a pen doesn't feel comfortable it can inhibit your writing, yet it is an easy thing to change.

Inks and color

Ink for calligraphy needs to flow well, be an opaque black, and be non-waterproof. Higgins Eternal is excellent archival ink.

- Any medium described as "permanent" means that it is lightfast.
- Introducing color can bring an exciting new dimension, even to practicing. Colored inks available include Calli, Winsor & Newton, and Ziller. The lettering may not always be as sharp with these inks, and diluted watercolor or designer's gouache can also be used.
- Try not to let acrylic-based inks dry on the nib.
- Ink for pointed pen work is usually thinner than ink used for broad pen work.

Pointed nib. This is a flexible elbow nib that would be used in a straight pen holder.

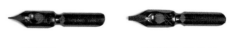

Mitchell Roundhand nib size 2, inserted in a cork pen holder

Mitchell Roundhand nibs—size 0 to 6

Ruler

Choosing paper

Any paper used, even practice paper, needs to produce sharp lettering. Paper is categorized by its weight, which also indicates its thickness, and surface finish. Weight is measured in pounds (lb) and grams per square meter (gsm).

Layout paper

Layout paper is often used for practice. Its advantage lies mainly in that writing guidelines will show through.

Cartridge paper

A good quality smooth cartridge paper of 120–150 gsm is recommended.

Hot Press (HP) watercolor paper

A Hot Press (HP) watercolor paper is a very good surface, and there are several good makes such as Arches, Saunders, and Fabriano.

1 Bockingford HP: Reasonably priced, smooth writing surface, also suitable for watercolor.

2 Fabriano Artistico HP: A more luxury paper with a good writing surface, also suitable for watercolor.

3 Khadi—Not: A textured surface for more informal work.

4 Zerkall: Has a laid pattern to the paper, and is useful for making books.

5, 6 , 7 Mi-Teintes pastel paper: Available in a range of colors. Has a slight "tooth" to retain the chalk pastel on its surface, which can also be used for backgrounds.

8 Smooth cartridge: An inexpensive paper. There is a wide range of cartridge papers available, and it may be necessary to try several before finding a favorite.

9 Bockingford: Textured surface

10 Khadi handmade: Textured surface

11 Khadi wool: This paper contains small strands of colored wool and has a textured surface.

12 Butcher paper (kraft paper): Inexpensive paper with a surprisingly receptive writing surface; try using both sides.

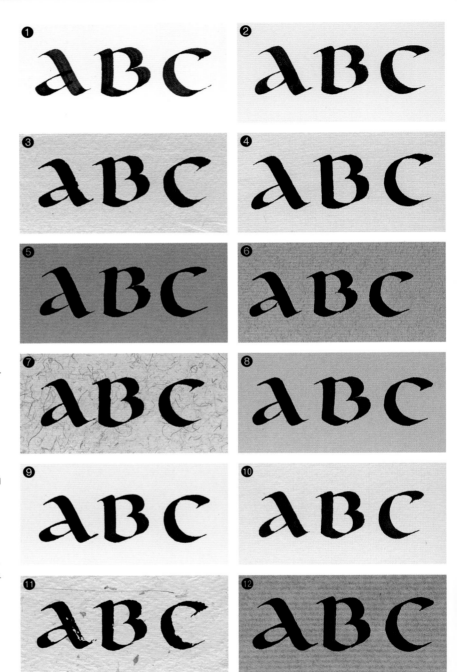

Don't leave the best till last

Keep trial samples of papers, both good and bad, for reference.
Overuse of layout paper can result in a form of stage fright when using a better quality paper, so do practice on better paper as well.

Your work surface

Writing position is a matter of personal preference and you may prefer to work flat. You might also prefer to have the paper at an angle, rather than straight. However, medieval scribes are always shown working at a sloping desk. The flow of ink from the nib is designed for this purpose, and the position allows a clear view of your writing, enables freedom of movement of hand and arm, and is good for your posture.

- An angle of 30°–45° is ideal.
- To make an easel: Prop up a piece of plywood or MDF not less than 18 x 24 inches (450 x 600 mm) against a pile of books, or rest it in your lap with the top leaning against the table.
- The board should be padded with about eight sheets of inexpensive drawing paper, with a final layer of blotting paper. Alternatively, a large piece of chamois makes an excellent top layer.
- Use a sheet of paper under your hand to keep the surface clean and oil free.

Lighting

A source of natural light is ideal, coming from your left if you are right handed or vice versa. Make sure that there are no shadows across your writing. Alternatively, use daylight bulbs in an adjustable desk lamp.

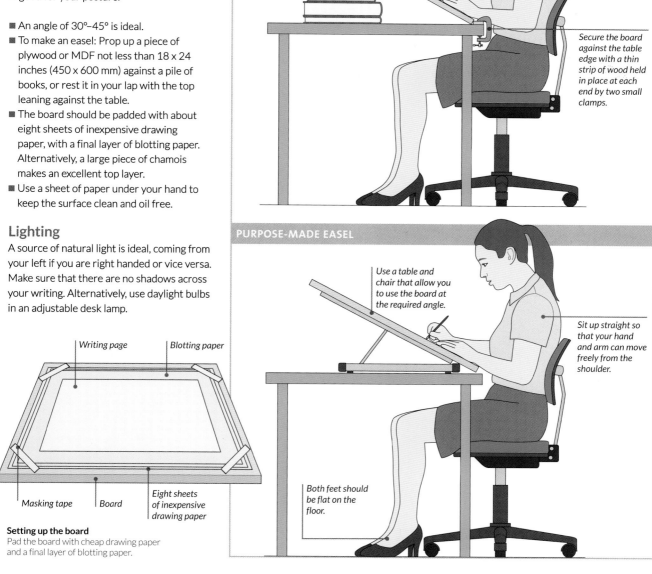

IMPROVISED DESK

Place one end of the board on the table and lean the other end on books or covered bricks.

Secure the board against the table edge with a thin strip of wood held in place at each end by two small clamps.

PURPOSE-MADE EASEL

Use a table and chair that allow you to use the board at the required angle.

Sit up straight so that your hand and arm can move freely from the shoulder.

Both feet should be flat on the floor.

Writing page

Blotting paper

Masking tape Board Eight sheets of inexpensive drawing paper

Setting up the board
Pad the board with cheap drawing paper and a final layer of blotting paper.

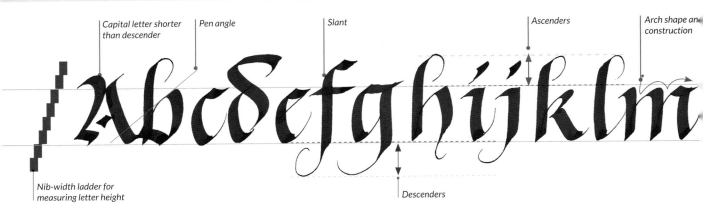

Capital letter shorter than descender

Pen angle

Slant

Ascenders

Arch shape and construction

Nib-width ladder for measuring letter height

Descenders

Understanding Letters

There are two types of scripts in this book—those that involve the use of a broad-edge in the writing, and two that use a flexible, pointed nib (see pages 112–135).

While the scripts share many characteristics, the actions of the two types of writing tool are very different, and this will be explained where necessary. Despite the different and individual appearance of our repertoire of scripts, the features that define them are common to all, and are the key to truly understanding pen lettering.

Writing with a broad-edge pen produces thick and thin strokes that are the result of the constant angle that the edge of the nib makes with the horizontal writing line. The thickness of the line changes as the direction of movement changes. The letters are built up from a sequence of strokes with the pen moving from left to right and top to bottom. Handwriting is much more economical in terms of movement in order to achieve speed—several letters are written without any pen lift and many letters are joined (ligatured). The finished letter is the product of three main characteristics, known as weight, angle, and form.

Weight

Whether the overall appearance of a script appears to be heavy or light is determined by the ratio between the width of the nib and the height of the body of the letters. This is usually referred to as the "x height."

Pen angle summary
The main pen angles used with the scripts.

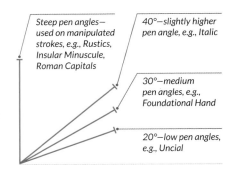

Steep pen angles— used on manipulated strokes, e.g., Rustics, Insular Minuscule, Roman Capitals

40°—slightly higher pen angle, e.g., Italic

30°—medium pen angles, e.g., Foundational Hand

20°—low pen angles, e.g., Uncial

HEAVYWEIGHT

These letters are written at an x-height of 3 nib widths, so the white counterspace is small, and the emphasis is much more on the pen strokes. Written en masse this would have a very dense appearance.

LIGHTWEIGHT

These letters use an x-height of 8 nib widths, and the counterspace of "o" is much greater than in the heavy-weight example, so the emphasis here is more on the white space rather than the pen strokes. A piece of writing would look light and airy.

X-height and body of the letter between these lines

Form of "o"

Hook serif

Order, number, and direction of strokes

nopqrstuvwxyz

The latter is a term borrowed from typography, which shares the same historical roots as calligraphy. There are recommended letter weights for each script based on historical examples, although it is possible to experiment with alternatives.

Pen angle

Because the pen has a broad edge, the angle of this edge to the writing line will affect the shape of the pen stroke. The pen angle controls the position of the thick, or weighted, parts of the letter and therefore needs to be consistent. Again there are recommended pen angles for each script based on historical research. Some scripts use a constant pen angle, but there can be changes for others. Pen angle is measured from the baseline, and it would probably be helpful at first to draw the pen angle required at the beginning of your guidelines using a protractor.

THE EFFECT OF PEN ANGLE ON VERTICAL AND HORIZONTAL PEN STROKES

As the pen angle increases, the vertical line becomes thinner and the horizontal line thicker.

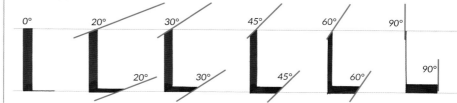

THE EFFECT OF PEN ANGLE ON CIRCLES AND COUNTERSPACES

As the pen angle increases, the thick and thin lines that form the circle change position.

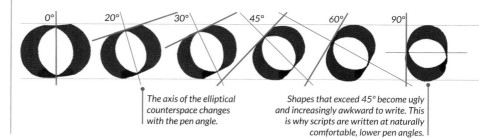

The axis of the elliptical counterspace changes with the pen angle.

Shapes that exceed 45° become ugly and increasingly awkward to write. This is why scripts are written at naturally comfortable, lower pen angles.

PEN ANGLE FOR COPPERPLATE AND SPENCERIAN, POINTED PEN

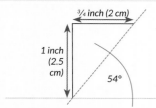

¾ inch (2 cm)

1 inch (2.5 cm)

54°

1 To obtain the angle of 54°, simply measure 1 inch (2.5 cm) up from the baseline, then ¾ inch (2 cm) across the top. Join the two points to give the angle.

2 Diagonal guidelines are required to keep the angle of the letters constant.

3 Your nib needs to be held constantly at 54°. It may help right-handed calligraphers to turn the paper to the left, so that they are writing more upright.

Form

Each script has a structure, known as form, which underlies the majority of the letters, ensuring that there is a common, family unity. This is usually based on the shape of the letter "o" (see diagrams on right).

Slant

As shown on this page, the Uncial, Foundational, and Gothic letters are upright, whereas the Italic "o" and "n" have a forward slant. The downstrokes must slant consistently at the chosen angle. Slant is measured from the vertical and for Italic can be between 3° and 7°. Additional guidelines may prove useful for practice.

Stroke order and direction

(Also known as ductus.) The sequence used to build up the letters stroke by stroke. For clarity and where it is helpful, this information is shown on some of the exemplars in The Scripts section using a multicolored system, linked to the order of strokes. The direction that the pen moves in is also significant, using mainly pulled rather than pushed strokes.

Arch shape and structure

The arch shape (for example "h," "m," and "n" in Italic) reflects the form of "o," and the ductus (see above) used will also affect their shape (see Italic example on this page).

Speed

Some scripts are written slowly due to the number of pen lifts required between strokes, and letterform and accuracy would deteriorate if written quickly. Others can be written at greater speed and will have a freer, flowing rhythm.

EXAMINING FORM: BROAD-EDGE PEN CALLIGRAPHY

These letters demonstrate the different underlying forms of Uncial, Foundational, Italic, and Gothic. In each case, the second letter reflects the shape of its parent "o."

Uncial
Uncial: written at 4 nib widths, the low pen angle facilitates writing the wider "o" shape.

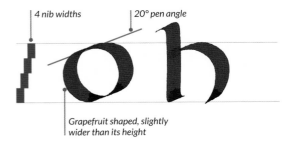

4 nib widths 20° pen angle

Grapefruit shaped, slightly wider than its height

Foundational
Foundational: the x-height is the same as for Uncial, but the pen angle is increased to 30°. The underlying form is a circle, and a segment can be seen in the arch of "h."

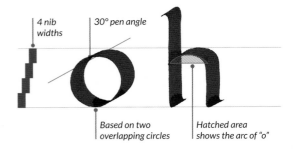

4 nib widths 30° pen angle

Based on two overlapping circles Hatched area shows the arc of "o"

Italic
Both x-height and pen angle are higher than the other examples here, making it easier to construct the oval shape. The arch of "n" is made in one springing pen stroke, and both letters slant.

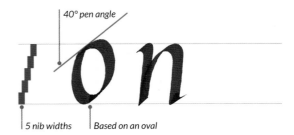

40° pen angle

5 nib widths Based on an oval

Gothic
These letters are tall and angular with an underlying rectangular form.

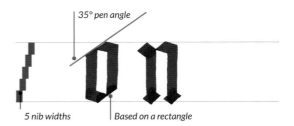

35° pen angle

5 nib widths Based on a rectangle

EXAMINING FORM: POINTED PEN CALLIGRAPHY

Copperplate and Spencerian slope at approximately 55°, so guidelines are essential (see pages 114 and 128, and the relevant chapters). When practicing these strokes, remember that the more pressure you apply, the more the nib will splay, enabling thicker downward strokes. Avoid applying presssure and pushing upward with the nib, as this will damage the pen.

Copperplate

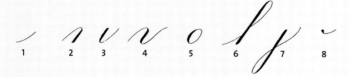

The strokes shown here are the building blocks of the script. All letters are formed with these eight basic movements.

1 Light upstroke/joining stroke

2 Upstroke, with pressure on downstroke

3 Downstroke with pressure, upstroke without

4 Pressure on downward stroke, pushing up without pressure

5 One side with pressure, one without

6 Loop stroke with pressure on ascender

7 Looped letter with pressure on descender

8 Joint dot, as for "o" or "v"

Spencerian

These strokes form the basis of the Spencerian script—diagonal lines, two flattened curves, and a loop. The loop is made from the diagonal lines and one curve; avoid making it too big.

Serifs

The small exit and entry curved or tick strokes, serifs are created by a sideways movement of the pen that encourages ink flow and forms neat ends to the letters. Their shape is in keeping with the form of the script. Serifs add a secondary pattern to writing, and a selection are shown here.

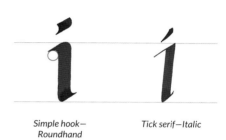

Simple hook— Roundhand *Tick serif—Italic*

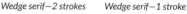

Wedge serif—2 strokes *Wedge serif—1 stroke*

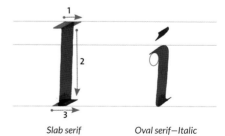

Slab serif *Oval serif—Italic*

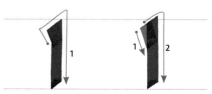

Club serif made with 1 stroke *Club serif made with 2 strokes*

Measuring and Ruling

Part of the skill and craft of being a calligrapher is in preparing the parallel guidelines needed for your writing. The measurements used are based on the x-height of the script, which is measured in nib widths so that the letters are in proportion to the nib being used.

Nib-width steps and ladders

The most practical way to measure the x-height is to make multiples of marks in the form of squares that are the full width of the nib you want to use. These squares are accurately placed on top of each other either in steps or by forming a ladder for the required number of nib widths. You can label and keep these measurements for future reference.

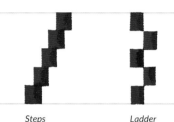

Steps

Ladder

The nib is not at right angles to the baseline— this measurement will be too short.

The blocks are either not touching or are overlapping—this measurement will be incorrect.

MEASURING X-HEIGHT: MAKING NIB-WIDTH STEPS

The x-height is measured in nib widths to ensure that the letters are in the correct proportion to the nib being used. A small nib will make a correspondingly small ladder, the guidelines will be narrower, and therefore the writing small, and vice versa for a larger nib.

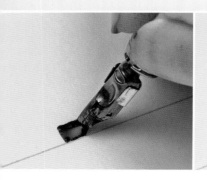

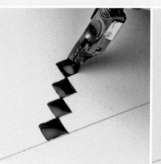

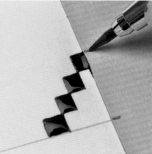

1 Hold the nib at right angles to a baseline and pull briefly to the right (or left).

2 For a 4 nib-width script, add another three blocks that just touch but don't overlap.

3 Transfer these measurements to a strip of paper. This is now your x-height. The spacing between lines of writing (interline spacing) is a multiple of the x-height, the standard being 2 x-heights. This ensures that the ascenders and descenders in lines of writing will not clash.

4 Transfer this additional measurement to your paper strip underneath the first. Label the strips with the pen used for future reference.

RULING UP FOR POINTED PEN

Ideal proportions for minuscules:

- Ascender = 3
- X-height = 1
- Descender = 3

This means that ascenders and descenders are roughly twice the chosen x-height. Be sure to leave sufficient interline space to prevent ascenders and descenders from clashing.

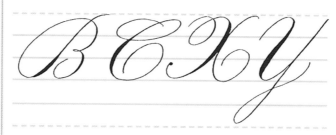

Spencerian minuscules
The ascenders are almost twice the x-height.

Ideal proportions for majuscules:

- X-height + ascender, which is taller than usual with broad-edge pen scripts.
- **Pen angle:** There is no pen angle for these scripts, but the nib must constantly point along the correct slant line (approximately 55°).

Spencerian majuscules
These capital letters are approximately three times the x-height of the minuscules.

ACCURATE RULING

This method uses the x-height measurement shown opposite. Taking care with this task will save time in the long run. The guidelines should be precisely measured and drawn using a very sharp pencil and a ruler. An HB pencil will rule lightly without scoring the paper and will be easy to erase later. Keep re-pointing the pencil as it wears down. It's a good idea to rule up spare sheets for finished work in case of mistakes.

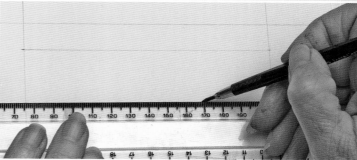

1 Rule margins across the top and both sides of your sheet of paper. Create a staircase or ladder for your chosen nib and the requisite number of nib widths.

2 Starting from the top of the sheet, use the marks on the paper strip to mark the x-height and interline space down both side margins. Continue for the required number of lines.

3 Use a ruler and sharp pencil to join the marks across the page.

Getting to Know Your Pen

A broad-edge pen makes lines of varying thicknesses depending on the angle the edge makes with the writing line and the direction of movement. The pointed, flexible nib used for Copperplate and Spencerian relies on changes of pressure alone. Both types of nib benefit from the investment of a little time familiarizing yourself with how they work.

ASSEMBLING A BROAD-EDGE CALLIGRAPHY PEN

The three components of a dip pen are easily put together. The pen holder and the reservoir will fit any nib, although it is more convenient to leave each size assembled and ready to use. Speedball, Brause, and pointed nibs are simply inserted into the pen holder in the same way as the Roundhand nib in picture 1. New nibs can have a protective coating that can be washed off with hot water.

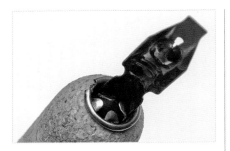

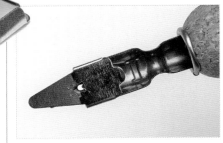

1 Slide the nib into the holder as far as possible so that it is firm and doesn't move about. The nib fits inside the ferrule but outside the claws.

2 New reservoirs may need to be adjusted to fit correctly: too tight and it will prevent ink flow and even cause the tines to cross over; too loose and it doesn't control ink flow and may even fall off. The shoulders can be closed or opened slightly using fine pliers.

3 Slide the reservoir over the nib until the tip of the reservoir is about ⅛ inch (3 mm) from the end of the nib.

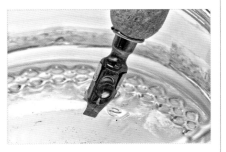

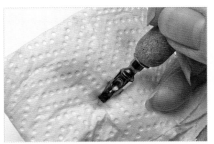

4 This is the correct position of the reservoir— it is just making contact with the underside of the nib.

5 Clean the nib by dipping just the nib section of the pen in water containing a drop of dishwashing liquid.

6 Wipe it dry on some paper towel. Periodically disassemble the pen and give the nib a good clean with an old toothbrush.

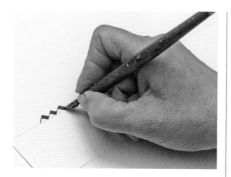

HOLDING A BROAD-EDGE PEN
Hold the handle close to the nib with your thumb and index finger. The full edge of the nib should be in contact with the paper; try a thick stroke, then slide the nib up to make a thin stroke.

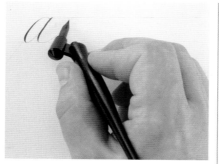

HOLDING A POINTED PEN
Holding a Copperplate pen is very different, as the thick strokes are made by pressure alone. Hold the nib directly in line with the slope of writing. The elbow nib (shown) is fashioned to assist the right-hander in twisting farther to the right; hold the pen with the handle pointing roughly toward your chest.

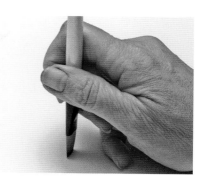

HOLDING A CHISEL BRUSH
Hold the brush almost perpendicular to the writing surface (which may be better flat or on a slight slope), so that the writing comes from the very edge of the brush. Hold the brush with your thumb on one side and the first two fingers on the other. This should make it easier to "roll" the brush for the manipulated strokes. Use a whole hand movement and not just the fingers.

LEFT-HANDERS

Left-handers have developed their own way of writing, and it can be difficult to change a pen hold to which you are accustomed. The underarm position is recommended for calligraphy, but two alternatives are shown, so do experiment and also try a left-oblique nib (see page 11). Try using the paper at a left-to-right angle, which will also help. Take heart, though: there are many professional left-handed calligraphers, and many problems are common to all beginners, no matter which hand they use.

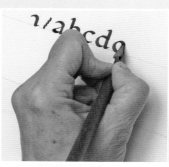

Underarm position
At the wrist, turn the left hand as far as possible to the left in order to place the nib on the paper at the correct angle. It may help to slant your paper down to the right. Encourage free arm movement by placing the paper slightly to the left of your body and writing from this position.

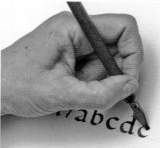

Hook position
Place your hand above the writing line in a hook position by flexing the wrist downward. Then, after placing the nib on the paper at the desired angle, move the nib in the direction of the stroke. It may help to slant the paper slightly to the left.

Vertical position
Place the paper at 90° to the horizontal and work from top to bottom instead of left to right. This enables strokes to be rendered as for right-handers, but the unusual angle may make it difficult to judge the letterforms as you work.

FILLING THE PEN

The pens hold only a small amount of ink, which is trapped between the nib and its reservoir. A wide nib will exhaust the amount of ink more quickly than a narrow nib, so will need replenishing often. There are two methods of doing this, either by dipping the nib into an ink well or loading from a brush.

Filling by dipping
Decant some ink from your bottle into a smaller container. To avoid overloading the nib, don't dip it any farther than the clips on the reservoir. Remove any excess ink from the top of the nib by wiping on the edge of the container or with a paper towel.

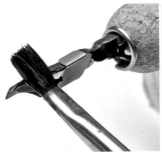

Filling by brush
This method provides more control over the amount of ink loaded into the pen. Using an inexpensive, small brush, load the brush with ink. Feed the ink in from one side, between the nib and reservoir, by stroking the brush across the edge of the nib.

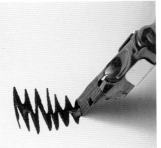

Wiggle nib
Each time the pen is filled, test the ink flow on a piece of scrap paper first. If the ink doesn't flow very well, move the nib in a left–right–left, zigzag movement to encourage flow and to check that the lettering is sharp.

Making marks

Making marks and patterns is a useful introduction before tackling letters, words, and sentences.

One of the first issues is how to control the flow of ink from the pen. The pen is usually filled by dipping no more than the first ⅜ inch (1 cm) into a well of ink. Using a scrap of paper, apply gentle pressure on the nib (too much pressure will force the nib apart) with a slight left–right–left movement. This will start the ink flowing and also show if the nib is delivering too much ink. Problems with ink flow are often caused by an ill-fitting reservoir, so check that it is in the correct position (see page 20) and that it is not too tight.

Try the following exercises and pattern making, which are based on the individual strokes that make up the letters. A Mitchell No. 1 nib was used here, but you can use whichever nib you are most comfortable with, as long as it is reasonably wide.

FIRST STROKES

1 Rule lines ⅜ inch (1 cm) apart. Practice vertical strokes with the edge of the nib held horizontally to the writing line (i.e., a pen angle of 0°). Make sure that both edges of the stroke are clean and sharp, showing that the nib is in even contact with the paper, and try to keep the lines parallel.

2 Keeping the 0° angle, make some horizontal strokes moving from left to right. Again try to keep the lines parallel and the same distance apart.

3 Make horizontal strokes, but push the pen lightly up or down at the end of each stroke.

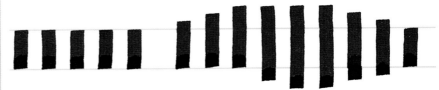

4 With lines ruled as before, practice parallel downstrokes. Concentrate on making the downstrokes the exact height of the writing lines.

5 Allow the strokes to "grow" above and below the line. Starting with a stroke at the height of the writing lines, draw parallel strokes progressively taller, then progressively smaller, as shown. Concentrate on spacing the strokes as evenly as possible.

PEN ANGLE EXERCISES

These exercises have been made with a Mitchell No. 1 nib. They give you an opportunity to observe what happens to pen strokes when the pen angle is changed and to practice the individual strokes that build together to make the letters.

AT 30°

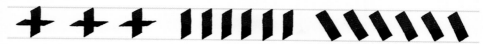

The horizontal stroke is thinner than the vertical. *Thick vertical lines* *Left–right diagonals*

Right–left diagonals *Counterclockwise and clockwise curves: Note the positions of thick and thin parts of the strokes.*

AT 45°

The horizontal stroke is the same width as the vertical stroke. *When the pen angle is increased from 30° to 45°, the strokes become thinner.* *Left–right diagonals*

Right–left diagonals *Counterclockwise and clockwise curves: When the pen angle is increased from 30° to 45°, the thick and thin parts of the strokes change position.*

Patterns and color

Practice strokes can be combined to form patterns, and present a good opportunity to play with color. They can also have a practical purpose and can be used to make bookmarks, patterns on handmade cards, or borders for calligraphy.

Lines made with the same size pen at a flat (0°) pen angle

Lines made with a large and small nib at 0° and 45°

Lines made with two nib sizes, both used at 30°

Lines made with two nibs at 45°

Spacing

The aim of spacing is to position letters, words, and lines so that the overall pattern of writing appears evenly balanced.

Letter spacing

Balance is achieved when the space inside the letters appears equal to the space on either side of them. This would be straightforward if all the letters had straight sides, but because of the variations in letter shapes it cannot be an exact science. However, there are basic guidelines. Using the distance between two adjacent verticals as a guide, a round stroke should be a little closer than this to an adjacent vertical, and two round strokes closer still.

Word spacing

Too much space between words can create vertical "rivers of white" in a page of writing. Allow no more than the width of an "O" from the script you are using between words, and make allowances for those open letters. Balanced word spacing also aids fluency of reading, so only enough space is required to separate the words.

It is often easier to assess your spacing when you cannot read the words, so try viewing your writing from a distance or upside down.

Letter and word spacing for specific scripts

The generic guidelines, above, apply to spacing for all scripts. Here, we look at the specifics of spacing three of the scripts in the book, and these strategies can also be applied to the other scripts.

Roman Capitals

To ensure that the space inside and between letters is balanced, use the distance between

THE RULE OF THREE

One of the best ways to check spacing is to use the Rule of Three, as illustrated below. Progressing through a word in this manner means that you are assessing only three letters at a time, making it easier to focus on each letter. Rewrite if necessary.

1 Look at the first three letters of your word and check if the space on either side of the second letter appears equal and if the letter appears to be in the middle.

2 Move on a letter and look at the next group of three, checking that the new middle letter appears to be in the center.

3 Progress through the rest of the word in this manner.

two adjacent verticals as a benchmark. This distance should be slightly less than the width of the counterspace of an "H." Adjacent vertical and round strokes should be closer and two round strokes closer still. Make adjustments for the open letters: "C," "E," "F," "G," "L," "P," "S," and "T," and the diagonals of "A," "V," "W," "X," "Y," and "Z." The Rule of Three (see above) is especially helpful with this group of letters.

The distance between words should be no more than the width of an "O."

Uncial

The rule of thumb for spacing Uncial letters uses two-thirds of the width of the counterspace of "N" for the distance

between two adjacent verticals. Because of its shape, a round stroke should be closer to an adjacent vertical, and two round strokes closer still. As with Roman Capitals, further adjustment needs to be made for letters with open counterspaces, otherwise the extra space is visually added to the letter space and can create the appearance of holes in the text. For Uncial, these are "A," "C," "F," "G," "L," "S," "T," "X," and "Z."

The distance between words should be no more than the width of an "N."

Italic minuscule

The majority of letters in Italic are of a similar width (except for "i," "j," "m," and "w") and have almost straight sides. A spacing pattern of

ROMAN CAPITALS

H.I I.O OO

Round and round closer still

Adjacent verticals are slightly less than the width of "H"'s counterspace apart

Vertical and round slightly closer

Too close

AUTUMNUS AUTUMNUS

Irregular spacing and pattern

Counterspaces and interletter spaces closer balanced

These areas not balanced by other letter spaces

SAPIENTIA ET VERITAS

Counterspaces, interletter, and word spaces balanced

Too close—compare with space between "N" and "T"

Width of "O"

SAPIENTIA ET VERITAS

Irregular spacing and pattern

Too close

NATURAL UNCIALS

Irregular spacing and pattern

Too close, doesn't balance counterspace of letters

NI NO OO AUTUMNUS AUTUMNUS

The distance between adjacent verticals is two-thirds of the counterspace of "N"

Vertical and round a little closer

Round and round closer still

Counterspaces and letter spaces balanced

Counterspace of "T" not matched

Different areas

SAPIENTIA ET VERITAS

Counterspaces, interletter, and word spaces balanced

Width of "n"

SAPIENTIA ET VERITAS

Irregular spacing and pattern

Word spacing too wide and words are not relating to each other

ITALIC

"o" is almost straight-sided, only minor adjustment needed

"r" is an open letter that can disrupt the pattern of equidistant parallels if not positioned carefully

Irregular spacing

Too close—impairing legibility

ni no oo ran autumnus autumus

Pattern of equidistant parallel lines

Adjustment made for adjacent ovals

Correct spacing

This area should visually balance the counterspace of "a"

sapientia et veritas

Counterspaces, interletter, and word spaces balanced

Width of "n"

sap.ientia.et veritas

Irregular spacing and pattern

Too wide, breaks up word

Too close, hard to distinguish separate word

Too wide, letters don't relate

COPPERPLATE

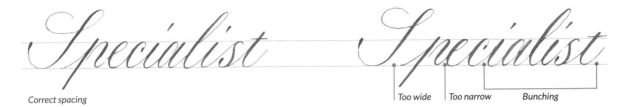

Correct spacing Too wide | Too narrow | Bunching

equidistant parallel lines can be used with only minor adjustments needed for combinations such as the curves on "o," "c," and "e" and the diagonals of "v," "w," "x," "y," and "z." Adjustment also needs to be made for the open letters "r," "s," and "t," as shown above.

The distance between words should be no more than the width of an "n."

Copperplate/Spencerian

Letters for the pointed pen scripts are joined with hairline upstrokes. The space between the letters should be similar to the space inside letters; space between words should be equal to the size of "o." In Copperplate particularly—as this is delicate, lightweight writing—generous space between letters and words can reduce legibility considerably. Controlling word spacing holds the line of

text together and helps you maintain a writing rhythm. The right-hand side of a majuscule is always less flourished so that it can be joined easily with the minuscules that follow it.

Interline spacing

The purpose of the space between writing lines is threefold. Many of the proportions that we use have been inherited from the handwritten book, and as an aid to reading, the white interlinear space helps the eye to track back to the next line of writing. The longer the writing line, the greater this space needs to be. Allowing sufficient interlinear space also avoids ascenders and descenders clashing, and of course it also plays a big part in the design of a piece of calligraphy. As a general rule, use an interline space equal to 2 x-heights, although Copperplate,

Spencerian, and flourished Italic would need more than this (4 x-heights is generous and useful for long lines of text; 3 x-heights should still allow for flourishes and long ascenders/descenders). Too much interline space can result in lines looking like they don't "belong" together. On the other hand, scripts with short, or no, ascenders and descenders, for example Uncial, Roman, or Italic capitals, allow for a greater choice of interline space and, if desired, can be closely packed for a more dramatic textural effect.

INTERLINE SPACING—CORE PRINCIPLES

These graphics show the effect that three different interline spaces have on the textural appearance of a block of text.

Interline space 1 x-height

Interline space 1½ x-height

Interline space 2 x-height.

IN OMNIBUS
REQUIEM
QUASIVI ET
NUSQUM
INVENI
NISI IN
ANGELO
CUM LIBRO

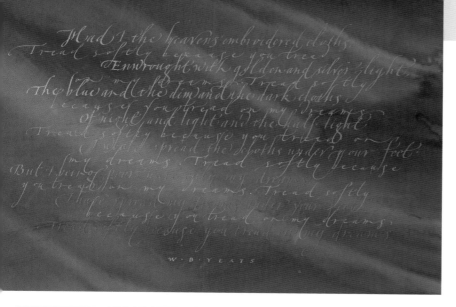

Cloths of Heaven by W.B. Yeats, Gaynor Goffe
(left-handed scribe)
This is an example of a piece of calligraphy with long writing lines and generous interline space. This space has been used for light and delicate cursive Italic writing, giving an impression of texture that is sympathetic with the words of the poem. [Gum ammoniac with gold leaf, small writing in white acrylic ink, on an acrylic wash on Fabriano Hot Press paper]

Der Zeit, Yukiko Fukaya
(Words from the Secession, Vienna, which translate to: "Art for the time, freedom for art")
Heavy angular capitals and close letter spacing allow these lines to be placed close together, giving the words much greater impact. The words that share a line are differentiated by a gold dot rather than a word space. Imagine how different this work would look with an interline space equal to the x-height. [Brush, gouache, watercolor, gold leaf, and shell gold on vellum]

Text from "Imaginaçion de Vraye Noblesse," Anne Jamieson
This example, written in Batarde, uses the standard word count per line of between five and nine words. The interlinear space is 2 x-heights, making the text clear and easy to read, and visually there is a pleasing balance between the text area and the space around it. [Metal nibs, gouache, and ink on Arches Hot Press paper]

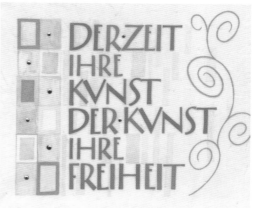

LINE WIDTH AND INTERLINE SPACING

Short lines of text (left)
These heavyweight letters are written at 3 nib widths. An absence of ascenders and descenders, coupled with very short lines, allow for a minimal interline space of only 1 nib width.

Long lines of text (right)
These Uncials are written at an x-height of 4 nib widths with interline space of 2 x-heights. The absence of ascenders and descenders, combined with a generous interline space, give these longer lines of text a strong lateral pattern and ease of reading.

NOX ERAT ET PLACIDUM CARPEBANT FESSA SOPOREM CORPORA PER TERRAS · SILVAEQUE ET SAEVA QUIERANT AEQUORA · CUM MEDIO VOLVUNTUR SIDERA LAPSU · CUM TACET OMNIS AGER · PECUDES PICTAEQUE VOLUCRES · QUAEQUE APERA DUMIS RURA TENET.

Numbers and Punctuation

The history and development of numerals and punctuation is almost as long and fascinating as that of the scripts themselves, and has culminated in the systems that we are familiar with today. Any symbols combined with the scripts need to share the characteristics particular to that script.

Numbers

Arabic numerals were introduced to Europe in the Middle Ages, but the invention of the printing press in the fifteenth century helped them become accepted, and they quickly displaced their Roman predecessors. It is believed that the value of Arabic numerals is derived from how many angles they contain, but this is contested.

Numbers need to reflect the same characteristics as the script that they are being used with. For example, if the script is compressed, rounded, or sharp, the numerals must be as well. The numerals should harmonize with the style of the script and match the rhythm, size, and spacing of the letterforms. Note that the letterforms have different variations in different countries (such as the crossbar of the 7 used in France); they also have ascenders and descenders. Unlike their calligraphic forms, printed numbers are of uniform size and height, usually the same height as the capital letters of the script being used.

POINTED NIB

0 1 2 3 4 5 6 7 8 9

GOTHIC

0 1 2 3 4 5 6 7 8 9

ITALIC

0 1 2 3 4 5 6 7 8 9

NATURAL UNCIALS

0 1 2 3 4 5 6 7 8 9

Punctuation marks

Punctuation is now an essential ingredient of written language, in order to clarify meaning and facilitate smooth, steady reading, whether aloud or silent. Although small, the marks need to harmonize with the script style and be spaced correctly. As Roman Capitals have been adopted by so many different countries and languages, it is necessary to add sound marks or diacritics to differentiate the various pronunciations. Diacritics need careful placing so that they are not so close that they overpower the letterform and not so far away that their relationship to it becomes unclear. This is especially important in languages such as Latvian or Finnish, which use many diacritics. Diacritics and punctuation marks should flow naturally from even and balanced spacing. If the spacing is correct and easy to read, then the punctuation will be too.

Most punctuation marks are made by a small pulling movement. Even with a pointed nib it is usually unnecessary to push a stroke.

The ampersand originates from the Latin word "et," its form becoming more abstracted over time. It is rarely used in blocks of text but is common in names and titles, especially of registered businesses. If you are intending to address invitations or envelopes, the ampersand will be especially important. Like other symbols, the ampersand must harmonize with the rest of the text and reflect the characteristics of the script you are using. See the examples below.

POINTED NIB

GOTHIC

ITALIC

NATURAL UNCIALS

Layout and Design

Layout is the organization of the design elements in a given space to create a balanced, visually interesting, and harmonious whole. Even a simple greeting written on a card requires planning and decisions about style, color, size, and placement so that the writing looks attractive and visually balanced.

There are various types of layout that can be used, and the best option for a project is usually arrived at by a process of "cut and paste," which then provides a blueprint for the finished piece. Even large and seemingly complex calligraphic panels can be seen to contain a combination of more simple arrangements.

Space around the work

The amount of space around the work is vital to the visual balance of the design. Inadequate margins are a common mistake and make writing appear hemmed in. The amount of space needed around the work is related to the space within the work; for example, lightweight writing needs more space. Layouts should always be assessed by placing strips of cardstock around the work (as shown below). Most rules are there for guidance and are frequently broken for artistic reasons; contemporary calligraphy often takes a more painterly, freer approach, so it is worth analyzing as much finished work as you can see in books and exhibitions.

Space within the work

As a general rule, the hierarchy of space within a simple piece of calligraphy is as follows:

1 Counterspace (the space within letters)— smallest space
2 Letter spacing
3 Word spacing
4 Interline spacing
5 Margins—largest space required (see below).

Types of layout

Whether a design is landscape or portrait will depend mainly on the length and number of lines, and, to a lesser extent, additional design elements such as decorated initials and/or borders.

ESTABLISHING MARGINS USING CARDSTOCK

Move pieces of contrasting-color cardstock in and out until you feel they look right. You will soon develop an eye for noticing unbalanced areas of the design, which might otherwise go unnoticed.

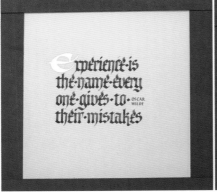

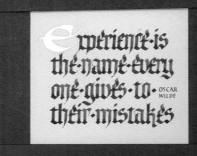

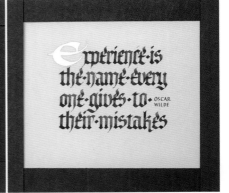

Margins too wide
Here the text is "lost" within overly wide margins. Experiment by moving the strips toward and away from the edges of the text.

Margins too narrow
Take care not to cramp the text between narrow side margins, as occurs here.

Correct margin spacing
When the balance between text and white space looks right, mark the chosen margins with a light pencil point in each corner.

Left alignment

Text that is aligned to the left is the easiest layout form. All lines start from a vertical left-hand margin. Alternate lines, or groups of lines, can be indented as a variation. Left alignment is most suitable for lines of a similar length.

100 Days On Holy Island, **Sue Gunn**
(recto page of a double-page spread)
This left-aligned, two-column layout is a format with a long history, used in large volumes for ease of reading. A good historical example is the ninth-century Grandval Bible (London, British Library). [Watercolor, metal nibs, and pointed brush on Saunders Waterford Hot Press paper]

Autumn, **Michael Orriss**
The script in this piece is based on an italicized Insular half-Uncial. The left-aligned layout is emphasized by the marginal decoration, which is balanced by the bold central word, "Autumn," in pointed Italic and the gilded leaf at the bottom of the page. [Acrylic paint, raised and flat transfer gold leaf, gilded acer leaves, gouache, and metal pens on Hot Press paper]

And all around us in nature's organised chaos lay the wonderful colours of **Autumn** harvest. This random laying down of colours could not be surpassed.

MIKE ORRISS

For an hour I waited. A flock of unknown birds whirred past like high-speed freckles…

A shadowy man passed with a dog. I scanned the horizon, the way impatient rock fans scanned the stage for the first view of their inevitably late-arriving hero. I walked about, flapped arms. Behind me the village was merging into light; the windows of the nearby Herring Houses threw back the glowing horizon in molten gold. The upturned herring boats on the shoreline, a monument to the industry's early twentieth-century collapse defined their hunched shape in the slowly strengthening light.

So where was that blooming sun? I walked to the top of the Heugh, arguing that being 50ft nearer to a burning globe 83 million miles distant would bring an advantage.

I had, of course, been looking in the wrong spot. Somewhere above the Farne Islands to the south-east came the pierce of a red-hot searchlight. The searchlight escaped from a dark cloud, a single spoke that then multiplied rapidly. The spokes ignited the edges of every cloud, which in turn ignited the sea, and there I was an apocryphal, biblical scene spread out in front of me…

Something called me back out onto the silent streets at midnight. A moonless night, the village's sparse collection of lamp-posts weakly splashing down their small orange circles; beyond the village confines, the night was gripped tight in a thick black glove.

I walked to Chare Ends, looked out across the dark lonely flats, heard the occasional cry of a bird, saw the smudges of mainland light from Beal up north to Berwick and down to Seahouses.

Something kept me out there, sent me back on the road to the castle, a solid black curtain of dark.

Until, a remarkable sight. Glimpsed briefly, like a sudden silhouette in a haunting German expressionist film, backlit for one second by the sweeping beam of Longstone Lighthouse, was Lindisfarne castle in all its Gothic glory.

Quickly the night swallowed it again. But wait a moment. The light swept round once more, once more the crag and castle leapt briefly from the dark.

My day had started with the pre-dawn castle, and was ending with it displaying for me once more. The island had spoken to me this day & had summoned me twice.

Leonardo, **Rosella Garavaglia**
Chisel-edge brush Roman Capitals, written in short lines, allow for narrow interline spacing, which is balanced by the overall height dimension of the text. This work fully exploits the medium of brush and fabric, and the color palette used is based on Da Vinci's paintings. [Gouache on calico]

MUOVERSI
L'AMATO PER LA
COS'AMATA
COME IL SENSO
COLLA
SENSIBILE
E CON SECO
S'UNISCE E
FASSI UNA CO
SA MEDESIMA
L'OPERA È LA
PRIMA COSA
CHE NASCE
DALL'UNIONE
SE LA COSA
AMATA È VILE
L'AMANTE SI FÀ
VILE. QUANDO
LA COSA UNI
TA È CONVENI
ENTE AL SUO
UNITORE
LI SEGUITA
DILETTAZIONE
E PIACERE E
SADDISFAZIONE

LEONARDO
DA VINCI

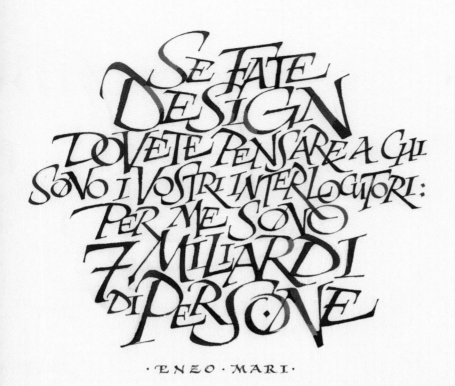

· ENZO · MARI ·

Centered

Lines of text are equally balanced around a central vertical line. The writing needs to be accurate so that you can be consistent with the line lengths used in the draft layout. Often appropriate for poems of different line lengths, and also works well for short lines with minimum interline space.

Enzo Mari Quote,
Luca Barcellona (left)
A lively composition, which was improvised without pre-planning and executed step by step. For compactness, serifs, ligatures (joins from letter to letter), and overlapping are used to interweave the letters—freely written letterforms based on classical Roman Capitals. The design has a strong central core. [Gouache and metal nibs on cotton paper]

Y Ddraig Goch

Since the time of Uther Pendragon, father of King Arthur, the Red Dragon has appeared on the Standard of every Welsh king. It was believed that he protected his own people, whilst inspiring fear into the hearts of the enemy warriors

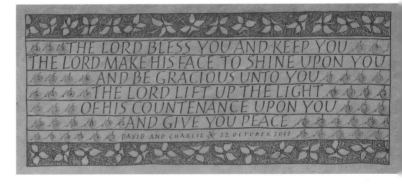

Detail from *Red Dragon*,
Jan Pickett
A formal commission with contemporary touches by using color through the heading and carefully placed flourishes on the Italic. [Gouache on Arches Aquarelle paper]

The Lord Bless You, **Sue Gunn**
This was a commissioned piece with the decoration and writing made with the same pen. The Italic capitals lettering is centered and the decoration has been used to create a block. The proportions are perfectly matched by the framing. [Gouache, using metal pens on Khadi Nepalese tissue]

Asymmetric

This layout form is freer, less formal, and has more movement. The text and space are evenly balanced on either side of a strong central axis. No two lines begin or end in the same place, but they are visually balanced around the axis.

Those Birds, Gaynor Goffe
A personal free-flowing Italic conveys the flight of birds and the movement of leaves. The generous interline space allows for flourishes, ascenders, and descenders, and the short lines add to the feeling of space while conveying an upward movement. [Acrylic wash background, metal nibs, and FW acrylic ink on Fabriano Hot Press paper]

Nord, Birgit Nass (right)
The powerful, energetic, and fast strokes of a ruling pen are used here to dramatic effect, with a cursive style based on Italic letters, loops, and ligatures that all help to balance the layout. [Automatic pen, ruling pen, nib, airbrush ink, and water on Aquarelle paper]

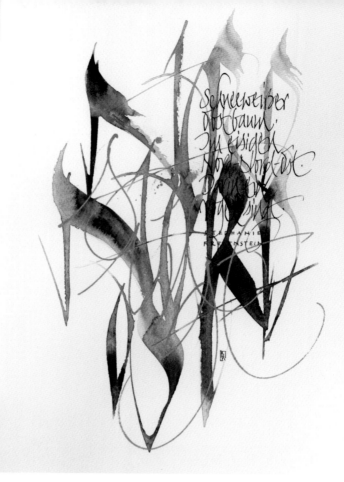

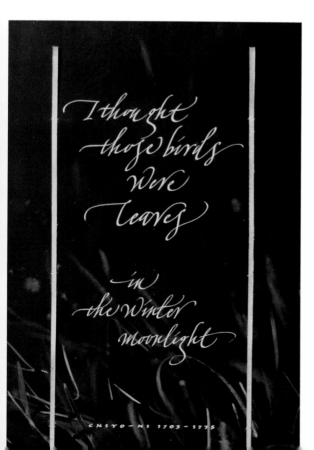

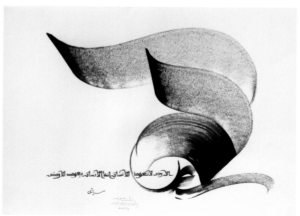

"Earth doesn't belong to man, it is man who belongs to the earth." Chief Seattle's letter to President Pierce, 1885, Hassan Massoudy
The large, textured, sweeping strokes carry the eye around and down to the dense line of red script that visually balances and moves into the dark and heavy ink on the right-hand side. [Ink on paper]

Other layouts

As calligraphers take a more creative, painterly approach and the main function of writing moves away from legibility, lettering no longer needs to be in straight lines. When writing on curves the letters should be aligned with the radius of the curve. In the case of a wavy line this will change along the line, so orientate the paper as you write. These designs explore some of the possibilities of introducing shape in the form of circles and wavy lines.

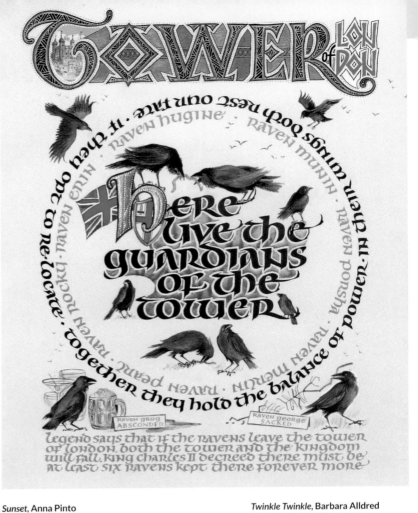

Tower of London, Jan Pickett (right)
This design of Celtic Angular majuscules and half-Uncial lettering cleverly combines several forms of layout, from the strong asymmetric center, moving out to two concentric circles of writing sandwiched between the centered heading and text at the bottom of the page. The corners around the circle are filled with illustrations, making a coherent whole. [Gold leaf, variegated schlag, and watercolor on Saunders Waterford Hot Press paper]

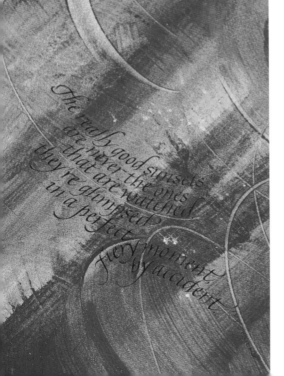

Sunset, Anna Pinto
The paste paper has been used to represent the blaze of colors in a sunset, while the Italic writing is following the free movements that happened when the paper was made. Keeping a slanting script such as Italic consistent when writing on curving lines presents quite a challenge. [Metal nib and gouache on paste paper (made by the artist)]

Twinkle Twinkle, Barbara Alldred
The focal point of this piece is a manipulated, gestural Italic in flat gilding, enhanced with raised gesso gilding. The letters are written in a tight circle, and gilded lines explode into space. The text is Roman Capitals in a white and silver gouache mixture, flowing from the focal point into deep space. [Metal nibs on black Canson paper]

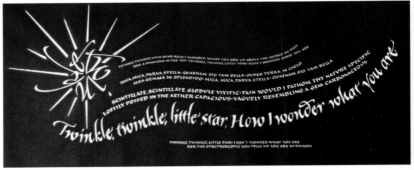

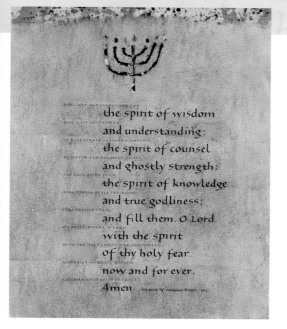

the spirit of wisdom
and understanding;
the spirit of counsel
and ghostly strength;
the spirit of knowledge
and true godliness;
and fill them, O Lord
with the spirit
of thy holy fear,
now and for ever.
Amen

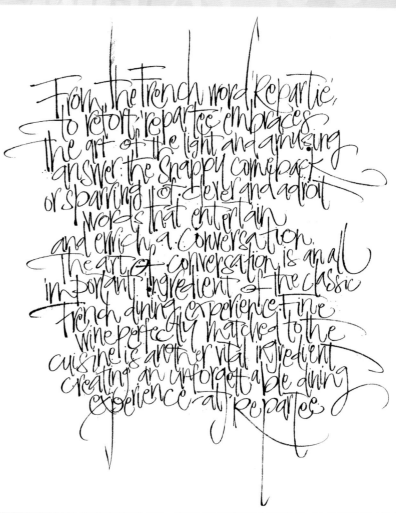

The Spirits of Wisdom, Yukiko Fukiyama
This left-aligned layout is given additional interest by contrasting scripts, sizes, and colors, and by indenting the lines of small Roman-based capitals. The artistic representation of the menorah is in keeping with the style of the Foundational Hand script. [Metal nibs and Sumi ink on Canson paper; gold leaf]

Repartee, Kirsten Burke
A ruling pen provides freedom of movement, allowing fast, flowing strokes. With its sprays of ink as the pen reverberates across the paper, and contrasting thick and thin strokes, Kirsten's lettering has an energy that would have been difficult to achieve with any other calligraphy pen. [Ruling pen, canvas, acrylic colors, mixtechnic, gesso, and chalk]

MAKING A LAYOUT

A common mistake is that the design does not relate well to the text. For the beginner, the available repertoire is obviously limited, but study how artists have used calligraphy to visually represent the mood of the text, and follow the guidelines here.

Start with the text
Read through the words and make quick thumbnail sketches of your ideas.

Consider line length
Poetry will have line breaks already, but prose can be divided into lines by phrasing and/or punctuation.

Try out the key elements
Make writing trials of different scripts, weights, and sizes. Write all the text in one nib size.

Take some photocopies of the text
Cut up the lines of writing and arrange in possible layouts on layout paper. The text will begin to take shape as you work on it. (It is helpful to number the lines to avoid muddling them up.)

Experiment with various interline spaces
Be open minded, as you may wish to change some of your first ideas in light of your trials.

Use four strips of dark cardstock/paper
Set the margins and assess the overall shape of the text area.

Consider incorporating the title and credit (if used).

Think about introducing contrast
This might be as a simple initial letter in a contrasting color and/or size and weight.

Explore creative options
Possibilities include using circles, spirals, writing around the sides of a square with a focal point at its center, or writing on wavy lines.

Start simply
Try more challenging layouts as you progress.

Breaking the rules
Most rules are there for guidance and are frequently broken for artistic reasons.

DOUBLE
BOTTOMLESS
PERDITION.
here to DWELL
n ADAMANTIN
HAINS AND PEN
FIRE WHO DU
FIRE THE

parlee

by their Hand
an undisting
only
wered by
Brittish
and fe
tably i
Separ
rca, in
ly publ
t all politi
Race, co

G
HILPA
OETAM
IMO SIC SIB
ANTE QVAM
DITEREBVSVM

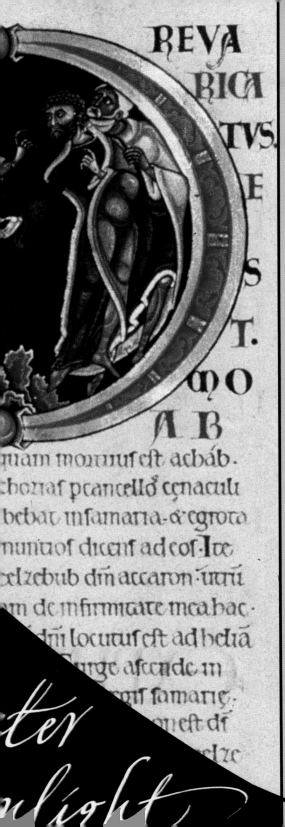

The. Scripts 2

Spanning the history of Western lettering, the 21 scripts featured in this section use a variety of tools and have equally varied applications. The scripts are linked to their historical counterparts, which form the basis for modern lettering, while still offering creative inspiration to the contemporary calligrapher. The scripts are organized with clear explanations and guidance for practitioners.

Roman Capitals

The shape and proportions of Roman Capitals are based on "monumental capitalis," that is, large capital letters inscribed in stone. The most famous example is Trajan's column. It is still possible to view this 38-yard (35-m) high triumphal column erected in Rome in 113 A.D. to commemorate one of the emperor's important victories.

At this time, all letters were majuscules; there were no minuscules. Roman Capital is a script in its own right, and forming as it does the bedrock of all Western lettering, Roman Capitals reward study by leading to a greater understanding of any script, and so improving skills and knowledge at all levels.

Classical letterforms

The classical letterforms of Ancient Rome have profoundly influenced every letter that is in use today. By the second century A.D., the Romans had developed an alphabetic system that remains largely unchanged, apart from the addition of "J," "U," and "W." Fine examples are to be seen in monumental inscriptions, where beautifully proportioned letters, made according to geometric principles based on the square and circle (see page 39), were painted onto stone with a chisel-edged brush before being incised.

Roman Capitals can also be adapted to be used with minuscule scripts where appropriate, as well as being modified to form Italic capitals. They are an extremely versatile script as the weight (nib-width height) can be varied from anywhere between heavy and dramatic to light and airy, and they can be formal or informal and shades in between.

Circular "C"
This is one of the full-width letters that is based on a circle, and is only slightly narrower than the "O" because it is open. This letter is constructed from two simple strokes. It is helpful when making any circular letters to concentrate on the inside shape. The other letters in this group are: "C," "D," "G," "O," and "Q."

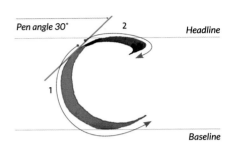
Pen angle 30° Headline Baseline

A couple of circles
"S" is a half-width letter, based on two small circles within squares. The letter must be aligned vertically on the right-hand side. The top bowl is slightly smaller than the bottom for the letter to look balanced. The other letters in this group are: "B," "E," "F," "K," "L," "P," and "R."

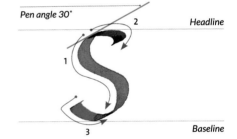
Pen angle 30° Headline Baseline

Increased angle
"V" is a three-quarter-width letter and is composed of diagonal strokes that require an increase in pen angle for the left–right diagonals to achieve even weight distribution (stroke thickness) in order to match visually the weight of the other letters. The other letters in this group are: "A," "H," "N," "T," "U," "X," "Y," and "Z."

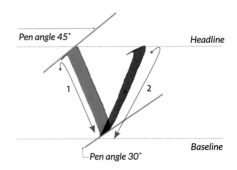
Pen angle 45° Headline Baseline Pen angle 30°

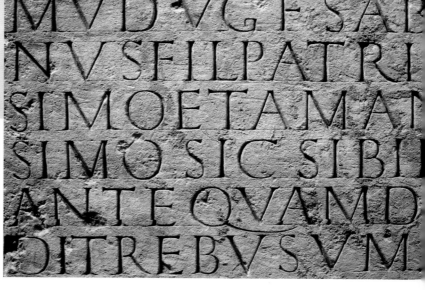

Corinthians 13, Jilly Hazeldine
These formal proportioned Roman Capitals have some manipulation (for example, the "A," "N," and "S") and are without foot serifs. [Gouache and metal nibs on BFK Rives paper]

Inscriptional Roman letters (Roman Empire, 27 B.C.–476 A.D.), Musee Sainte Croix, France
These inscribed letters demonstrate the geometric relationship of letter widths, which is the basis of classical Roman lettering and all that followed. For example, the wide letters "M" and "O" and half-width letters such as "P." Note the balance between the top and bottom bowls of "B" and the consistently top-heavy form of "S." Yet, despite being in stone, there is a touch of flamboyance in the sweeping tail of "Q."

UNDERLYING GEOMETRY

O, C, D, G, Q
The fundamental shape for these wide, circular letters is "O." "C," "G," and "D" are narrower and are seven-eighths the width of the square.

H, A, V
These three-quarter-width letters are based on a rectangle that is three-quarters the width of the original square.

N, T, U, X, Y, Z
Of these three-quarter-width letters, the "U" is the only letter that shares part of the "O" in its construction.

B, P, R
These half-width letters are based on two small circles within squares, half the width and approximately half the height of the original square.

S, J, I
With the exception of "I," these are also half-width letters. The "S" is aligned on the right-hand side of the square and "J" follows the curve of its bottom bowl.

K, E, F, L
These letters are the remainder of the half-width letter group; the "K" is slightly wider.

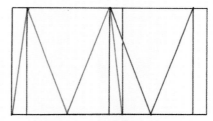

M, W
The wide "W" consists of two symmetrical "V"s, so it is one-and-a-half times the width of the original square. "M" is based on a symmetrical "V" and its outer vertical strokes are angled to fit inside the base of the square.

Roman Capitals are constructed on the basis of a square and a circle within the square. There are four groups of geometric formations, as demonstrated in the accompanying seven diagrams.

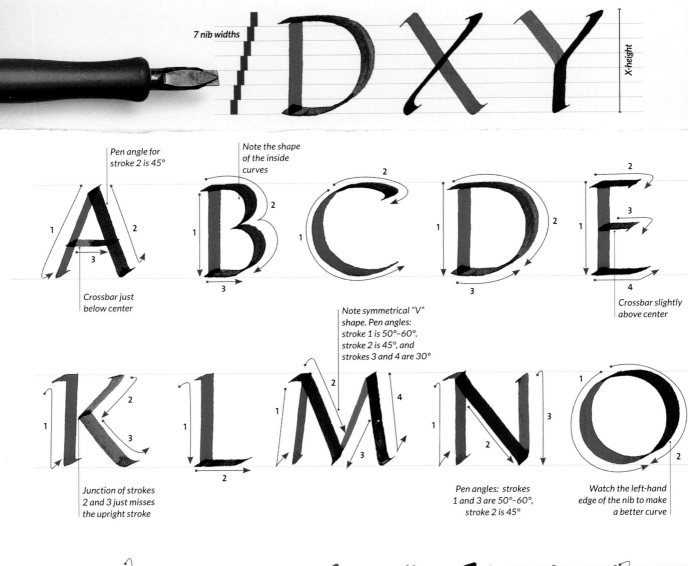

7 nib widths

X-height

Pen angle for stroke 2 is 45°

Note the shape of the inside curves

Crossbar just below center

Crossbar slightly above center

Note symmetrical "V" shape. Pen angles: stroke 1 is 50°–60°, stroke 2 is 45°, and strokes 3 and 4 are 30°

Junction of strokes 2 and 3 just misses the upright stroke

Pen angles: strokes 1 and 3 are 50°–60°, stroke 2 is 45°

Watch the left-hand edge of the nib to make a better curve

This part of the letter is a small section of a circle

Pen angles: stroke 1 is 45°, stroke 2 is 30°

Pen angles: strokes 1 and 3 are 45°, strokes 2 and 4 are 30°

Pen angles: stroke 1 is 45°, stroke 2 is 30°

CLIP 1
Roman Capitals
http://qr.quartobooks.
com/cask/clip1.html

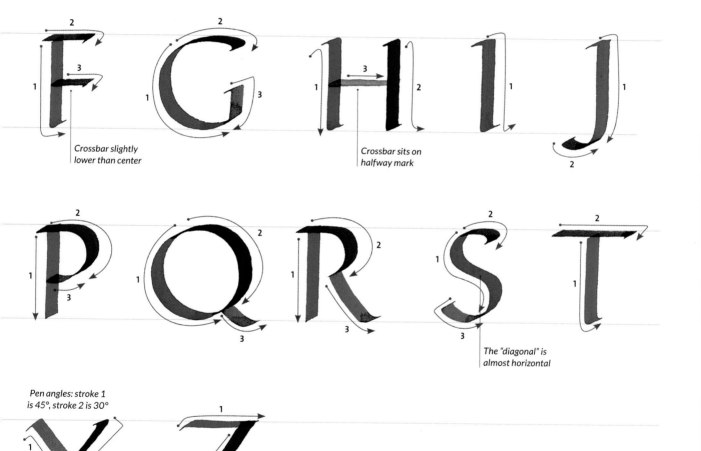

*Crossbar slightly
lower than center*

*Crossbar sits on
halfway mark*

*The "diagonal" is
almost horizontal*

*Pen angles: stroke 1
is 45°, stroke 2 is 30°*

*Flatten pen to 0°
for stroke 2*

Basic structure

The relationship between the letters is one of geometry rather than of a common underlying form. The basis of this is that the square and round letters are based on circles (the circumference equal to the square) or part circles. The family groups are based on these groupings.

Roman Capitals is a rather slow and carefully written script of 7 nib widths high. This can be altered for use with other scripts, such as Foundational Hand. The pen angle is 30°, but there are a number of pen angle changes for several letters in order for the strokes to be the right weight (thickness). The letters "A," "V," "W," "X," and "Y" require a pen angle of 45° for left–right diagonals. "M" and "N" need 50°–60° for thin verticals, and "Z" needs 0° (flat) for its diagonal stroke.

The exemplar uses a simple round hook serif at the top and bottom of the strokes.

IN DETAIL

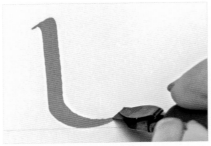

1 Starting just below the headline using a pen angle of 30°, push up and curve clockwise to form a serif. Pull straight down to just above the baseline. Pause, then curve counterclockwise, touching and then coming off the baseline.

2 Starting just below the headline using a pen angle of 30°, push up and curve clockwise to form a serif, then pull straight down to the baseline, curving counterclockwise to make a smaller serif at the end of the stroke.

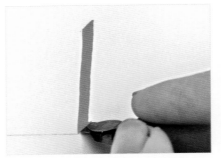

1 Using a pen angle of 55°–60°, start at the headline and make a shallow diagonal stroke to the baseline. Curve to form a serif at the end of the stroke.

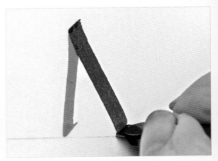

2 With a pen angle of 45°, overlap the beginning of stroke 1 and make a left–right diagonal stroke to the baseline. At the end of the stroke, pull the pen down vertically for a short distance.

PEN POSITIONS

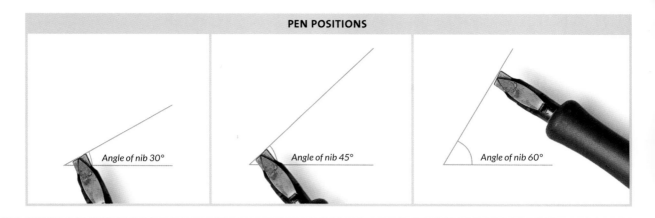

Angle of nib 30°

Angle of nib 45°

Angle of nib 60°

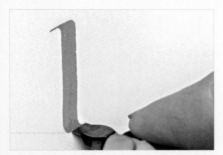

1 Starting just below the headline using a pen angle of 30°, push up and curve clockwise to form a serif. Pull straight down to the baseline, curving counterclockwise. Make a smaller serif at the end of the stroke.

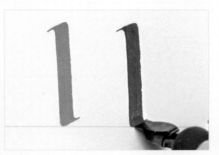

2 Leaving a gap of slightly less than three-quarters the height of the letter, make a second stroke the same as the first.

3 Draw a crossbar between the two strokes that sits on the halfway point of the letter.

3 Position stroke 3 at the headline so that the "V" is symmetrical. Using a pen angle of 30°, make a right–left diagonal to meet the end of stroke 2.

4 Keeping the pen angle at 30°, overlap the beginning of stroke 3 and make a shallow diagonal stroke, mirroring stroke 1, down to the baseline. Curve up at the end to form a serif.

CONTINUED NEXT PAGE

BEFPRKLS

1 Start at the headline using a pen angle of 30° and pull straight down to the baseline.

2 Start just to the left of the vertical stroke, pull straight across, then curve around to form the top bowl. Pull in toward the stem, then out and around again, forming the bottom bowl. Lift off the pen when the stroke becomes thin.

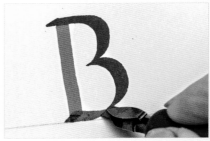

3 Start the third stroke just to the left of stroke 1, pull across and up slightly to overlap the thin part at the end of stroke 2.

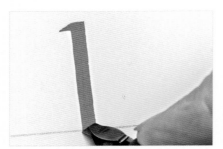

1 Start at the headline using a pen angle of 30°, pull straight across to form a small serif, then straight down to the baseline.

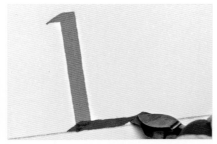

2 Start just to the left of stroke 1; pull straight across to complete the letter.

In practice

Roman Capitals are a standalone script and are capable of a wide range of variations, for example, by changing the weight (nib-width height) or lateral compression. Reduce the height to 6 nib widths to use with Foundational Hand (see pages 136–141). Used in a formal context, Roman Capitals are clear and elegant and need generous spacing because of the varying widths of the letters. The spacing rule of thumb is based on the width of the counterspace of "H." The distance between two vertical strokes is slightly less than this, a curve and an upright slightly closer, and two adjacent curves closer still.

I J

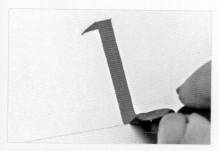 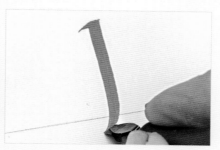 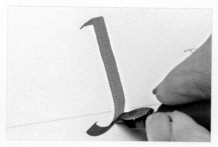

1 Start at the headline using a pen angle of 30°, pull straight across to form a small serif, then straight down to the baseline.

2 Pull the stroke through the baseline and curve to the left. Lift the pen when the stroke becomes thin.

3 Start this stroke slightly below and to the left of stroke 1. Pull across and up to overlap the thin part at the end of stroke 1.

O C D
G Q

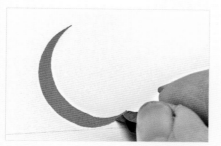 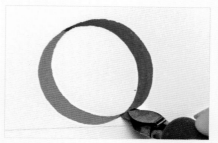

1 Using a pen angle of 30°, make a generous clockwise curve around to the baseline, ending with a thin stroke.

2 Overlap the start of stroke 1, pulling the pen around in a generous counterclockwise curve to meet and overlap the end of stroke 1.

Make adjustments for open letters such as "E."

Use the Rule of Three (see page 24) so that each letter looks midway between its partners.

TEMPUS

Rustics *by Jilly Hazeldine*

Rustics is an ancient, stately, and majestic majuscule script, which reached its high point around the fourth to sixth centuries A.D. When written using narrow interlinear space, the letters create a striking pattern and texture.

Very early examples of Rustics have been found where the main writing tools would have been papyrus and the reed pen. Around the first century A.D., Rustic letters as high as 6 inches (12 cm) were also written with a chisel brush onto walls and used as notices in places such as Pompeii. Among the thousands of examples of graffiti, one inscription translates as, "If you want to lean on a wall, please lean on someone else's."

Rustics can be seen in prestigious manuscripts such as the *Codex Palatinus* and *Vaticanus* (Vatican Library), and *Codex Mediceus* (Florence), dating from the sixth century. Probably the finest example, the writing in *Palatinus* was about ¼ inch (6 mm) high. As newer scripts evolved, Rustics continued to be used for display, such as in chapter headings.

Points to consider

Writing Rustics involves manipulating the pen on verticals from a starting point of 80° to finish the stroke at 45°. Diagonals are written at 45°–60° and large curves at 60°. Letters and bowls are narrow, and a few letters are fractionally taller. The main difference between "E" and "F" is their height, although the middle limb on "E" is more definite, whereas that of the "F" has a diamond shape.

Rustics would still look very effective as a bookhand and also when combined with scripts with contrasting weight and height.

The tall "B"
Rule up guidelines at 6 nib widths—"B" is one of the taller letters by about 1 extra nib width. Stroke 1 forms a small serif at the beginning, then steepens to around 80°. Toward the end of the downstroke, the pen is turned until it reaches an angle of 45°, just above the baseline. It then moves down and to the right to form the left-hand side of the lower bowl. The corner of the nib fills in the right side of the upright. When writing smaller, this could be achieved using pen pressure. Both bowls of "B" and related letters droop, with the top bowls being quite small.

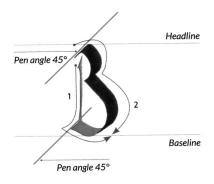

The curves of "G"
With the pen at 60°, the stroke begins with a thin starting just below the headline, forming a shallow curve to the right. Using a pen angle of 45°, the second stroke starts inside the bowl of "G" and curves around to meet the end of the first stroke. For the third stroke, the pen is placed at the beginning of the first and, maintaining the steep pen angle, forms a short arched stroke just below the headline.

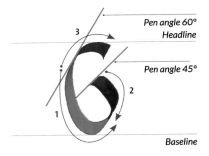

Spot the "V" shapes
Unusually, the first stroke of "M" begins with the "V" shape at its center. With the pen at 45°–50°, starting below the headline, a curved serif is formed before moving in a shallow diagonal to the baseline. Just before the baseline, the angle is steepened to around 80°, then a sharp turn takes the stroke right up to the headline. The second stroke replicates the serif on the first and then makes a shallow diagonal to the baseline, parallel to the left-hand side of the letter. The third stroke starts level with the point where 1 and 2 merge, pulls to the left until just before the baseline, then down to the right and up again to the left, to meet the first part of the stroke, forming the foot at the bottom of the stroke.

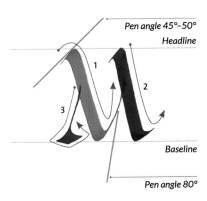

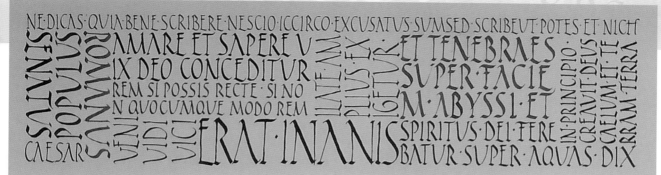

Latin Fragments, **Janice McClelland**
This collage of Rustics features
different sizes and weights of letters
moving in different directions. The
"fragments" are held together by the
long continuous line across the top.
[Metal nibs and gouache on Fabriano
Artistico]

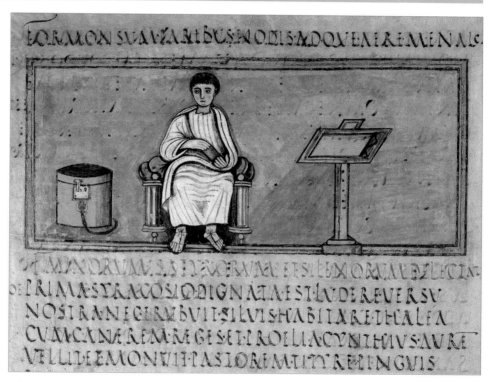

The contemporary letters remain
fairly faithful to the original here. The
main difference lies in the changes of
size, weight, and direction of writing
to create a collage effect.

The Aeneid, Virgil (70–19 B.C.),
fifth century A.D.
The compactness of the
lettering and regular spacing is
balanced by the narrow
interline space. It is interesting
to see a few letters squeezed in
at the end of the line of red
writing and a tiny red "OF" at
the beginning of the next line—
this isn't something that we
would be able to do today.

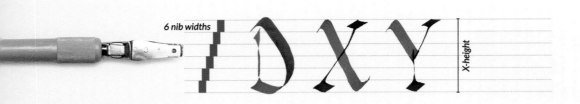

6 nib widths

X-height

Rustics

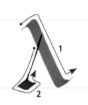

Starting the stroke at 55°, rotate the nib counterclockwise to increase the pen angle to about 80°

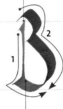

Use the corner of the nib to fill in with ink

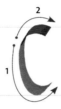

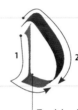

Touch in with corner of nib

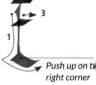

Push up on the right corner

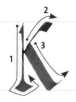

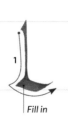

Fill in

Push right up to the top

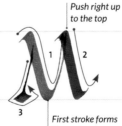

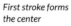

First stroke forms the center

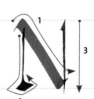

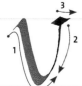

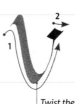

Twist the pen at the base

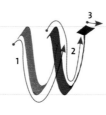

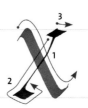

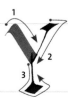

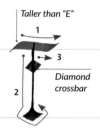

Taller than "E"

Diamond crossbar

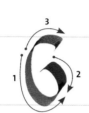

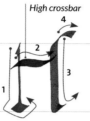

High crossbar

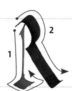

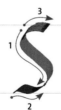

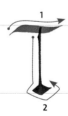

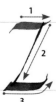

Basic structure

The exemplar is written at 6 nib widths with a pen angle that varies from 80°–45°. The letters are upright. The family relationship of this script comes from the consistent shape of the vertical strokes, the droop on the bowls, and the narrow letterform. The inward curve on the bowls of "B," "P," and "R," and the crossbars on "E," "F," and "H" are high and well above the midpoint of these letters.

Writing consistently using a steep pen angle that also varies between 45° and 60°, as well as manipulation using the corner of the nib, make this a challenging but rewarding script to be tried once pen control has perhaps moved on from the beginner stage. A few letters are slightly taller, which softens what might otherwise be a rigid top line. Practice the various movements involved in writing this script separately before tackling the letters.

IN DETAIL

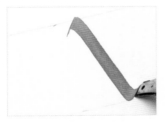

1 Start below the headline with a pen angle of 60°, curve up to the headline, then change direction and make a diagonal stroke to the baseline, ending with a small serif.

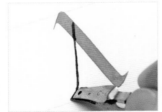

2 With a pen angle of 80°, start the second stroke over the first. Form a thin, right–left diagonal and, just above the baseline, switch to a 45° angle and pull slightly to the left.

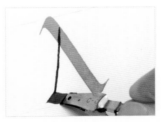

3 Pull down to the right and up again to the left to merge with the first part of the stroke, forming the foot at the baseline.

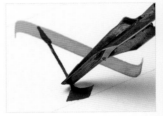

4 Fill in the inside of the foot with the corner of the nib.

1 Start below the headline with a pen angle of 80°, curving upward to form a small serif. Pull down to the baseline and then turn up sharply.

2 Repeat the shape of stroke 1, ending at the turn sharply at the baseline.

3 Continue up to the headline, repeating the shape of stroke 1.

4 Change the pen angle to approximately 45° and make a wedge serif at the top of the second stroke.

Left-handers

This can be a difficult script for a left-hander, but writing with the paper at right angles to yourself may help.

PEN POSITIONS

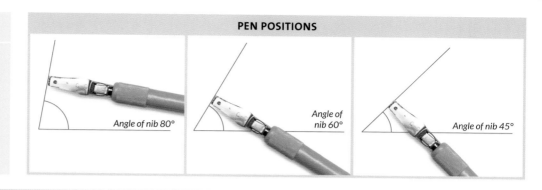

Angle of nib 80°

Angle of nib 60°

Angle of nib 45°

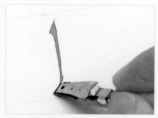

1 Form a small serif and then, using an 80° pen angle, pull the pen downward and, just above the baseline, turn it to a 45° angle and pull it slightly to the left.

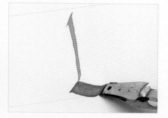

2 Move the pen down and to the right to form the left-hand side of the bowl.

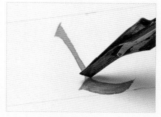

3 Use the corner of the nib to fill in the right side of the upright.

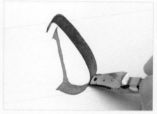

4 With a pen angle of 60°, curve above the top of the first stroke and pull the pen downward, forming a pear-shaped bowl to connect with the end of the first stroke.

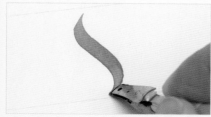

1 Just below the headline, using a pen angle of 80°, draw a shallow curving stroke down to just above the baseline.

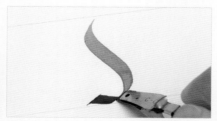

2 Change the pen angle to 45° and align the nib with the left-hand side of the "S" as well as the baseline and make a slight curve to meet the end of the first stroke.

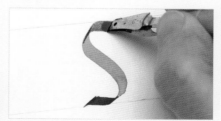

3 With a pen angle of 80°, place the pen on the beginning of stroke 1 and form a clockwise curve ending level with the right-hand side of the "S."

CONTINUED NEXT PAGE ▷

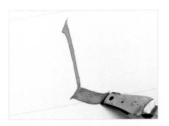

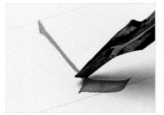

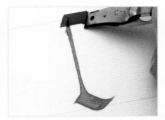

1 Form a small serif. Steepen the pen to around 80° and pull it down to just above the baseline, then using an angle of 45° pull the pen slightly to the left and down to the baseline.

2 Fill in the inside curve using the corner of the nib.

3 Using a pen angle of 80° make a short, horizontal stroke across the top of the letter. At the end of the stroke, pull very slightly downward and to the left to form a serif.

4 About three-quarters up the stem of the letter, make a third stroke in the same manner as stroke 2, but make it slightly shorter.

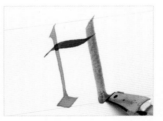

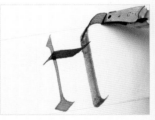

1 Form a small serif, then steepen the pen to 80°, pull it down to just above the baseline. Turn the pen to 45° and pull it to the left and then down to the baseline for the serif.

2 The crossbar sits two-thirds up the stem. With an angle of 45°, start to the left of stroke 1, pull the pen across and finish with a slight upward turn forming a thin.

3 Start just above the headline, using an angle of 45°, and bring the stroke in from the right, pulling it to the baseline, skimming the end of stroke 2. Finish with a curved serif.

4 Place the nib at the start of stroke 3 and make a small upwardly curving serif to complete the letter.

In practice

This word demonstrates the striking elegance of the Rustic script. Spacing is close, but rhythmical with visually balanced counterspaces. You will develop an eye for this with simpler scripts than Rustics.

K P R

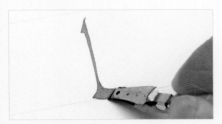 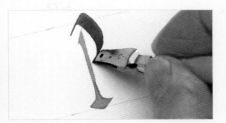 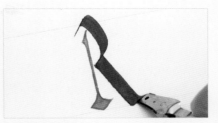

1 Form a small serif. Steepen the pen to around 80° and pull it down to just above the baseline, at which point turn the pen to an angle of 45° and pull it slightly to the left and then right down to the baseline (see "A" and "H").

2 The bowl of "R" is narrow and meets the stem just above the halfway point. With a pen angle of 60°, curve over the top of stroke 1 and pull the pen down and inward, forming the pear-shaped bowl that does not quite meet the stem.

3 Change direction and make a left–right diagonal stroke down to the baseline, ending with a small serif.

X Y Z

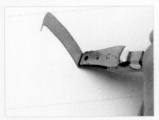

1 The top, V-shape section of "Y" is about half of the letter height. Using a pen angle of 80°, make a steep, left–right diagonal stroke.

2 Make a small wedge serif using an angle of 45°.

3 Increase the pen angle to 80° and pull the pen down to meet the end of the first stroke.

4 Change direction and pull the pen down to just above the baseline, then pull slightly to the left, then across to the right to form the serif.

Natural Uncials

The family of Uncial letters is seen very early in the evolution of scripts and was commonly used in Christian books between the fourth and eighth centuries. The rapid spread of Christianity at this time meant that a large number of books were being produced, and this clear and quickly written script was ideal.

Uncials are often referred to as a "true penman's alphabet," because their round and legible form is the direct result of writing with a broad-edged pen held at a natural angle, rather than seeking to imitate inscriptional forms.

Uncials are a majuscule, or large letter. They were in use before the emergence of upper- and lowercase (a printing term), more often referred to as capitals and small letters. The evolution of the minuscule, or small letter, began around the seventh century and was more or less complete by the ninth. Uncials continued to be used for display and headings in combination with these later developments, a layout now mimicked by newspapers.

The beginner's hand

Because of its simple shapes and combination of pen strokes, Uncials are an ideal beginner's hand, and as there is no upper- and lowercase, there are only 26 letters to learn. There were originally 22 letters in the alphabet when the manuscripts were in Latin. "J," "k," "v," and "w" were added as language developed.

There are two types of Uncial: Natural and Artificial. Natural Uncials—featured here—are so-called because they use a natural pen angle and are more freely written, whereas Artificial Uncials are written with a flat pen angle. This necessitates manipulation of the pen in order to use its corner to form the serifs. Artificial was more ornate, in keeping with the increasing majesty of the books being produced. It is likely that the nib of a quill or reed pen would have been cut at a right-oblique angle to facilitate this.

Legs first
The legs of "N" are formed first with strokes 1 and 2. The pen angle of 30° is slightly higher to make them a bit thinner. The third joining stroke has a flatter pen angle of 20°–25° and overlaps both strokes at the start and finish. The letter is as wide as "o"—a common mistake is to make it too narrow.

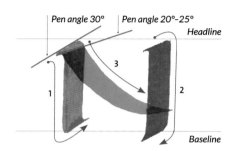

Pause and turn
The first stroke of "B" pauses just above the baseline, before turning and ending with a thin. This pause and turn movement is also used on "l," "m," and "w." The second stroke starts by overlapping the first; the bowl is open and does not meet the vertical stroke before slightly overlapping the end of the first stroke.

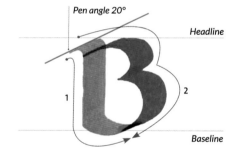

Two open bowls
Start stroke 1 of "m" just below the line and overlap it with the second stroke, which has a pause and turn at *. This is the point where stroke 3 starts. Be sure to keep the two bowls open at the baseline.

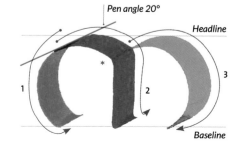

To the druids the birch tree represents renewal and rebirth as it was the first tree in winter's aftermath to bring forth leaf. Birch people are determined·resilient and ambitious·good organisers·leaders and strategists·they are not deterred by set-backs·believing hard work·patience and persistence will triumph·they are loyal but reserved in showing affection·

24·dec–20 jan

A Book of Celtic Astrology, Vivien Lunniss
The essential personality of Uncial has been retained in this contemporary example, but the letterform is narrower, taller, and written with a lighter weight. The pen angle is still very low, and some of the letters have been allowed to join adjacent letters.

Facsimile of a sixth-century Merovingian manuscript
With its uneven lines and irregular letter sizes, this manuscript gives the impression of being hastily or carelessly written. However, all the Uncial letterforms are distinguishable and it demonstrates how this script became such a well-used bookhand that retains its legibility despite being written at speed.

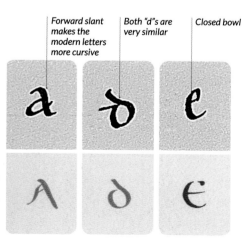

Forward slant makes the modern letters more cursive

Both "d"s are very similar

Closed bowl

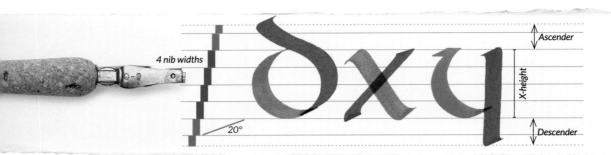

4 nib widths

20°

Ascender

X-height

Descender

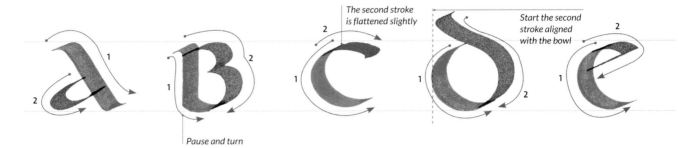

The second stroke is flattened slightly

Pause and turn

Start the second stroke aligned with the bowl

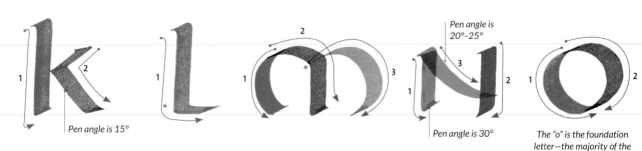

Pen angle is 15°

Pen angle is 20°–25°

Pen angle is 30°

The "o" is the foundation letter—the majority of the other letters take their shape from it. The first stroke of "o" is the same for "c," "e," "d," "G," and "q," and the second stroke is present in "p"

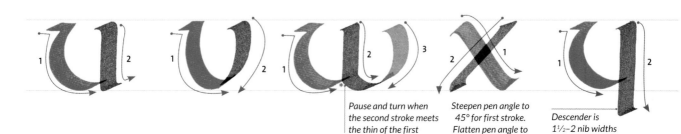

Pause and turn when the second stroke meets the thin of the first

Steepen pen angle to 45° for first stroke. Flatten pen angle to 15° for second stroke

Descender is 1½–2 nib widths

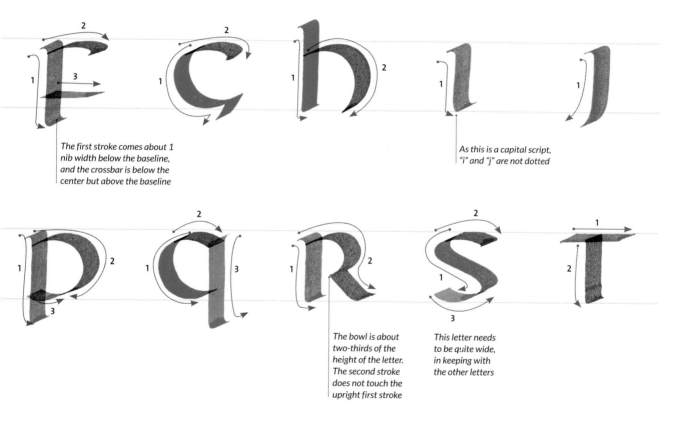

The first stroke comes about 1 nib width below the baseline, and the crossbar is below the center but above the baseline

As this is a capital script, "i" and "j" are not dotted

The bowl is about two-thirds of the height of the letter. The second stroke does not touch the upright first stroke

This letter needs to be quite wide, in keeping with the other letters

Flatten the pen to 0°

Key
**Pause and turn*

Basic structure

The underlying form of Uncial is based on the shape of the letter "o," which is shaped like a grapefruit; it is slightly wider than its height. This form underpins the majority of the letters in the alphabet, and it is helpful to practice in family groups of closely related shapes rather than in alphabetical order.

Unlike handwriting, individual letters are constructed from separate pen strokes, which are shown here in different colors as a guide to their sequence and with directional arrows. The movement generally is from top to bottom, left to right, avoiding pushed strokes.

IN DETAIL

ANXZ

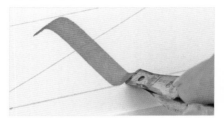

1 Starting just below the headline with the pen at an angle of 20°, curve up to the headline, then change direction and make a diagonal stroke down to the baseline.

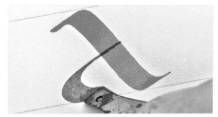

2 Start the second stroke over the first, slightly less than halfway up. Form a curve down to the baseline.

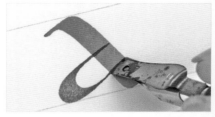

3 Close the bowl by continuing the stroke up to the first, approximately parallel to the first part of the second stroke.

1 With the pen at 30°, make a small serif followed by a vertical stroke down to the baseline, ending with a serif.

2 Leaving a space wider than the height of the letter, make a vertical stroke parallel to the first. Just above the baseline, pull the pen to the left so that the stroke cuts through the baseline.

3 Using a flatter pen angle of 20°–25°, join the two vertical strokes with a diagonal that overlaps the first stroke at its beginning and ends just above the baseline.

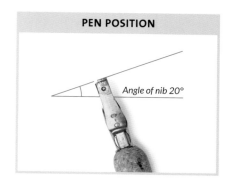
BRS

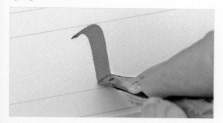

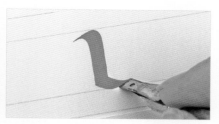

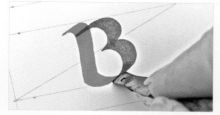

1 Using a pen angle of 20°, make a serif by starting just below the headline. Change direction to make a vertical stroke.

2 Just above the baseline, pause and change direction, making a shallow curve touching the baseline and ending with a thin.

3 Overlapping the first stroke, form the top bowl like a small "o," curve in toward the main stem without touching it, then make a larger bowl to meet the end of stroke 1.

cdeçopq

1 Using a pen angle of 20°, the first stroke is the same as for "o."

2 Align with the left-hand side of the bowl to start stroke 2 with a small serif about 1½ nib widths above the headline. Curve around and pick up the shape of "o" to complete the letter.

CONTINUED NEXT PAGE ▷

muhvwy

1 Make a counterclockwise "o"-shaped curve using a pen angle of 20°, starting just below the headline and ending with a small serif.

2 Overlap the start of stroke 1, make a clockwise curve to about 1 nib width below the headline, pause, then make a vertical downstroke to the baseline, ending with a small serif.

3 Place the nib onto the angle created by the pause in the second stroke and make a clockwise curve mirroring the first bowl, down to and just cutting through the baseline.

1 With the pen at an angle of 20°, make a short, horizontal stroke just below the headline. Make a generous counterclockwise curve around to, then off, the baseline until you reach a thin.

2 Starting level with the first stroke, make a small curved serif and then pull straight down toward the baseline. On reaching the end of stroke 1, make a curve around to, then off, the baseline until you reach a thin.

3 Starting level with the first two strokes, make a small curved serif and then curve around clockwise to merge with stroke 2.

In practice

The word "aurora" shows the personality of Uncial well, with its strong pen strokes and round shapes. The form of "a" with its sloping back continued into subsequent generations of scripts, and the large bowl of "R" is a particular characteristic of this script.

JIFKLT

1 Using a pen angle of 20°, make a serif just below the headline, followed by a vertical stroke to about 1½ nib widths below the baseline, ending with a small serif.

2 Overlap the first stroke and make a very shallow curve that ends with a serif.

3 This stroke is straight, ending with a small serif, and should align with the second stroke on the right-hand side.

1 Starting above the headline, make a serif followed by a vertical stroke to the baseline, ending with a small serif.

2 Flatten the pen angle and, starting at the headline, make a small serif, then pull diagonally in toward the stem, just above halfway.

3 Change direction and make a right–left diagonal down to the baseline. This stroke should extend farther to balance the letter.

Shows the placement of adjacent upright strokes (compare this with "O–R")

AURORA

Slightly closer than "U–R" (due to the shape of "O")

Insular Pointed Minuscule *by Jilly Hazeldine*

"Insular" means "of the islands," namely the sharing of skills between monasteries in Ireland and Britain. The pattern and texture of this script on the page, with its generous interline spacing, is very attractive and lends itself well to modernization.

The Insular Minuscule is from a group of Anglo-Saxon scripts that developed alongside the formal writing of the day. It also appears in manuscripts such as the *Lindisfarne Gospels* (A.D. 698, British Library, London) as a "gloss." A gloss is usually comments or translations which were written between lines of text at a later date.

The exemplar on these pages is based on *Bede's Commentary on the Book of Proverbs* (Bodleian Library, Oxford) written in northeast England in the mid- to late eighth century. The actual size of the letters in the manuscript is about ⅛ inch (3 mm) high.

Speedy yet characterful

A pattern is created by the script's long, pointed ascenders and descenders, which also occur on "s" and "r," the narrow form of the other letters, and the characteristic wedge serifs. Despite some pen manipulation, this is a fairly quickly written script. Insular Minuscule can be used to effect when contrasted with Natural Uncial (see pages 54–61). The archaic forms of "s," "g," and "r" can be modernized and the open top of "a" closed if desired, but this will lose some of the personality of the script.

Open top

The letter "a" is constructed from a single stroke. The top of the letter is open, so the first stroke starts at the headline with a thin stroke. With the nib at 30°, a shallow curve is formed so that it just touches the baseline, then pushes upward to form the bowl. About halfway up the letter the nib is moved vertically up to the headline. While still touching the paper, the pen shifts slightly to the left, then pulls back into the vertical stroke, making a small wedge serif. A quick curve with a thin stroke forms a serif to finish.

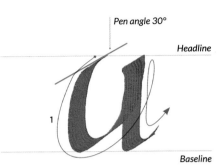

One-stroke "h"

The letter "h" can also be made in a single pen stroke that starts with the wedge serif on the ascender, then moves straight down to the baseline, pushing back up the vertical and forming the arch by branching from the main stem about 1 nib width below the headline. A curved stroke mirrors the shape of "a" around to the baseline. The fishtail at the end of the stroke is formed by quickly rotating the nib onto its right-hand corner.

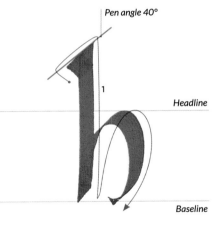

Anglo-Saxon influence

This version of "g" retains some of the archaic characteristics to reflect the flavor of the script. The first stroke hangs from the headline and is made at a slightly flatter pen angle. The second stroke is a curving "s" shape, with the thin descender made by going onto the right-hand corner of the nib and exerting pressure. The descender of "g" is not quite as long as the pointed descenders.

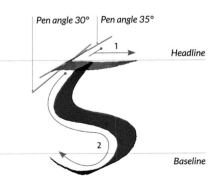

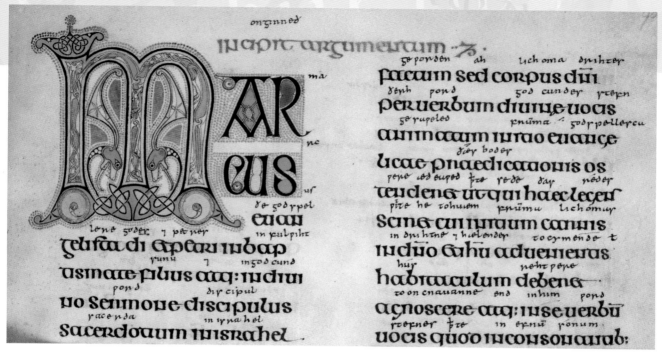

Preface to the Gospel of St Mark, The Lindisfarne Gospels, c.698 A.D.
The interlinear Anglo-Saxon gloss on this page was written circa 950 and is the earliest surviving English translation of the Gospels. As such it is an example of the cursive handwriting of the day, but it had developed into the more formal bookhand used in *Bede's Commentary on the Book of Proverbs* (late eighth century) and on which the Insular Pointed Minuscule exemplar is based.

Medieval Scribes Colophon, Vivien Lunniss
The Insular Pointed Minuscule script is written at a heavier weight for a more dramatic effect. The red Uncial, with its absence of ascenders and descenders, makes it ideal for writing the translation between lines while retaining the Anglo-Saxon feel. [Walnut ink, gouache, metal pens on Fabriano Artistico Hot Press paper. Insular pointed minuscule and Natural Uncial]

MEDIEVAL · SCRIBE'S · COLOPHON

At this time, the form of "r/R" was rather uncertain

Simplified form to suit compact layout

A more recognizable form

Style consistent with the letters in the text

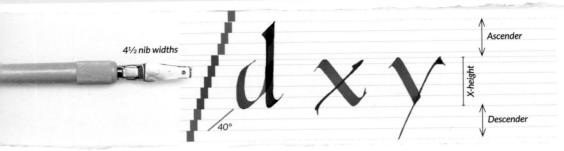

4½ nib widths

40°

Ascender
X-height
Descender

Insular Pointed Minuscule

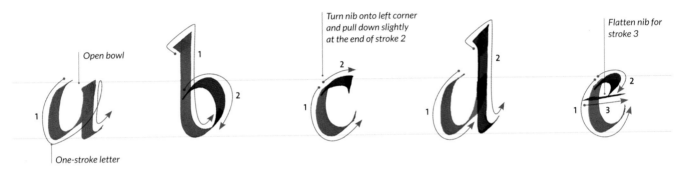

Open bowl

One-stroke letter

Turn nib onto left corner
and pull down slightly
at the end of stroke 2

Flatten nib for
stroke 3

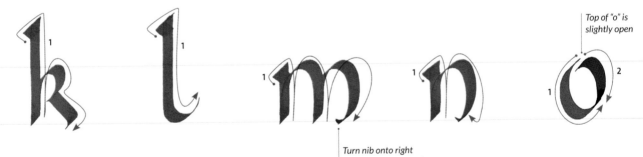

Top of "o" is
slightly open

Turn nib onto right
corner for end of stroke

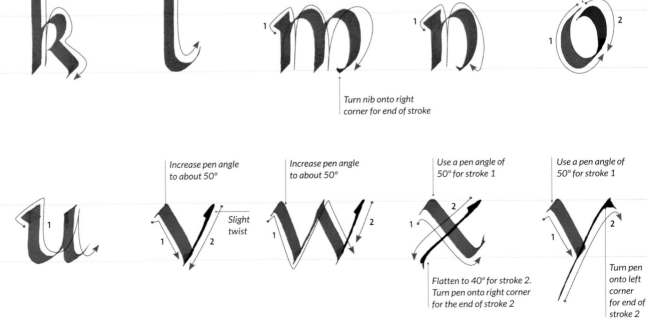

Increase pen angle
to about 50°

Increase pen angle
to about 50°

Use a pen angle of
50° for stroke 1

Use a pen angle of
50° for stroke 1

Slight
twist

Flatten to 40° for stroke 2.
Turn pen onto right corner
for the end of stroke 2

Turn pen
onto left
corner
for end of
stroke 2

CLIP 4
Insular Pointed Minuscule
http://qr.quartobooks.com/
cask/clip4.html

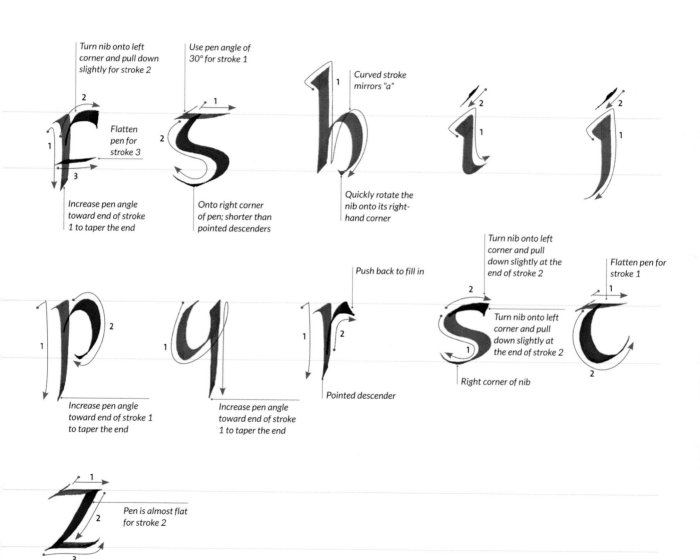

Turn nib onto left corner and pull down slightly for stroke 2

Use pen angle of 30° for stroke 1

Curved stroke mirrors "a"

Flatten pen for stroke 3

Increase pen angle toward end of stroke 1 to taper the end

Onto right corner of pen; shorter than pointed descenders

Quickly rotate the nib onto its right-hand corner

Push back to fill in

Turn nib onto left corner and pull down slightly at the end of stroke 2

Flatten pen for stroke 1

Turn nib onto left corner and pull down slightly at the end of stroke 2

Increase pen angle toward end of stroke 1 to taper the end

Increase pen angle toward end of stroke 1 to taper the end

Pointed descender

Right corner of nib

Pen is almost flat for stroke 2

Use a pen angle of about 30° for strokes 1 and 3

Basic structure

The exemplar is written at 4½ nib widths. Ascenders are about 3 nib widths. The tapering descenders are also 3 nib widths, however "f" and "r" have a tapering base that is shorter than "p" and "q." The basic pen angle is 40°, but the pen is turned counter-clockwise until it reaches approximately 65° at the end of the descender strokes to form the characteristic point. The wedge serif is constructed the same way for ascenders but is slightly sharper. The "o" is an oval, and this shape is reflected in the related letters. The letters are upright.

There are two methods of constructing the wedge serif (see page 62). The exemplar shows the serif made in a single pen stroke by starting below the headline, making a small pushed stroke (reminiscent of the diamond serif on Gothic) in a northeasterly direction, then changing direction at right angles to the first, using the edge of the nib up to the headline, pausing to keep the angle crisp, and completing the letter.

IN DETAIL

a d q u

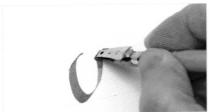

1 Using a 40° pen angle, form a shallow curve to the baseline, and then push the pen upward to form the open bowl. About halfway up the letter, move the nib vertically until it reaches the headline.

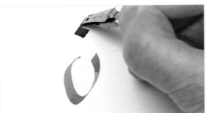

2 About 1½ nib widths above the headline, place the nib at a 40° angle and make a short stroke for the first part of the serif. Move the nib by 1 nib width to form a thin, upward and to the headline.

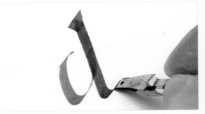

3 Pull the pen down vertically, crossing the end of stroke 1, to the baseline, then turn up and to the right to form a hook-type serif.

b l

1 Using a pen angle of 40°, form the serif as for "d," pull the pen down to the baseline, and make a counterclockwise curve for the bowl.

2 The second stroke overlaps the first and curves clockwise to meet the end of stroke 1.

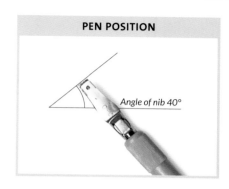

Angle of nib 40°

ceot

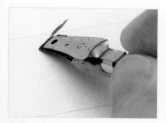

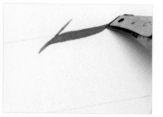

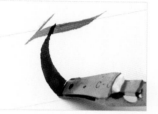

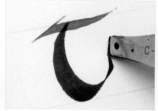

1 Using a pen angle of 30°, start above the headline and make a thin stroke down from right to left until the nib is just below the headline.

2 Pull the nib along the headline for the width of the letter and finish with a slight upward movement.

3 Using a pen angle of 40°, overlap the first stroke and make a clockwise curve, just touching the baseline.

4 Turn the pen onto its left corner, ending the stroke with a thin.

Fr

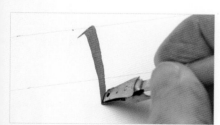

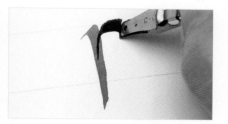

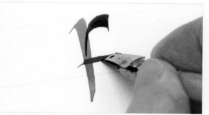

1 With an angle of 40°, form a hook serif, then pull the pen toward the baseline. Turn it counter-clockwise through the stroke to an angle of 65°, finishing 1½–2 nib widths below the baseline.

2 Begin halfway up the stem at an angle of 70°. Push the pen upward and right for a shallow curve. Rotate the pen through the stroke, ending at 90°, pulling the nib downward at the end.

3 The crossbar is slightly above the baseline using a pen angle of 30°. Start to the left of stroke 1 and pull the pen straight across until it aligns with stroke 2.

CONTINUED NEXT PAGE ▷

ς s

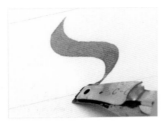
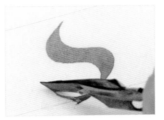

1 Starting below the headline at 40°, make a small, clockwise curve the width of the letter, then change direction to make a counterclockwise curve ending with a thin just above the baseline.

2 Turn the nib onto its right corner and continue the curve. This forms the "fishtail" at the end of the stroke.

3 Overlap the top of the first stroke and make a shallow curve to the right.

4 Increase the pen angle toward the end of the stroke and pull the nib down to make the serif. The top counterspace should be slightly smaller than the bottom.

i j

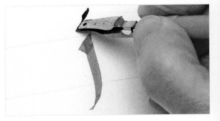

1 Place the nib at a 40° angle and make a short pushed stroke to form the first part of the serif, then move the nib by 1 nib width, forming a thin, upward and to the right (as "b" and "d").

2 Without taking the pen off the paper, pull it down vertically and through the baseline. Pull the nib to the left and onto its right corner.

3 Add the dot above the letter.

In practice

The counterclockwise arches of the final strokes of "n" and "m" are mirrored by the clockwise shape of "t." The archaic "g" has been retained, but there is a modernized form of "r."

The adjacent round strokes of "n" and "t" are the most closely spaced.

interregnum

Distance roughly equal to the counterspace of "n."

Adjacent strokes of the round "n" and straight "u" are closer than the width of the counterspace of "n."

v w x y z

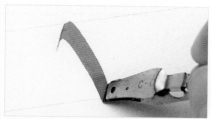

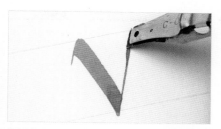

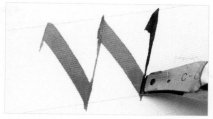

1 The pen angle for diagonal strokes is about 50°. Form a small, curved hook serif then pull diagonally down to the baseline.

2 Without taking the pen off the paper, make the second diagonal by pushing up to the headline.

3 Still keeping the pen on the paper, make a diagonal that is parallel to the first. Start the final stroke just below the headline. Make a small serif, then pull down to the baseline, parallel to the second diagonal.

h k m n p

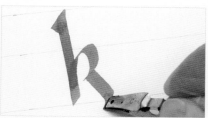

1 About 1½ nib widths above the headline, place the nib at a 40° angle and make a short stroke for the first part of the serif. Move the nib by 1 nib width to form a thin, upward and to the right. Then pull the pen straight down to the baseline.

2 Without lifting the pen, push back up the stem and start to curve away about halfway up the x-height.

3 Still keeping the pen on the paper, form a small clockwise curve, pulling in toward the stem but leaving some space. Change direction to make a diagonal to the baseline, pulling the pen to the left at the end of the stroke.

Gothic

Incorporating some liveliness while maintaining the accuracy demanded of this style can make Gothic or Black Letter quite a challenging script to write, but its impact is undeniable.

Over the course of approximately 200 years, the tenth-century Carolingian script gradually became compressed laterally into the heavy, narrow styles of the late medieval period.

There are many subtle variations between examples from the eleventh to the fifteenth centuries, some named after the Latin for weave, Textura. However, all the variations share a drama, power, and richness of pattern, where individual letters have become subservient to the overall textural effect. The scripts were often written to be quite large, typically ³⁄₁₆–¼ inch (5–7 mm) high, and often looked best tightly packed in short lines of double columns, as in medieval bibles and psalters, although there are examples of tiny, perfectly executed Gothic to be found.

This period was also the high point of manuscript illumination, using real gold leaf, and decoration. The majesty of these manuscripts reflected the architectural style of the time.

The main challenge

Balanced spacing is probably the least forgiving aspect of this script as the space inside letters (counterspaces) and the space between letters should be equal to the width of the vertical stroke. This gives rise to the "wicket fence" appearance that can make Gothic more difficult to read. However, legibility may not have been a problem in medieval times as text was often accompanied by an illustration of its content.

Length determines width
A pen angle of 35° is used for the first stroke and starts at about half the x-height. One nib width above the baseline, the direction is changed, moving down and to the right to reach the baseline. The inside length of this stroke determines the width of the counterspace. Stroke 2 starts at the headline. The pen moves down and to the right until the width at the top of the letter is the same as at its base. A change of direction sees a vertical stroke complete the counterspace. When the left corner of the nib reaches the corner of the first stroke, again, the direction changes down and to the right to form an exit serif. The letter is completed with a hairline using the corner of the nib.

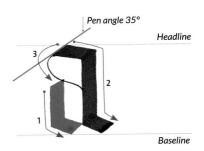

Similarities to Uncial
The ascender on this "d" is reminiscent of the Uncial "d" (see page 56). The first stroke starts at the headline, makes a vertical stroke to about 1 nib width above the baseline, then pauses before moving down and to the right to echo the "a." The ascender starts about 2 nib widths above the headline and is aligned with the left-hand side of the letter. It starts with a small hook serif before moving diagonally to meet the headline, matching the start of the first stroke. This determines the width of the counterspace. A change of direction sees a vertical move to meet the end of stroke 1.

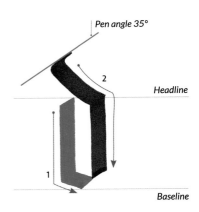

Four-stroke "g"
The first stroke is the same as "d," except it starts slightly below the headline to allow room for the second stroke. Stroke 2 is almost horizontal, dipping slightly and ending with a thin just below the headline. With stroke 3, the counterspace is closed up, moving from the second stroke straight down to the corner of the first, curving out slightly, and then round until the stroke becomes thin. Stroke 4 starts to the left of the body of the letter with a shallow upward curve, then dips down to meet the thin at the end of stroke 3.

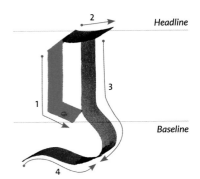

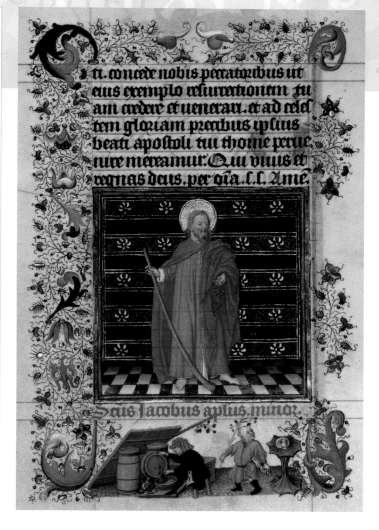

Entities, Anja Lehtinen
Gothic is known for its dense, black texture, yet in this piece the use of red for the Gothic script with lightweight Roman Capitals, changes of direction in the writing, and subtle pastels all combine to create a feeling of lightness and modernity. [Metal nibs, pastels, gouache, felt tip pen on BFK Rives]

***Book of Hours of Catherine of Cleves,
c.1435, Master of Catherine of Cleves***
The fifteenth century marked the high point of manuscript production and illumination (the use of gold leaf) as Books of Hours were very popular. This example demonstrates the measured formality of the script combined with a delicate filigree border and a portrait.

The construction of the historical and contemporary Gothic letters in these two pieces is very similar, but Anja has written them at a lighter weight with increased counterspaces to create a much lighter texture than is usually associated with this script.

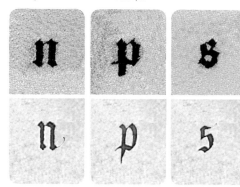

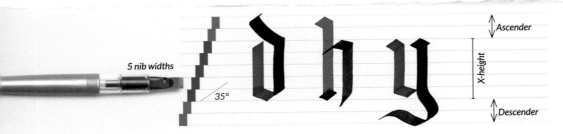

5 nib widths

35°

Ascender

X-height

Descender

Gothic

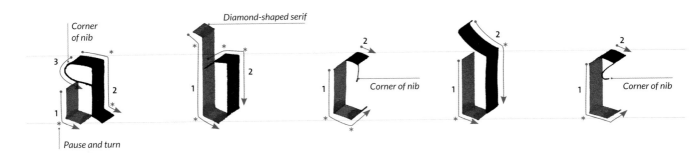

Corner of nib

Diamond-shaped serif

Corner of nib

Corner of nib

Pause and turn

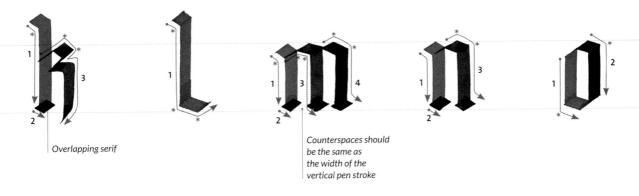

Overlapping serif

Counterspaces should be the same as the width of the vertical pen stroke

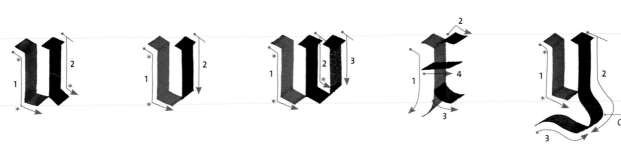

Curve

Gothic serifs

Serifs are diamond shaped and can lead into the vertical stroke or can overlap it, forming small spurs on both sides. This can be done without a pen lift: make the diamond, pause, then slide the nib back halfway, pause again, and change direction to make the vertical stroke. The pauses will ensure crisp angles.

Hairlines

For the recurring hairline strokes of the Gothic script, use the corner of the nib.

CLIP 5
Gothic
http://qr.quartobooks.
com/cask/clip5.html

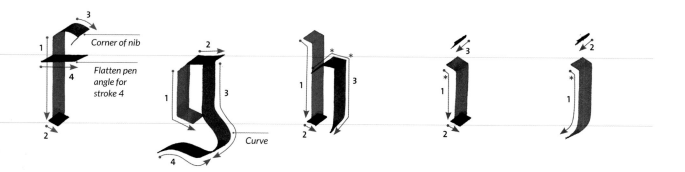

Corner of nib

Flatten pen angle for stroke 4

Curve

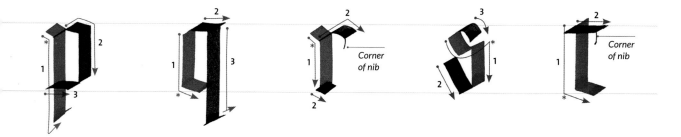

Corner of nib

Corner of nib

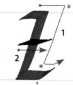

Flatten pen for diagonal stroke

Key
*Pause and turn

Majuscules

For capitals, use Batarde (see pages 92–97), Roman (pages 38–45), Uncial (pages 54–61), or Lombardic Versals (pages 76–83).

Basic structure

The exemplar for this basic Gothic script is written at 5 nib widths, with an additional 2 nib widths for ascenders and descenders. The pen angle is 35°, and the only change of angle is a flattening of the nib for the diagonal stroke of "z." The letters are upright and their sides are uniformly straight, the underlying shape being a rectangle.

All the strokes that make up a letter are joined by angles, not curves, which help the strokes to fit together like building blocks.

Curves appear on "g," "y," and "p," and hairlines (made with the corner of the nib) on "a," "c," "e," and "r" serve to alleviate some of the heaviness of the script. Vertical guidelines as well as the usual horizontal tramlines may be useful.

Crisp corners are achieved either by stopping the movement of the pen for an instant or by lifting the pen a little before changing the direction of the stroke.

Spacing is regulated; the space inside letters (counterspace) and the space between letters should be the same as the width of the vertical pen stroke. Practice on squared paper to help develop an eye for this.

In most scripts, letters start from a thin stroke, which encourages ink flow. However, this is not the case with Gothic; ensure the pen is charged with ink and flowing before writing.

In practice

There are two types of serif used in this word. The entry serif on "n" turns and continues with

IN DETAIL

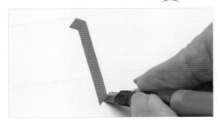

1 Using an angle of 35°, make the diamond serif by pulling the pen down and to the right. Pause and pull the pen down to 2 nib widths below the baseline. Make a small hairline serif.

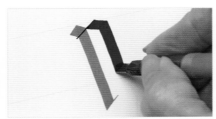

2 Place the nib on the angle formed by the change of direction on stroke 1. Make a thin, short diagonal stroke, change direction to form the top of the letter, and pull down to form the right side of the bowl.

3 Complete the letter with a slightly curved stroke, starting just to the left of stroke 1 and joining the left-hand corner at the end of stroke 2.

1 Begin 2 nib widths above the headline with a short left–right thin and a pen angle of 35°. Pull the pen vertically to the baseline.

2 Overlap the end of stroke 1 with a diamond serif.

3 Place the nib on the thin at the top of stroke 1, pull down slightly, and then use the corner of the nib to form a hairline.

4 Flatten the pen angle to about 30°, start just to the left of stroke 1, and pull the pen horizontally to align with stroke 3.

the vertical stroke down to the baseline, where an overlapping serif has been used. The "a" can disrupt the spacing pattern due to its open counterspace, and a hairline has been used to visually break up the space.

Hairline is used to break up the open-letter space.

The first serif on "u" has been omitted to allow it to be placed the required distance from "t."

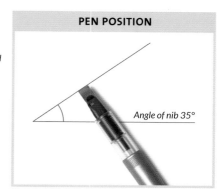

PEN POSITION

Angle of nib 35°

Miniatum

Hairline is used to join the first two letters.

h k m n r u v w y

1 Start 2 nib widths above the headline, using a pen angle of 35°, and make the diamond serif by pulling the pen down and to the right. Pause and pull the pen down to the baseline.

2 Overlap the end of stroke 1 with a diamond serif.

3 Overlap stroke 1 just below the headline and make a thin, short diagonal stroke. Pause and change direction to form the top of the letter. Pause again, pull the pen to the baseline, just cutting through it, and end with a thin.

s f z

1 At 35°, make a short, right–left thin, then a short, curved diagonal stroke. Slide the pen across, making a nib-width thin. Pause, then pull down vertically to just above the baseline.

2 Begin stroke 2 level with the end of the curve on stroke 1. Pull diagonally until its right-hand corner meets the left-hand corner of the first stroke.

3 Place the nib on the thin at the top of stroke 1, then pull down and in slightly, so as to be aligned with stroke 1.

Lombardic Versals

A versal is the word used for the first letter of a "verse," drawn larger than the text script. Its purpose is to show the beginning of a title, chapter, or paragraph.

Versals became increasingly prevalent from the mid-eleventh century and progressively more decorative from the twelfth, their use continued into the sixteenth century, and enjoyed a revival in the nineteenth. The size and decoration of Lombardic Versals balanced the increasing compression and heaviness of the scripts.

Richly decorated

In its simplest form, the letter is outlined and filled with color (the same color as used for the outline). Plain colored letters were often surrounded by filigree patterns in a contrasting color. As the decoration of large initial letters occupying several lines of text increased in popularity, they were used for the beginnings of important chapters. These initials were often "historiated," meaning that they contained illustrations, often of the content of the accompanying text. The lavish use of gold leaf resulted in magnificent, deluxe volumes.

Along with the main initial letter, Lombardic Versals were also used as display capitals, perhaps for the first phrase of the text, and smaller versions also appear as initial letters throughout the text.

Unlike their elegant and sophisticated predecessor, the Carolingian Versal (see the large "O" and "E" on the left-hand side of *Drogo Sacramentary*, page 137), Lombardic letters are easier to construct. Because of the width of the stems, they can be overpainted with abstract patterns, stylized flowers, or leaves, often in white, offering many creative opportunities.

Lombardic Versals also lend themselves well to carving in wood or metal, or engraving on glass.

A building block
The "I" forms part of the letters "B," "F," "H," "J," "K," "L," "N," "P," "R," "T," and "U," and is constructed from four pen strokes that are all made with the pen flat to the writing line (0°). The letter is slightly waisted, known as entasis. It gives the letter a more elegant shape, the top being subtly wider than the bottom. Because this is such a common shape, it is worth practicing first.

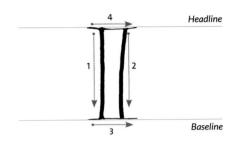

Inside out
The construction of "O" is also seen in the letters "B," "C," "D," "E," "G," "H," "K," "M," "N," "P," "Q," "R," "S," "U," and "W." For this reason, it is worth practicing, along with the "I." Because this letter is composed of curves, a pen angle of 20° is used. Make the inside shape first. When adding the "lobes," make sure that they don't come too far around the top and bottom of the letter.

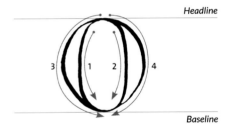

Seven-stroke "A"
"A" is a more complex letter composed of seven pen strokes using pen angles of 0° for the straight lines and 20° for the curves. Although the right-hand side of the letter slopes, it is essentially the same shape as "I," and the lobe on the left-hand side is similar to "O." The way that strokes extend across the top of the letter and through the baseline can be freer for a less formal appearance.

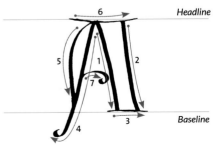

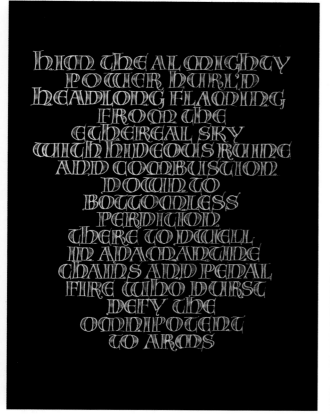

Paradise Lost, Janice McClelland
These Lombardic Versals are of a heavy weight, creating a rich texture and pattern. The interline space is kept to a minimum. A different form of "D" has been used but is equally valid. [Gouache and transfer gold on miniatum ink on Canson pastel paper]

The Winchester Bible, Elijah and the messenger of Ahaziah, II Kings 1 v4, mid-twelfth century
There is a large, glorious, decorative initial letter at the opening of the chapter, and the right-hand side shows alternate lines of red and blue versals used for the first phrase. They are generously spaced and have two forms of "A." There are smaller and plainer versals used in the body of the text and a large, initial "M" used in the second column, which occupies two writing lines and is half inset into the text and half in the margin.

Larger bowl

Both counterspaces are closed by a fine, curved line

Uncial form

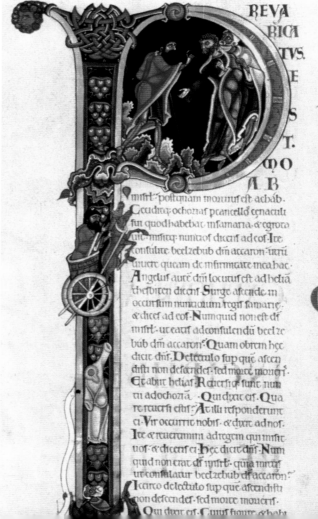

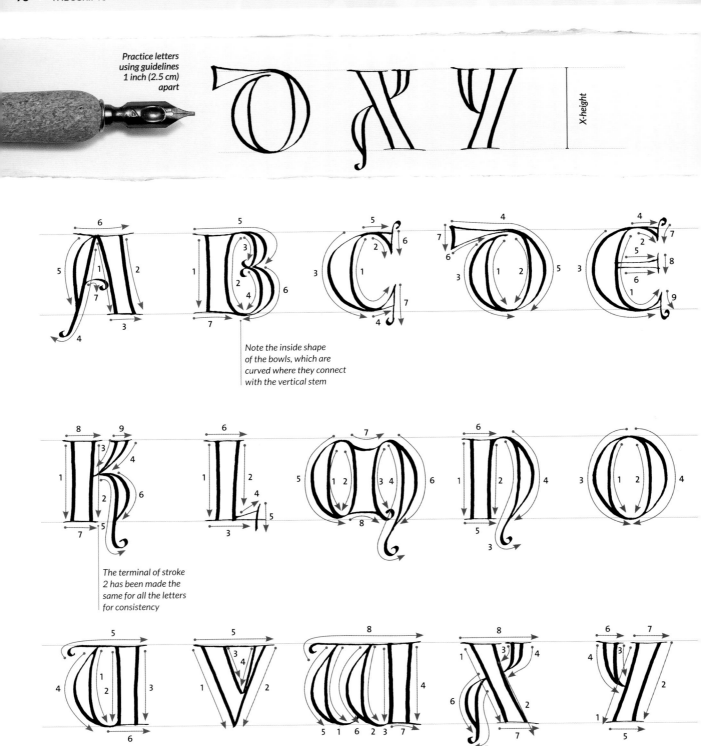

Practice letters using guidelines 1 inch (2.5 cm) apart

X-height

Note the inside shape of the bowls, which are curved where they connect with the vertical stem

The terminal of stroke 2 has been made the same for all the letters for consistency

Keep the stem widths consistent

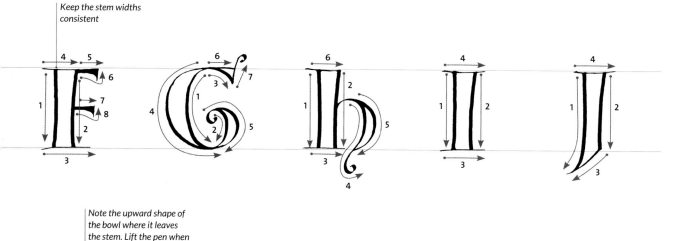

Note the upward shape of the bowl where it leaves the stem. Lift the pen when the stroke becomes thin

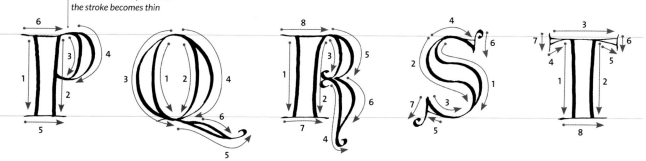

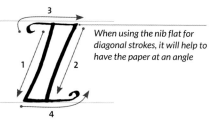

When using the nib flat for diagonal strokes, it will help to have the paper at an angle

Basic structure

The exemplar is based on letters used in the Winchester Bible (mid-twelfth century). The Winchester Bible versals are skillfully written in brilliant red, blue, or green in a variety of sizes, the clearest examples being in the complete lines of letters.

Lombardic Versals are a combination of penmade Imperial Roman Capitals (see pages 38–45) and some Uncial forms (see pages 54–61) particularly "a," "d," "h," and "m."

There are no historical examples for some of the letters, so the missing letters have been designed to share a family resemblance with the known letters to provide a complete alphabet.

Letters are built up from several composite strokes, with some pen angle changes. Vertical stem strokes are made at 0° (i.e., the pen is flat), curves at 20°, most horizontals and serifs at 0°, and vertical serifs at 90°. Stems are slightly waisted, and for rounded letters define the form by drawing the inside shape first before adding the "lobes."

IN DETAIL

AFIJKLT

1 Start with the right-hand stem. Using the nib flat to the headline, draw a sloping left–right diagonal stroke to the baseline. Pull in about halfway down the stroke. Mirror this stroke with a second.

2 Just to the left of the first stroke, draw an opposite diagonal, cutting through the baseline and curling around to finish the stroke.

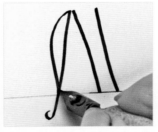

3 Using a pen angle of 20°, add the lobe, starting from the top of the stroke to just above the baseline.

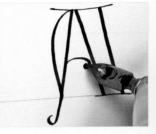

4 Using a flat nib, draw a thin stroke across the top of the letter. Add the crossbar, echoing the terminal of the left-hand side.

1 With the nib flat to the headline, draw a vertical line down to the baseline and pull in slightly about halfway down to form a waist to the stem.

2 Mirror the first stroke with a second, forming the stem of the letter.

3 Keeping the nib flat, draw a thin stroke across the top of the stem. Note the subtle dip in the shape.

4 With a flat nib, draw a thin stroke across the bottom of the stem. Note the slight upward curve.

PEN POSITIONS

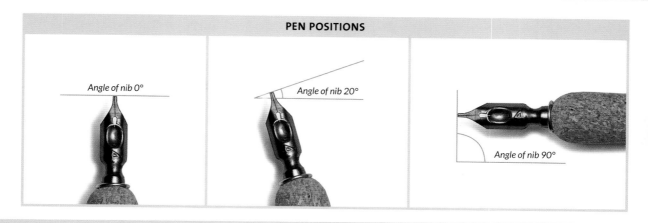

Angle of nib 0°

Angle of nib 20°

Angle of nib 90°

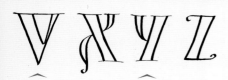

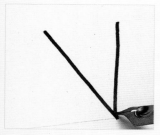

1 Using the nib flat relative to the direction of movement, draw a diagonal stroke to the baseline. Thin the end by pulling down slightly. Mirror this stroke.

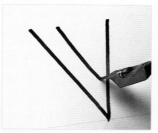

2 Draw the inside shape, with slight waisting about halfway down.

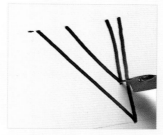

3 Mirror the previous stroke.

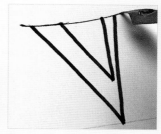

4 Using a flat nib, draw a thin horizontal across the full width of the letter.

1 Draw an "I" as before (see opposite page).

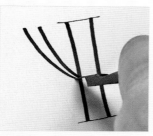

2 Draw the inside shape first, to just below halfway, then the outside shape, wider at the top, to meet the previous stroke at the stem.

3 Using a flat nib, draw a horizontal line across the top of the stroke to complete the letter.

Use your paper

Have the paper at an angle for diagonal strokes.

CONTINUED NEXT PAGE ▷

BCDEGhMNOPQ

1 Draw the inside shape of an "O," but leave the top open, with the left-hand side slightly lower.

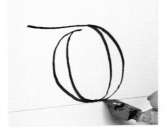

2 Add the left-hand lobe first, then start the second part to the left of the letter and slightly above the headline. Pull across and pick up the "O" shape, then add the right-hand lobe.

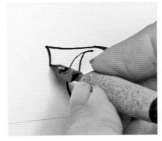

3 Going back to the start of the previous stroke, use a flat nib to draw a short vertical stroke to form the end of the ascender.

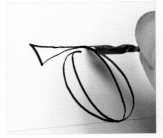

4 Keeping the same angle, draw a slight upward curve to blend in with the top of the "O" shape.

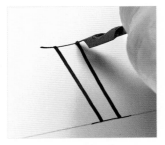

1 Draw an "I" as before (see page 80).

2 Starting halfway down the stem, using an angle of 20°, curve up and around to form the inside bowl. Pull through the baseline, ending with a small curled serif.

3 Draw the outside lobe, ending just above the baseline.

Decorative versals

These letters combine gouache and gold leaf on a PVA base. The white pattern is added using Dr Martin's Bleedproof White.

1 With the nib at a 20°, and drawing the inside shape first, draw a clockwise oval to the baseline.

2 Overlap the start of the previous stroke and mirror its shape to overlap at the bottom of the oval.

3 With the same angle, add the left-hand lobe to the letter.

4 Mirror the previous stroke on the right-hand side.

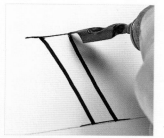

1 With the nib flat to the headline, pull down to the baseline, pulling in halfway down to form a waist. Mirror the first stroke with a second. With a flat nib draw a thin stroke across the stem's base.

2 Keeping the nib flat, draw a thin stroke across the top of the stem. When you meet the top of the inside stroke, change the angle to 20° and draw the inside shape of the bowl.

3 Place the nib on the vertical stroke and draw a counter-clockwise curve to complete the bowl. Note the curve here where the bowl joins the stem.

4 Add the lobe to the outside of the letter.

In practice

Spacing Lombardic Versals is similar to other scripts. When used as display capitals, they benefit from generous spacing. Adjacent verticals are farthest apart, a round stroke and a vertical slightly closer, as in "d-I-E" and adjacent round strokes closer still. Make allowances for extra space from open letters, like the "E–U" combination.

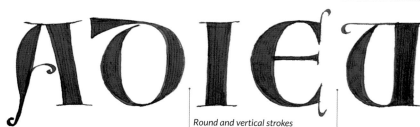

Round and vertical strokes are closer together than two verticals would be.

Open letters create extra space.

Batarde

The Batarde script contains elements of the more formal Gothic scripts of the time, yet still exhibits influences of Carolingian and Uncial. It is thought that this mixed parentage is responsible for the script's dubious name, which is the French word for "bastard."

Between the thirteenth and fifteenth centuries, the Gothic scripts became increasingly ornamental and complex to write, sacrificing some legibility. However there also existed numerous cursive (running) scripts, which were used in commercial and other documents. Batarde is also often referred to as Gothic Cursive. A more formalized version of these cursives evolved in Northern France initially, with variations appearing in England and elsewhere. Consequently, there are many models upon which to base a more contemporary version of Batarde. In this instance, a French example has formed the basis of the exemplar.

Find your rhythm

When writing Batarde, its contribution to the evolution of the Italic script becomes apparent. It is a decorative and lively hand that involves some manipulation of the pen to achieve, for example, the hairline strokes. With increasing familiarity and fluency, this manipulation becomes part of the rhythm of writing this script.

Majuscules for Batarde are usually quite wide, with the shape based more on an Uncial model than on Roman Capitals. The exemplar letters shown on pages 92–93 are slightly narrower. They are very decorative, with optional spurs, hairlines, and diamond pen dots. It is not possible to find a complete alphabet of majuscules from existing manuscripts, so missing letters have been designed to match those we know.

You may find that with increasing confidence and fluency these letters can be written with fewer pen lifts than are on the exemplars.

Fat to thin
This minuscule "a" is composed of three pen strokes. The first stroke starts with a thin just below the headline. The pen is turned onto its left corner and the wet ink is pulled up to the headline using the corner of the nib. The second stroke starts at the top and overlaps the beginning of the first stroke. Stroke 3 starts just underneath the second, is brought down to the baseline, and is finished with a thin using the corner of the nib. In cursive writing this stroke would connect to the following letter.

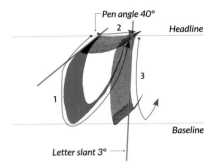

Clockwise arches
The first stroke of the minuscule "m" starts just below the headline. The pen is turned onto its left corner at the baseline and the wet ink is pulled up to the headline, forming the first clockwise arch. The second stroke starts from this thin, forms an arch, and repeats the thin, going back up to the headline. The third stroke has a slight dip, and the fourth goes from here down to the baseline, forming the second arch.

Optional decoration
The first stroke of the majuscule "B" is shaped a little like the number 2. It starts just below the headline, curves around, changes direction just above the baseline, and pulls to the right to form the bottom part of the bowl. The second stroke starts from the first using the corner of the nib and finishes as a short, full-width stroke. The third stroke is brought in to form the top bowl of the "B," then completes the bottom bowl by joining with the first stroke. The hairline and diamond are optional.

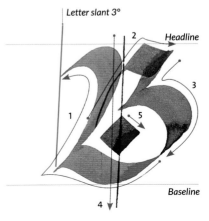

A custome loathsome to the eye
hatefull to the nose
harmfull to the braine
dangerous to the lungs
and the black stinking
fume thereof, nearest
resembling the horrible
Stygian smoke of the pit
that is bottomlesse.

JAMES I · 1604

***King James I Quotation on Smoking**, Vivien Lunniss*
Batarde is an ideal script to express James I's disgust with smoking. It is strong and dramatic while extremely legible. This example is written at about 3 nib widths high. [Gouache, sumi ink, metal pens on khadi paper. Burnt edges to the paper.]

The main difference here is in the change of the form of "s." The long "s" (like an "f" without its crossbar) was used in the beginning or middle of words and a second form was used at the end. The contemporary example is written at a heavier weight and has more slant.

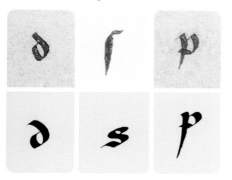

***Book of Hours**: Prayer to the Holy Trinity, France, late fifteenth century*
This script is quite dense in texture. The swelling vertical stroke on the long "s" and hairline ligatures are characteristic of Batarde.

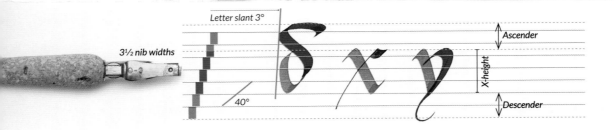

Letter slant 3°

3½ nib widths

40°

Ascender

X-height

Descender

Batarde Minuscule

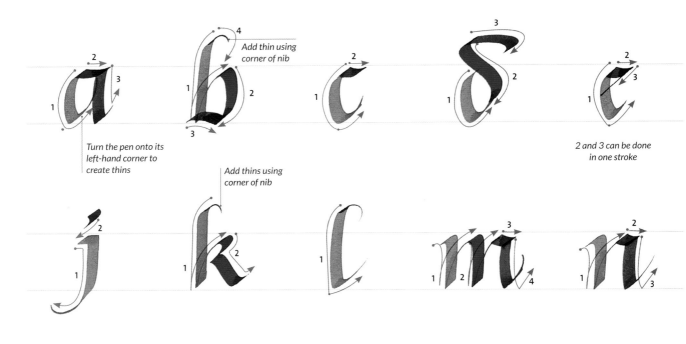

Turn the pen onto its
left-hand corner to
create thins

Add thin using
corner of nib

2 and 3 can be done
in one stroke

Add thins using
corner of nib

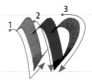

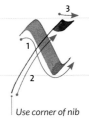

Increase the pen angle
to 45° for the rest of
the letters ("v" to "z")

Use corner of nib

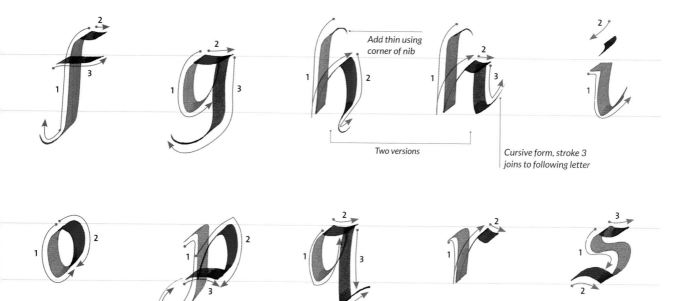

Add thin using corner of nib

Two versions

Cursive form, stroke 3 joins to following letter

Increase the pen angle to 45°

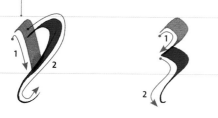

Basic structure

The exemplar is written at 3½ nib widths, with letters slanting forward at an angle of 3° from the vertical, in keeping with the cursive nature of the script. The pen angle is 40°.

The important features of Batarde are the extreme variation between thick pen strokes and fine hairlines made with the corner of the pen, and the way that downward pen strokes "bounce" off the baseline. At the point of that change of direction, the pen is turned onto its left-hand corner, dragging the wet ink to form the stroke, which goes up to the headline. The final stroke of a letter may connect naturally to the following letter, in keeping with the script's cursive character, making it quicker to write.

Although there are up to four strokes to complete some letters, this may change with fluency, and if writing the script smaller, you may find that fewer strokes are needed.

IN DETAIL

acδegoq

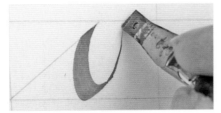

Use a consistent pen angle of 40°.
1 Start just below the headline. When you reach the baseline, turn the pen onto its left corner and take the stroke up to the headline.

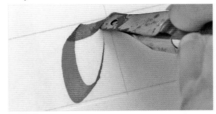

2 Start where stroke 1 began, dip slightly, and finish at the headline.

3 Start the third stroke just inside the second stroke, pull down to the baseline, and form a serif by turning the pen onto its left corner.

Use a consistent pen angle of 40°.
1 Start just below the headline. When you reach the baseline, turn the pen onto its left corner and take the stroke up to the headline.

2 Begin the ascender with a small serif, then pull the pen diagonally to the headline. Change direction, forming the right-hand curve of the bowl, and overlap the end of stroke 1.

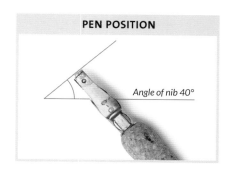
bijlpt

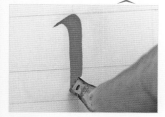

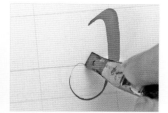

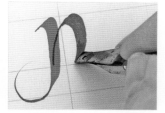

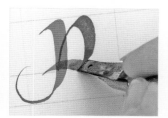

1 Make an upward movement to form a curved serif; as the pen approaches the baseline, turn it slightly to narrow the stroke.

2 Turn the pen onto its left corner, moving counterclockwise, to form a fine loop.

3 Superimpose stroke 1 using the corner of the pen in an upward direction. Just below the headline, turn the pen onto its full width and form a curved stroke down to the baseline.

4 Starting to the left of the letter, cross the first stroke in a shallow curve to meet the second stroke at the baseline.

hmnru

1 Finish the first stroke at the baseline. Keeping the pen on the paper, use the corner to make an arching stroke up to the headline.

2 Similar to the top of "a," start this stroke where the first ended and dip slightly along the headline.

3 Just inside the end of the second stroke, pull down to the baseline and form a serif by turning the pen onto its left corner.

CONTINUED NEXT PAGE

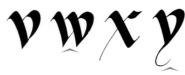

1 With a pen angle of 45°, start 1 nib width below the headline and form a serif at the beginning of the stroke, then pull the pen diagonally to the baseline, pulling to the left slightly to make a sharp point at the base. Turn the nib onto its left-hand corner and drag the wet ink diagonally upward, forming a thin stroke to about half the letter height.

2 Overlapping the first stroke with the second, echo its shape. Make the pointed base in the same way as step 1, by pulling the pen diagonally to the baseline.

3 Overlapping the second stroke with the third, make a shallow curve to meet the base of the second stroke.

1 With the pen at an angle of 45°, form a serif by pushing up to the headline and around, then pull diagonally to the baseline.

2 Stroke 2 overlaps the first stroke. Start about one-third down the letter and push the pen up to the headline and around.

3 Continue down to the baseline, meeting the end of stroke 1, and continue to about 2 nib widths below the baseline, using the corner of the nib to curl around.

In practice

The word "onion" is a suitable word with which to practice spacing because it consists of only curved or upright strokes. Note how adjacent vertical strokes are placed slightly farther apart than a curved stroke and a vertical.

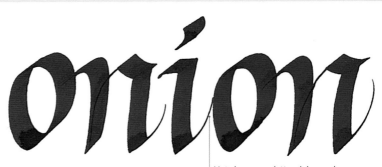

Note how some letters join up where it is natural for them to do so.

f k s z

(Ungrouped)

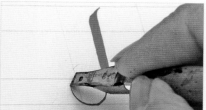

1 With the pen at 40° on the ascender guideline, start with a short thin stroke moving slightly to the left, then pull the pen vertically to just above the descender baseline. Turn the pen onto its left corner, moving counter-clockwise to form a fine loop, as in "p."

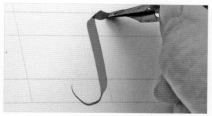

2 Overlapping the top of the first stroke slightly, pull the pen to the right to make a short, dipped stroke, which is the same shape as the top of "a" and "n."

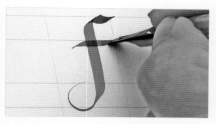

3 Suspend the crossbar from the headline, making sure it is no wider than the top of the letter.

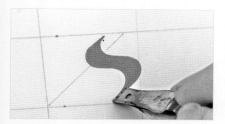

1 Start just below the headline and form a curved stroke that ends just above the baseline.

2 Add an upwardly curved stroke at the baseline.

3 Complete the letter with a curved stroke at the headline, a similar shape to the top of "a" and "n." The top bowl of "s" should be slightly smaller than the bottom bowl and its width similar to that of "n."

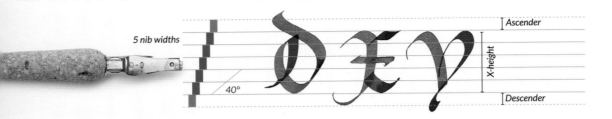

5 nib widths

40°

Ascender

X-height

Descender

Batarde Majuscule

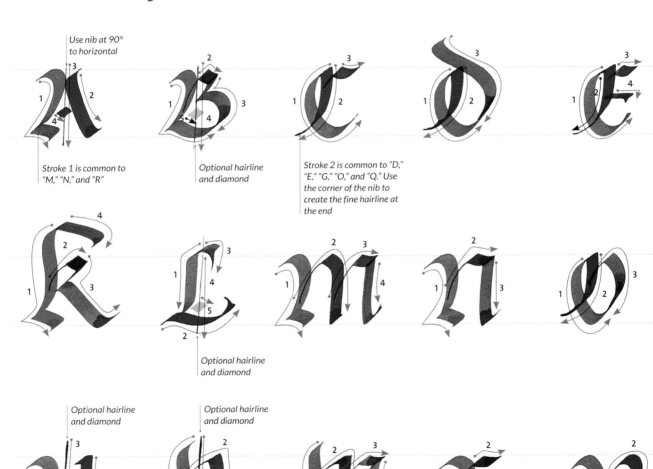

Use nib at 90° to horizontal

Stroke 1 is common to "M," "N," and "R"

Optional hairline and diamond

Stroke 2 is common to "D," "E," "G," "O," and "Q." Use the corner of the nib to create the fine hairline at the end

Optional hairline and diamond

Optional hairline and diamond

Optional hairline and diamond

CLIP 8
Batarde Majuscule
http://qr.quartobooks.
com/cask/clip8.html

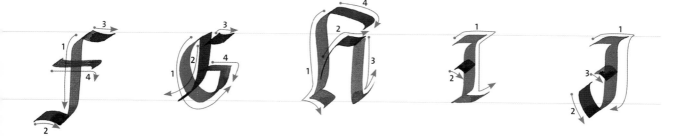

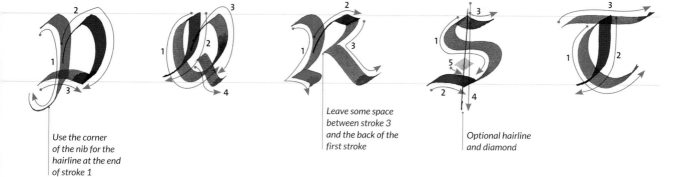

Use the corner
of the nib for the
hairline at the end
of stroke 1

Leave some space
between stroke 3
and the back of the
first stroke

Optional hairline
and diamond

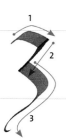

Basic structure

The letter height is 5 nib widths, although some letters extend above and below the writing lines. The letter slope will match that used for the minuscule (see pages 86–91), and the pen angle used here is 40°. These letters also require manipulation of the pen to produce fine hairlines.

Because the letters would be illegible when used together, they are used only in the conventional way of punctuation with majuscules. This does allow for some variation in style, which might not be acceptable when letters are normally written in words. These letters could also be used with the Gothic script.

(see pages 86–91)

IN DETAIL

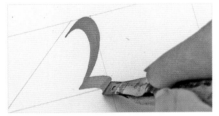

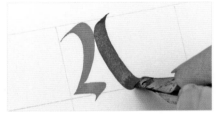

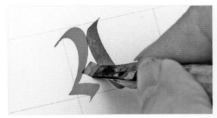

1 With the pen at an angle of 40°, make an upward movement to form a curve and pause just above the baseline. Change direction to form the foot of the letter, with a small curved serif at the end.

2 Starting to the right of the first stroke, form a gentle curve, curving away more strongly at the baseline.

3 Form the crossbar with a diamond-shaped stroke in the center of the letter.

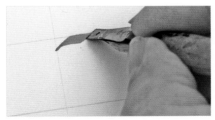

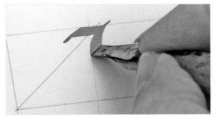

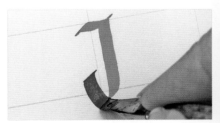

1 Begin with a short stroke that dips slightly along the headline.

2 Change direction and continue down to the baseline, ending with a slight curve (see step 3).

3 Starting about one-third above the baseline, pull the third stroke in a slight curve to meet the bottom of the first stroke.

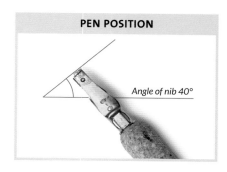

PEN POSITION

Angle of nib 40°

$CDEGOPQTUW$

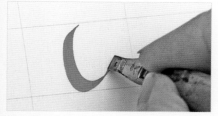

1 Draw a counterclockwise curve starting just below the headline and curving up from the baseline to end on a thin.

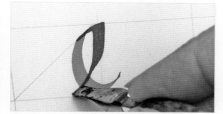

2 Superimpose the start of stroke 1, move up to the headline, then pull down for about two-thirds of the letter height, where it changes direction and crosses the first stroke.

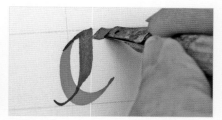

3 Make a small, slightly dipped stroke that starts by overlapping stroke 2 and ends level with the end of stroke 1.

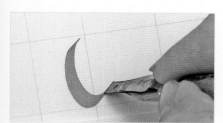

1 As for "C" above, draw a counterclockwise curve starting just below the headline and curving up from the baseline to end on a thin.

2 Superimpose the start of stroke 1, move up to the headline, then pull down for about two-thirds of the letter height, where it changes direction and crosses the first stroke.

3 Start stroke 3 on the second stroke as a thin, using the corner of the nib. Push up to the headline, then pull down to the baseline, mirroring the shape of stroke 1, which it joins.

CONTINUED NEXT PAGE

ħmnu

1 Starting below the headline, make a curved serif. Pull the pen down to just above the baseline, pause, and then change direction to form the foot of the letter, as in "A."

2 Superimpose stroke 1 using the corner of the pen in an upward arch, then dip slightly along the headline.

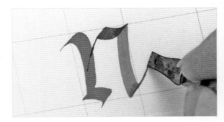

3 Starting just inside the second stroke, pull down to the baseline, and form a serif by turning the pen onto its left corner.

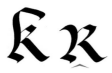

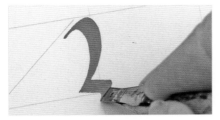

1 Starting below the headline, make a curved serif. Pull the pen down to just above the baseline, pause, and then change direction to form the foot of the letter, as in "N."

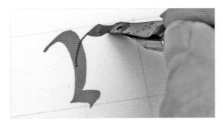

2 Superimpose stroke 1 using the corner of the pen in an upward arch, then dip slightly along the headline.

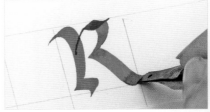

3 Starting inside the second stroke, form a clockwise curve less than half the height of the letter. Leave some space from stroke 1, change direction, and take the stroke out and down to the baseline. The base of the letter is slightly wider than the top.

In practice

Batarde majuscules are not legible enough to be used together but certainly add a touch of drama when combined with the minuscules. They also provide contrast with the compactness of the minuscule due to their generous Uncial-based forms. The extra space that this brings to a word is broken up by the use of vertical hairlines and diamonds in the counterspaces.

L S X Y Z *(Ungrouped)*

1 Starting just above the headline, pull the pen to the left, then vertically to the baseline. Just above the baseline, pull the pen to the left again to finish the stroke with a thin.

2 Start to the left of stroke 1 to form the foot of the letter, pulling the pen along the horizontal baseline with a lift at the end of the stroke achieved by turning the nib onto its left corner and dragging the wet ink upward.

3 Overlap the beginning of the first stroke, making a shallow arch that ends with turning the nib onto its left corner.

1 Making sure the pen is loaded with ink, start at about half the x-height, with the nib on its corner, forming a clockwise curve up to the headline.

2 Roll the nib onto its full width and pull down diagonally to the baseline.

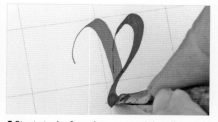

3 Start stroke 2 on the corner of the nib in the same way as for stroke 1, but overlap the first stroke. Push the pen up to the headline, curve around clockwise to meet the end of stroke 1, then pull in the other direction to form the descender just below the baseline.

The width between verticals is equal to the width of the counterspace of "u."

"The Texture of Writing,"
Calderhead Book,
Barry Morentz

𝕿𝖍𝖊 𝕿𝖊𝖝𝖙𝖚𝖗𝖊 𝖔𝖋 𝖂𝖗𝖎𝖙𝖎𝖓𝖌

Note how the hairline and serif break up the large counterspace.

The exaggerated serif of "W" compensates for the word space after "of."

Italic *by Mary Noble*

The Italic script is a popular one for today's calligraphers because of its legibility and elegance, and once you are completely familiar with it, you'll find that the script lends itself to many variations and flourishes.

The formal version shown here is the best one to study first as it is the basis from which any other version might spring; all other versions have this core form hiding inside.

Typing on a computer has made us aware of "italicizing," which essentially means sloping any font from upright to forward-leaning. This is not true Italic, although many examples are sophisticated adaptations.

The Italic script has a respectable pedigree originating in the early fifteenth century during the Italian Renaissance. This was a script developed as a cursive form (more flowing, joined-up strokes) of previous Humanist minuscules. If historical manuscripts fascinate you, look for ninth- and tenth-century Carolingian scripts, which were a source of inspiration to the Renaissance Italians.

Notable differences

The oval-shaped, sloping letters of the minuscules contrast strongly with the very rounded and upright forms of Foundational and Uncial. However, the defining feature of Italic Minuscule letters is the joined-up strokes within a letter. The pen is pushed upward to form smooth, springing arches that emerge about halfway up or down the stem.

As with Roman Capitals (see pages 38–45), Italic majuscule letterforms rely on their proportions to create a uniform set of letters. Strokes are curved or straight, and unlike the minuscule counterparts, do not contain any springing arches. The letters are made from separate downstrokes.

Pushing arch
The letter "a" shows the pushing arch formation. The bowl of this letter (see also "g," "d," and "q") shows smooth internal curves, with just one corner at the top. The left and right downward strokes are parallel, not bowed. The final downstroke emerges halfway down, leaving a triangular shape.

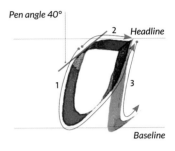

Pen angle 40°
Headline
Baseline

Serif ascender
The minuscule "h" has an ascender that starts four nib widths above the line, as it does for "b," "d," "k," and "l," beginning with a small serif. Note where the arched stroke emerges, halfway up the main body. As with "n" and "m," the final stroke is parallel to the first.

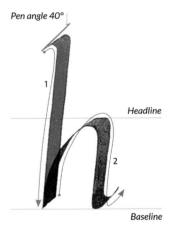

Pen angle 40°
Headline
Baseline

Supported "V"
The majuscule forms of "M" and "W" present a challenge of stroke thicknesses and of pen angles. See the letters as "V"s with side supports. The side supports aim to be parallel, and slightly forward-leaning. The resulting outer triangles should be almost right-angled triangles. The first and third strokes are thinner than the second and final strokes.

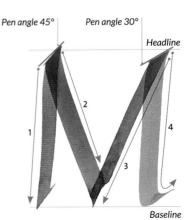

Pen angle 45° Pen angle 30°
Headline
Baseline

Julius Caesar, Commentaria di Bello Gallico et Civile, c.1465, Bartolomeo Sanvito
This Renaissance scribe is renowned for his beautiful and legible Humanist script—a prequel to what we now call Italic. It has a forward slope and arched letters, but some forms retain the earlier Carolingian characteristics.

Shape retains earlier form

Looped "g" later becomes version that mimics the curved "y"

Note the high arches; arches emerging halfway up are used more in Italic

Yellow, Mary Noble
This lively form of Italic shows how the script can be developed once the core structure is mastered. The majuscules have been kept simple, as a foil to the more elaborate, flowing "Y" in the title. The green minuscules are more laterally compressed than is usual, for visual effect. [Printmaking paper, gouache, watercolor pencils, and acrylic paints]

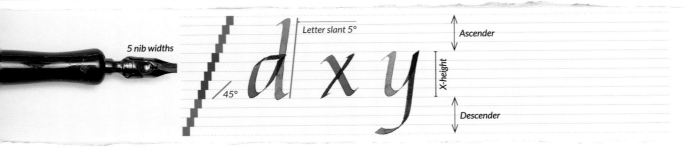

5 nib widths

45°

Letter slant 5°

Ascender

X-height

Descender

Italic Minuscule

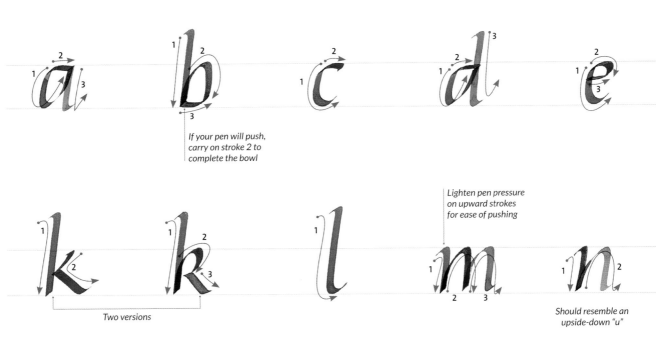

If your pen will push,
carry on stroke 2 to
complete the bowl

Lighten pen pressure
on upward strokes
for ease of pushing

Two versions

Should resemble an
upside-down "u"

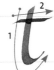

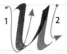

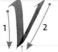

Keep the axis
of "v" sloping

Strokes alternate in
thickness; joins overlap

CLIP 9
Italic Minuscule
http://qr.quartobooks.
com/cask/clip9.html

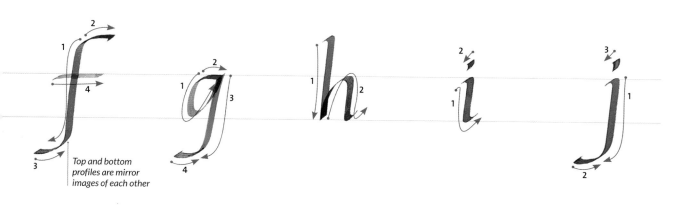

*Top and bottom
profiles are mirror
images of each other*

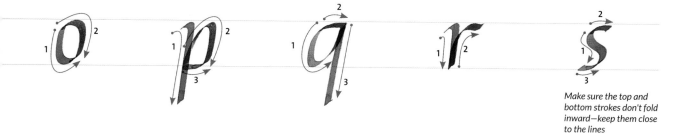

*Make sure the top and
bottom strokes don't fold
inward—keep them close
to the lines*

*Based on "v," the
second stroke keeps
going—don't curve it!*

*Flatten the pen
angle for stroke 2
to make it thicker*

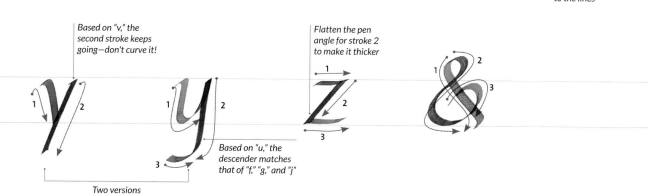

*Based on "u," the
descender matches
that of "f," "g," and "j"*

Two versions

Basic structure

Italic's characteristic thick and thin strokes, springing arches, and gentle forward slope are instantly recognizable in contemporary signage and illustration as well as in calligraphic work.

Italic minuscules are written at a pen angle of 45° and a forward slope of 5°–10°. The branching characteristic of this hand makes it necessary to adjust pen pressure to lighten up on the upward strokes, allowing the pen to flow unrestricted.

Practice all the arched letters as shown on this page first—they demonstrate the basis of what makes it Italic, keeping the pen on the paper for as many strokes as possible in one letter. This continuous look is a strong feature to preserve.

IN DETAIL

adguq

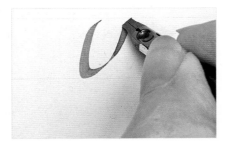

1 Observe the absence of the serif. To start the "g," push straight down and then curve smoothly up to the headline.

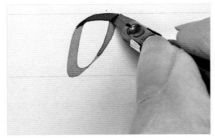

2 Blend in the top stroke, starting inside the first stroke to hide the join, then go down below the headline.

3 Pull down to make the almost vertical downstroke. Finish with a fourth stroke by pulling across horizontally from the left to join to the downstroke.

1 At 45°, make a small serif followed by a straight downstroke to the baseline.

2 Follow the steep corner and then smoothly curve upward to the headline.

3 Pull straight down again, parallel to the first downstroke, ending in the serif exit stroke.

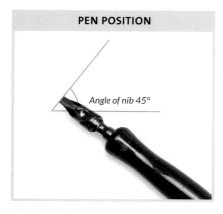

PEN POSITION

Angle of nib 45°

bhmnpr

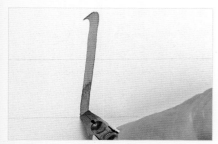

1 Make the ascender with a serif and a long stroke down, starting above the headline.

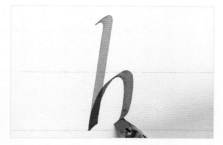

2 From the baseline, push uphill in a smooth curve then down again, parallel to the first stroke.

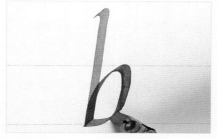

3 Complete with a flat blending stroke.

1 With your pen at 45°, make a small serif straight down to the baseline.

2 Without lifting the pen, push it back up the stem in a curving movement, emerging halfway up the stem.

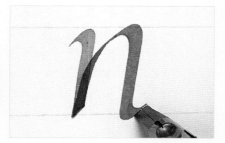

3 Make a tight curve, then pull straight down, parallel to the first stroke. Exit with a serif.

CONTINUED NEXT PAGE ▷

kvwxyz

1 Beginning with a small serif, make an almost vertical stroke down.

2 Without a serif, draw down to overlap the previous stroke's end.

3 For stroke 3, make a downstroke parallel to stroke 1. Start the final downstroke with a serif and continue, parallel to stroke 2, down to the baseline.

fjilt

1 From above the headline, make a strong, long downstroke to the same distance below the baseline.

2 Blend in a horizontal top and bottom stroke with tiny serifs.

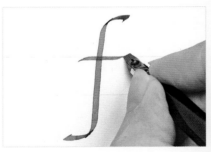

3 Add a horizontal crossbar sitting below the headline.

ceos

1 Begin and end the first stroke with a fine line, making an oval curve.

2 Continue within the fine top line, curving around.

3 Complete the small counterblending into the outer curve.

1 As with the "e," begin and end the first stroke with a fine line, making an oval curve.

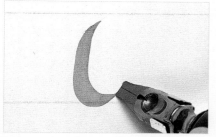

2 Continue, curving around and up, ending in a point.

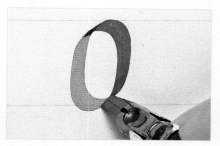

3 Curve down and blend into the first exit stroke.

In practice

The second most important element (after mastering the essential arch formation) is regularity of downstrokes. The gaps inside the letters should be evened out by the spaces between letters, keeping a rhythmic, even pattern.

With straight downstrokes, keep the spaces within and between letters about the same.

tempora

Sometimes letters have to touch in order to keep the spacing even.

Make sure "r" does not create a hole in your spacing by being too long; tuck the next letter in to close the gap.

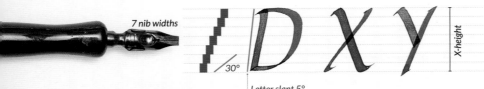

7 nib widths

30°

Letter slant 5°

X-height

Italic Majuscule

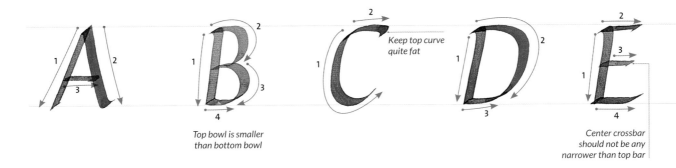

Keep top curve quite fat

Top bowl is smaller than bottom bowl

Center crossbar should not be any narrower than top bar

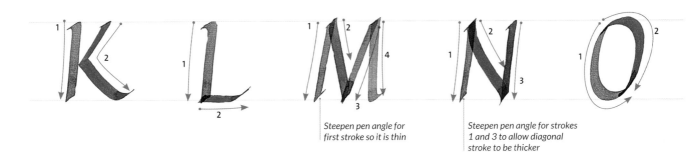

Steepen pen angle for first stroke so it is thin

Steepen pen angle for strokes 1 and 3 to allow diagonal stroke to be thicker

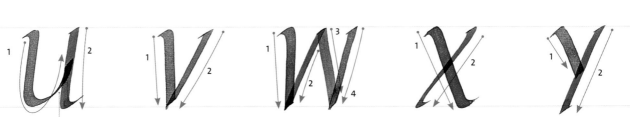

Similar to the minuscule "u," but the arch joins a little lower down on stroke 2

The Roman influence

It is important to remember that the pen angle for the majuscules is 30°, and not 45° as for the minuscules. This is because of the letters' Roman ancestry, and because of the necessity of having thinner horizontal strokes than upright strokes. If "E," for example, were written at 45°, all the strokes would be the same thickness, whereas our eye appreciates variety in stroke thickness.

CLIP 10
Italic Majuscule
http://qr.quartobooks.
com/cask/clip10.html

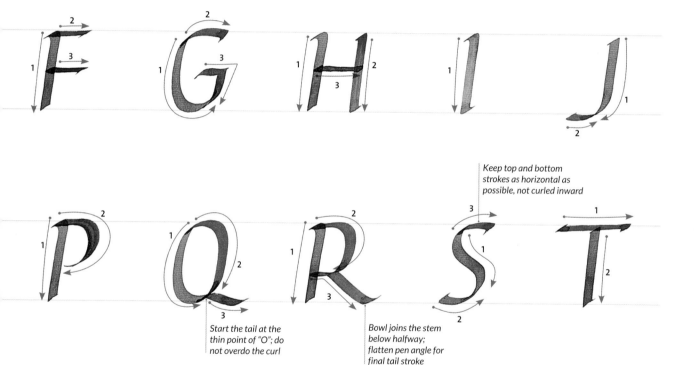

Keep top and bottom strokes as horizontal as possible, not curled inward

Start the tail at the thin point of "O"; do not overdo the curl

Bowl joins the stem below halfway; flatten pen angle for final tail stroke

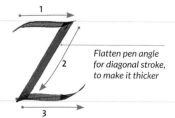

Flatten pen angle for diagonal stroke, to make it thicker

Basic structure

To match Italic minuscule, the majuscules are essentially classical Roman Capitals (see pages 38–45), compressed and sloped. They are strong but unadorned, making them ideal for formal use, where legibility and simple beauty are required. They are often used for whole blocks of text rather than just for the beginning of lines, providing a slightly less formal appearance than Roman Capitals.

Italic capitals are easier and faster to write than Roman Capitals. Like their minuscule counterparts, they lend themselves to more variations in letterforms, serifs, and spacing. It is important to understand the structure of Roman Capitals before attempting Italic capitals, as they share the same characteristics.

The letters are based on oval forms rather than on the circle seen in the Roman forms. These Italic majuscules have modernized simple serif forms that do not detract from their simplicity and strength. Keep a similar pen pressure throughout each letter. Unlike the minuscule letters, there are no springing arches to worry about.

IN DETAIL

CDGMOQ

1 Make an oval curved stroke down and back up, ending in a point.

2 Add a flattened curved top with a small serif.

3 Below the center of the letter, make a horizontal and then a vertical stroke, and blend this into the previous curve.

1 Make an oval curve down and back up, ending in a point.

2 Start inside the first stroke, curve around, and blend into the previous stroke at the bottom.

3 Add the tail in a single sweep of the pen.

PEN POSITION

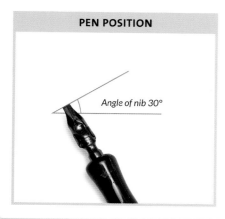

Angle of nib 30°

AHNTUVXYZ

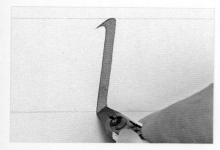

1 Starting with a small serif, make a straight downstroke.

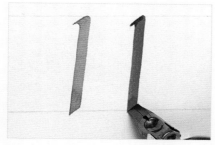

2 Form a second identical parallel stroke, less than the width of the "O" apart from the first stroke.

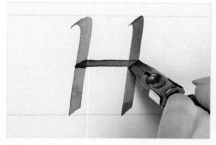

3 At the optical center, cross from left to right, going very slightly uphill (to avoid the letter appearing to fall over).

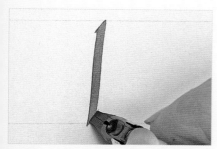

1 Steepen the pen angle to 60° to make the first downstroke.

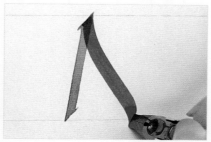

2 Turn the pen angle back to 30° for the diagonal stroke.

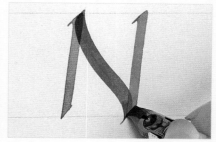

3 With an angle of 60° for the final parallel stroke, blend in at the bottom.

CONTINUED NEXT PAGE ▷

BEFJKLPRS

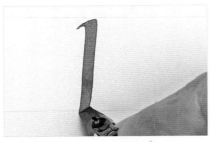

1 Start the letter "F" with a straight downstroke.

2 For the second stroke, start inside the stem and end with a tiny serif.

3 Repeat at the optical midway point.

1 Start with a straight downstroke.

2 Blend from the top and curve around to just below the midpoint of the downstroke.

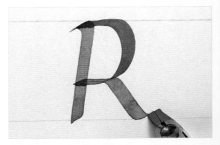

3 Pull out to the right and down with a gentle exit stroke that's not too bowed.

1 Make two gentle curves with thin ends.

2 Start inside the first stroke, curve around, and complete the end with a tiny exit serif.

3 Start the final stroke close to the baseline and blend in with a curve.

IW

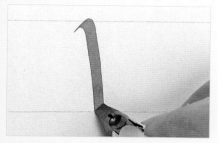

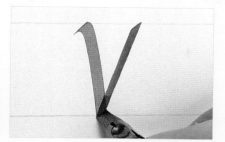

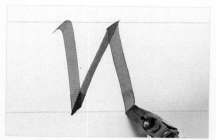

1 Beginning with a small serif, make a downstroke that's almost vertical.

2 Without using a serif, draw down to overlap the previous stroke's end. This second stroke should be thinner than the first.

3 Repeat steps 1 and 2, but start the final downstroke with a serif.

In practice

As Italic majuscules are compressed compared with Roman majuscules, so must their letter spacing be compressed. The same spacing rules apply: adjacent straight strokes should be spread apart at approximately the width of a half-width letter (such as "E"). Some letters present particular spacing challenges, such as "R" followed by "A," which creates a big gap.

Rule of Three

When spacing letters visually, try the "rule of three" test—for example, in "Homer" below, does "E" look to be central to "M" and "R"? See page 24 for more details on applying this rule.

IGA PÄEV *EVERY DAY*
IGA ÖÖ *EVERY NIGHT*
TULEB KEEGI *SOMEONE APPEARS*
SÕESTUNUD SILMIL *EYES SEARED*
EI RÄÄGI *NEVER A WORD*
MIDA TA NÄGI *OF WHAT*
ELAVAS *HE SAW IN THE LAND*
MAAILMAS *OF THE LIVING*

Although "O" has straight sides, it needs to be placed a little closer than the "E" on the other side, for visual reasons.

Space upright strokes well apart, about the width of an "E."

HOMER

Poem in red and white, Veiko Kespersaks
This delicate panel is written in two different-size pens, in two colors on black paper. The white lettering is Estonian, the red is the English translation. [HP Fabriano Tiziano paper, 160 gsm]

Copperplate *by Brian Colvin*

Copperplate, or English Roundhand, is a style of writing that uses a pointed nib instead of the broad-edged nib used for most calligraphy. The name comes from the copybooks from which students learned to write, which were printed from etched copper plates and led to the emergence of this style.

By the nineteenth century, Copperplate had superseded Italic to become the standard style taught in schools in Europe and America, and it was taught farther afield in Australia and New Zealand well into the twentieth century.

Fast flow

When learned as a handwriting style, all the letters are joined by virtue of the fact that the ascenders and descenders are looped in order to connect to the following letter, making writing much faster. Words can be written with an almost continual movement of the pen.

The thickness of the stroke is determined not by the width of a broad-edged nib, but by pressure applied to the flexible, pointed nib while writing. Light pressure will create fine strokes and an increase in pressure will create broad strokes. It can be helpful to practice the pressure and release technique with a 2B pencil first.

Letters are written at a slant of 54° from the horizontal—an angled pen holder can be used to facilitate writing at this extreme angle. Guidelines are necessary for the slant in addition to horizontal lines.

Copperplate majuscules cannot be used on their own, as any word written entirely in capitals would be very difficult to read, but they are pleasingly decorative when used in the conventional manner.

If you like Copperplate then you may also find the Spencerian script appealing (see pages 126–135).

Loops and curves

Minuscule letters with ascenders are almost twice the height above the x-height. This "h," together with the other ascenders, "b," "f," "k," and "l," start at the baseline with a slight curved stroke upward to the x-height line. At the line, the stroke loops out to the right, up to the headline, and returns downward while pressure is applied on the nib to construct a thick stroke to the baseline.

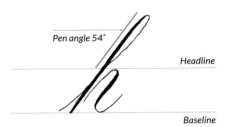

Pen angle 54°

Headline

Baseline

Opening the nib

Stroke 1 of the "j" starts with a slight curved stroke from the baseline up to the x-height. While at the top of this stroke, you will need to pause and, without moving the pen, apply pressure to let the tines of the nib open before completing the thick downstroke and the thin bottom loop.

Headline

Baseline

Optional flourish

Capital letters are three times the height of lowercase letters. Stroke 1 of this "A" occurs in 14 other letters—as a thick stroke, as for "F," "I," and "T," or, for the letters "A," "M," and "N," as a thin stroke. Apply minimum pressure for fine lines. The final flourish at the end of stroke 2 can be omitted in order to join the letter to minuscules.

Headline

Baseline

**Delicate, regular, elegant
Copperplate, Brian Colvin**
In this modern example of
Copperplate, the interlinear space is
almost the same as for the historical
example shown right, although much
care must be taken to make sure that
neither ascender nor descender
touch each other. Care must also be
taken by limiting any flourishes. The
piece also shows how important the
pencil lines at 54° are at keeping
the ascenders and descenders at a
consistent angle. [Fabriano4 Italian
paper and homemade Black Oak
Gall Ink]

In CONGRESS, July 4, 1776.

The unanimous Declaration of the thirteen united States of America.

*More upright,
with a sharper
lift-off*

*Both letters are similar
in shape, but the
historical "P" is
completed in one stroke*

*Avoids continuing
through the initial
stroke*

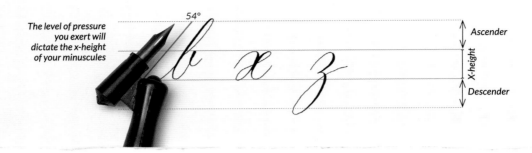

The level of pressure you exert will dictate the x-height of your minuscules

54°

Ascender

X-height

Descender

Copperplate Minuscule

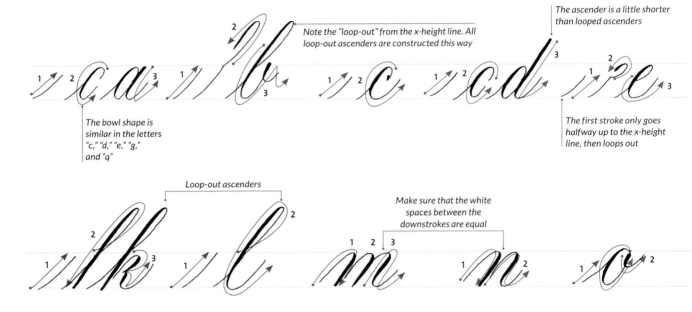

Note the "loop-out" from the x-height line. All loop-out ascenders are constructed this way

The ascender is a little shorter than looped ascenders

The bowl shape is similar in the letters "c," "d," "e," "g," and "q"

The first stroke only goes halfway up to the x-height line, then loops out

Loop-out ascenders

Make sure that the white spaces between the downstrokes are equal

The white space between the two downstrokes should mimic the "m," "n," and "y"

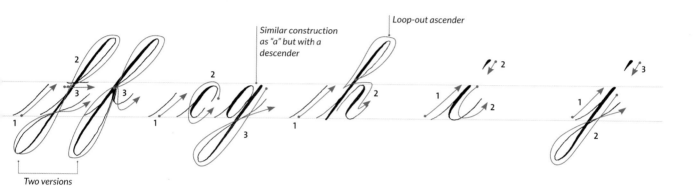

Similar construction as "a" but with a descender

Loop-out ascender

Two versions

The thick downstroke starts a little above the x-height line

The crossbar goes above the x-height line

Same shape as "g," but finishing stroke goes to the right

Make sure that the space between the first step and the thick downstroke is narrow

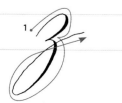

Looped letters: "b," "f," "h," "k," and "l"

The first stroke of each looped letter is a short, slightly looped stroke from the baseline up to the x-height line. The stroke is then continued by looping out to the right, up to the ascender line. Once the thin stroke has reached the ascender line it returns down through the point that it looped out, as a thick stroke. Pressure on the nib to make the thick stroke starts as soon as the downstroke has started.

Basic structure

Although this hand originates from Italic script (see pages 100–105), in execution it is closer to "normal" handwriting. The letters are small and evenly spaced. Each letter has a lead-in from the previous letter and leads out to join the following letter. It is important to choose a pen nib that is neither too stiff nor too flexible so that the pressure can be applied gently and rhythmically. The balance of pressure and release is key to this hand, as is maintaining branches at a consistent halfway point of the stroke. As the nib is monoline, there is no fixed x-height for this hand. Simply rule the lines to the width required and adjust the downstrokes to create the desired weight. The ideal proportions are ascender 3; x-height 2; descender 3. In practice this means the ascenders and descenders are one and a half times the x-height. The pen angle is a constant 54°. Copperplate takes time to master and is not the best hand for beginners. It is best to become proficient in Italic hand before attempting it.

IN DETAIL

1 Make the first stroke a gentle inner curve not quite to the x-height line.

2 Create the form of an oval, being careful not to make it too round.

3 The finishing stroke should stop mid x-height.

1 Begin with an upward oval loop. Apply pressure for the thick stroke, then release for the thin left loop, which is taken up and across the thick stroke.

2 Take the thin up to the x-height line, then over and down, touching the thick downstroke at mid x-height, then down to the baseline, finishing with a slight upward stroke.

PEN POSITION

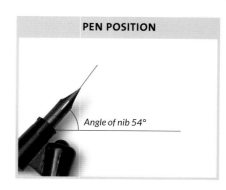

Angle of nib 54°

b d h k l p t

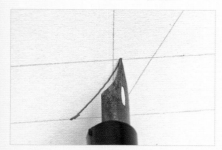

1 Without pressure on the nib, make the first stroke up to the x-height line.

2 Still without pressure on the nib, loop the line out to the right and up to the ascender line. Now apply pressure down to the baseline.

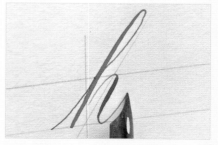

3 The white space between the ascender downstroke and this downstroke should mimic the counterspace in the letters "m," "n," "p," and "u."

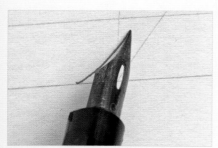

1 Start the first stroke with a gentle inner curve not quite up to the x-height.

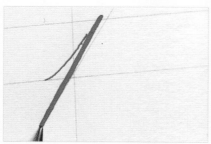

2 Make a constant thick stroke by applying equal pressure down its length.

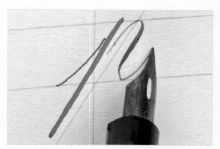

3 The inner white space should mimic the counterspace in the letters "h," "m," "n," and "u."

CONTINUED NEXT PAGE

ffgjyqz

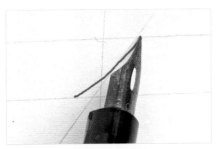

1 For the first movement, make a gentle inner curve up to the x-height line.

2 With the nib at the top of the inner curve, press on the nib and make a thick stroke down, releasing pressure before the baseline. Push up on a thin back to the x-height line.

3 With the nib on the x-height line, press on the nib and pull down for the parallel descender. Take pressure off the nib when approaching the descender line and take the thin loop stroke back to mid x-height.

1 Start with a thin stroke mid x-height, which loops up to the line. Apply pressure while looping down to a little above the baseline.

2 Starting on a thin line, apply pressure while looping out to the right and down. Approaching the descender line, release pressure. The thin line loops to the left and up to mid x-height.

Minuscules with ascenders are almost twice the height above the x-height.

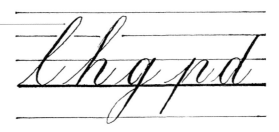

i m n r u v w

1 Apply light pressure on the nib for the upward stroke until you reach the x-height. Apply pressure down to the baseline.

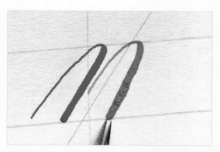

2 Start the second stroke about one-third of the way up the first stroke and take it up to the x-height line over to the right, applying pressure down to the baseline.

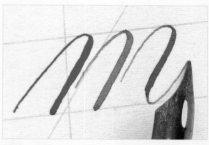

3 Imitate the second stroke with the third, but end the thick downstroke with a flourish to the right.

1 Without applying pressure, make a gentle inner curve up and through the x-height line. Continue with a loop and move to the right to start the downstroke.

2 Apply pressure immediately for the thick downward stroke, which runs parallel with the inner curve, finishing with a thin upward flourish.

In practice

Writing the word "minimum" will help you to develop a rhythm. Practicing this and similar words will develop your spacing skills. When a letter begins or ends with a hairline, as all the letters here do, it is joined with a single stroke without lifting the pen.

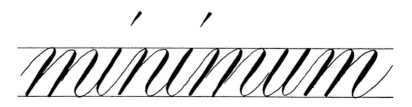

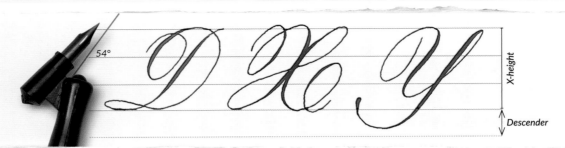

Copperplate Majuscule

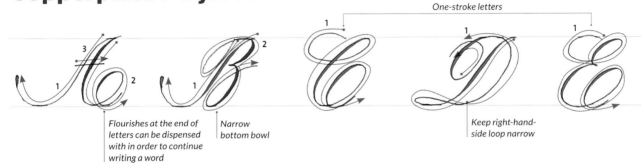

One-stroke letters

Flourishes at the end of letters can be dispensed with in order to continue writing a word

Narrow bottom bowl

Keep right-hand-side loop narrow

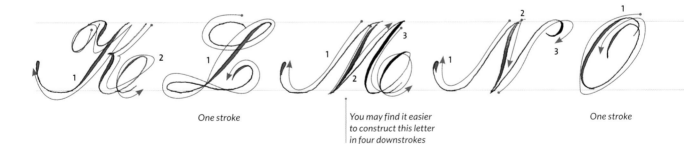

One stroke

You may find it easier to construct this letter in four downstrokes

One stroke

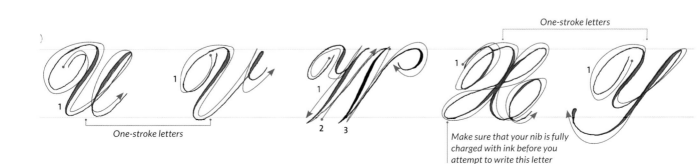

One-stroke letters

One-stroke letters

Make sure that your nib is fully charged with ink before you attempt to write this letter

To thicken the center of the stroke, turn the paper to 45° and go over part of the stroke again while applying a little pressure on the nib

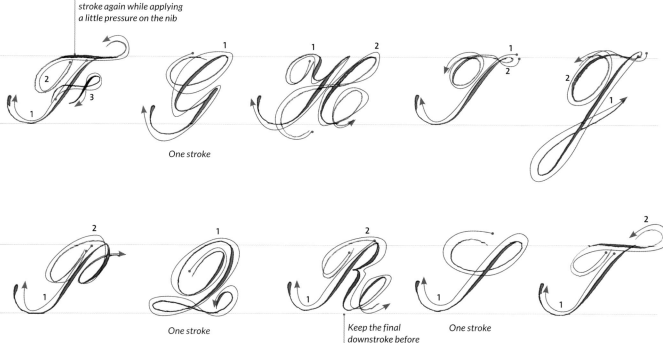

One stroke

One stroke

Keep the final downstroke before the flourish narrow

One stroke

One stroke

Script style

The majuscules shown here are a little more flourished than some popular Copperplate styles. For example, the majuscules in the *Declaration of Independence* (see page 113) have minimal, practical flourishing. Like all other scripts of calligraphy, Copperplate is constantly evolving and, as such, has no definitive style.

Basic structure

Copperplate capitals are used to indicate the first letter of a sentence only; they are not suitable for use as a standalone script like Roman Capitals. They also look best when given generous spacing around as well as between the letters. They can often be made in one line without any pen lifts.

Different pointed pens will affect the appearance of the writing, especially the width of the thick and thin strokes—so choose your nibs carefully.

IN DETAIL

1 This first stroke shape starts 13 capital letters, both as a thick or a thin stroke, so practice it copiously.

2 Start the second stroke as a thin line, briefly applying pressure on the nib to make a thick line before releasing toward the baseline and up for the finishing flourish.

3 Make the crossbar above the center line.

1 Make an oval for the starting loop.

2 Keep the bottom-left loop long and narrow.

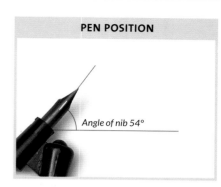

PEN POSITION

Angle of nib 54°

$\mathscr{B}\ \mathscr{D}\ \mathscr{E}\ \mathscr{F}\ \mathscr{P}\ \mathscr{R}\ \mathscr{S}\ \mathscr{T}$

1 Apply pressure for the thick downstroke, then release for the left-hand bottom loop and long push-up stroke on the right. Extremely light pressure is required.

2 Once the upward push stroke reaches the capital line, apply pressure slowly to make the oval-shaped loop on the right, finishing on a thin stroke.

1 Slowly put pressure on the nib to produce a thick stroke, then take the pressure off completely approaching the baseline and continue to the "teardrop" terminal.

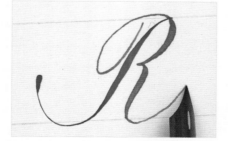

2 Lightly make a downward oval on the left, bringing it up and over the top of the first stroke, and then apply pressure to make the bowl. The final stroke should be parallel with the first.

CONTINUED NEXT PAGE

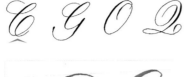

1 This letter consists of three oval shapes and is quite rhythmic to write. Make a thin oval that finishes at the capital line. Apply pressure for the main, thick downstroke, which is taken to the baseline.

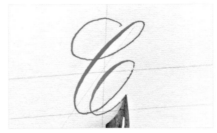

2 Start the final oval at the baseline with a thin stroke, taking it up to mid x-height. Apply pressure to the downstroke, then release it for the final upstroke.

1 The same first stroke starts three capital letters: "H," "K," and "W."

2 Make the second stroke a thick one that terminates with a "teardrop," which is simply a slight downward stroke with pressure applied to the nib for a split second.

3 Start this stroke with a thin line that is a push stroke around and up, before crossing the second stroke horizontally, then continue out and up to construct the "C" shape.

In practice

This example shows a capital letter starting a word. The right final flourish has been omitted in order to join the minuscules. This also occurs with the letters "A," "K," "L," "M," "Q," "R," "X," and "Z."

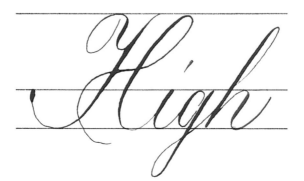

1 Make the first stroke similar to that in the capital "H."

2 For the second stroke, apply pressure for a downward thick stroke.

3 Achieve this step by two downstrokes instead of a push-up, pull-down stroke.

4 A thin push stroke is required to achieve the thick terminal stroke.

1 Begin with an upward oval loop, without applying pressure. Apply pressure on the thick diagonal downstroke, and release it for the upward thin.

2 From the top of the loop, apply pressure for the thick downstroke, slowly releasing as you approach the descender line. Make a thin stroke to the left, finishing with a teardrop.

Press, then pull down.

Fifteen majuscules start with the above stroke, so be sure to practice it. It finishes on the left side with a "teardrop."

Majuscules are three times the height of the minuscules in this script.

Spencerian *by Veiko Kespersaks*

Spencerian is based on the idea that writing should flow from the free movement of the arm and hand. In appearance, the script is lighter and more graceful than other cursive forms of handwriting.

The Industrial Revolution had a profound effect on nineteenth-century America. Changes to commerce and production, and the growth of business created an unprecedented need for written communication. Everyday handwriting, or "formal penmanship," was considered vital to gaining employment and prestige, and a number of handwriting artists emerged, most notably Platt Rogers Spencer, who established many successful writing academies and developed the Spencerian Handwriting System. Spencer took advantage of new lithographic printing methods to publish and distribute his writing system in copybook form throughout the United States.

Handwriting was seen as a social accomplishment as well as a function of commerce. Instructional books contained illustrations of elaborate ornamental lettering or illustrations of animals constructed of flourishes, which reflected the era's attitude to handwriting as an "art." Many handwriting artists were also great showmen, attracting crowds to public demonstrations of their skill. The majuscules were particularly favored for their flourishes, often to the point of compromising legibility.

Successful strokes

Like Copperplate, Spencerian is usually written using a flexible nib and an oblique pen holder. The key to success with this script is in understanding how pressure affects the shape of the letterforms. Practice the letterforms using a very light pressure to create thin, hairline strokes. Experiment with pressure on the second or third stroke of a word. As you become more skilled, try to work out where to apply pressure to create the most harmonious effect. You may need to apply pressure two or even three times in one word.

Balanced bottom
The minuscule "b" begins with a lead in from the baseline with an upward curving stroke. The pen is pushed up to form a small loop, then swept down and to the left with pressure to form the first side of the oval. Releasing pressure and pushing back up from the other side of the oval makes the small loop. Pressure is applied only to the bottom half of the letter, to avoid it looking top-heavy.

Branching out
Leading in from the bottom left, the first stroke of the minuscule "p" pushes up to the top of the letter and then sweeps down with pressure to form the descender. Pressure is released, pushing back up the stem, and branching at the halfway point of the x-height to form a loop. Sweeping down without pressure, releasing, and leading out finishes the letter.

Hairline curves
Leading in with a hairline curve for the majuscule "R," the pen is then swept down with pressure, but released before the baseline. The second stroke starts without pressure, which is then applied for the curved downstroke. A light stroke sweeps down under the baseline, finishing with a curve in above the baseline.

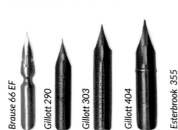

Pointed nibs
Each of these nibs can be used for Spencerian hand. They have different levels of flexibility, and their lifespan will depend on how "heavy" your hand is.

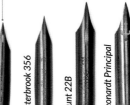

Brause 66 EF · Gillott 290 · Gillott 303 · Gillott 404 · Esterbrook 355 · Esterbrook 356 · Hunt 22B · Leonardt Principal · Zebra G

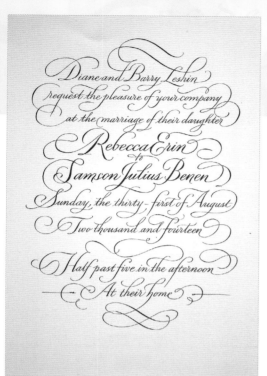

All vertical lines have pressure applied. Letterforms are taller; the interspace of letters is nicely balanced by the thickness of lines. The writing angle is more upright.

Pressure is applied on every third or fourth vertical stroke. The x-height is low, as is the writing angle, for a better rhythm of the writing.

Wedding Invitation package, John Stevens
This beautiful pointed pen piece was written with the same size nib. In the middle of the piece two lines are written with more pressure, for emphasis. The flourishes around the edge serve to balance each other and the piece as a whole. [Pointed pens, brushes on paper using ground sumi ink]

An example of Ornate Penmanship, Louis Madarasz (1859–1910)
Louis Madarasz is regarded by many as the most highly skilled ornamental penman that ever lived. His style was unique—a dramatic, heavily shaded variety of ornamental writing.

SAN FRANCISCO BUSINESS COLLEGE
908 MARKET STREET
SAN FRANCISCO

A. S. WEAVER, PRESIDENT

Kind hearts are gardens,

Kind thoughts are roots,

Kind words are fruits,

Kind deeds are flowers.

AN EXAMPLE OF ORNATE PENMANSHIP —— NOT BUSINESS WRITING

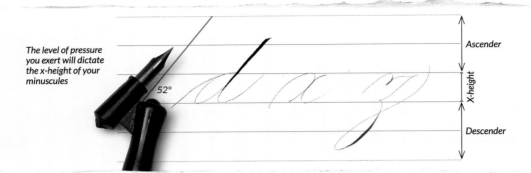

The level of pressure you exert will dictate the x-height of your minuscules

52°

Ascender

X-height

Descender

Spencerian Minuscule

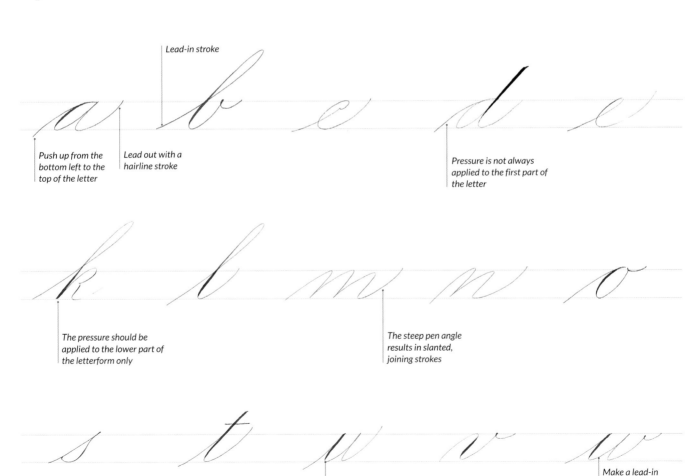

Lead-in stroke

Push up from the bottom left to the top of the letter

Lead out with a hairline stroke

Pressure is not always applied to the first part of the letter

The pressure should be applied to the lower part of the letterform only

The steep pen angle results in slanted, joining strokes

Note that pressure is applied to just one stroke, not the whole letter

Make a lead-in stroke and sweep down without pressure

Warm up

It is vital to warm up before beginning to write so that your hand becomes accustomed to making the movements of the script. Neglecting to warm up will result in jagged, uneven letterforms. Think of the warm-up as part of the whole writing experience that prepares your mind and hand for the task to follow.

Try zigzags. The upward stroke should be longer, the downward stroke shorter.

Make diagonal lines.

Practice making this simple shape, like the letter "n," repeated and joined together.

Practice joining different letters together.

Note that the pressure is applied to just one stroke, not the whole letter

Sweep down with pressure to form the descender

Two versions

Note that pressure is applied to just one stroke, not the whole letter

Two versions

Pressure is not always applied to the first part of the letter

Two versions

Two versions

CLIP 13
Spencerian Minuscule
http://qr.quartobooks.com/cask/clip13.html

Basic structure

The lowercase letters are delicate, and shading is often applied to just the third or fourth letter in a word. The building blocks of the script are the diagonal lines, flattened curves, and loops (such as for the "f"). The loops are made from the diagonal lines and one curve; avoid making them too big ("z" is an ideal letter for loop practice). As a general rule, if a letter has a long line, it looks better if the pressure is applied to the lower part (see "l") to keep it from becoming top-heavy.

In this example, the alphabet has been organized into four different letterform shapes to simplify practice sessions. Letters in the first group include straight lines, while in the second group you can see a mixture of straight and curved lines. Oval-shaped letterforms make up the third grouping, and the fourth group consists of combinations of different shapes and lines.

All Spencerian letters have thin entry and exit strokes and are joined with hairline upstrokes. It is important to consider what comes before and after the stroke so that your letterforms harmonize with the rest of the text. Remember to maintain a slow, even rhythm.

In practice

The space between the letters should be roughly equal to the space inside letters; space between words should be equal to the size of one letter (for example, "o").

IN DETAIL

1 Push up from the bottom left to the top of the letter. Make sure your pen angle is correct at 52°.

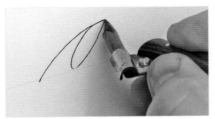

2 Sweep down without applying pressure, then release and push back up to form the oval shape.

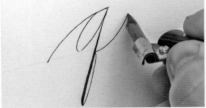

3 Sweep down, applying pressure for the descender. Release and form the loop to lead out.

1 Lead in with a hairline from the bottom left.

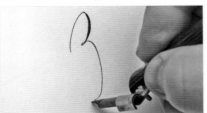

2 Make a reverse curved hairline stroke, applying a little pressure; make a small loop and then sweep down without pressure for the descender.

3 Form the loop and lead out with a hairline stroke.

The flourish serves to decoratively underline the word.

Applied pressure provides points of focus in words.

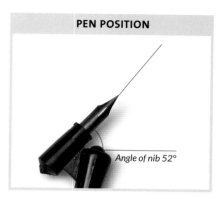

PEN POSITION

Angle of nib 52°

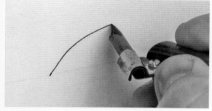

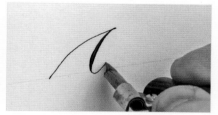

1 Push up from the bottom left to the top of the letter. Make sure your pen angle is correct at 52°.

2 Sweep down while applying pressure, release, and push back up to form the oval shape.

3 Lead out with a hairline stroke to join to the next letter.

1 Lead in with a hairline from the bottom left.

2 Push up and form a small loop just above the x-height of the letter; sweep down, applying pressure to the baseline. Make sure your pen angle is correct at 52°.

3 Release and push back up the stem, branching out at the halfway point of the x-height to form a loop. Sweep down without pressure, release, and lead out.

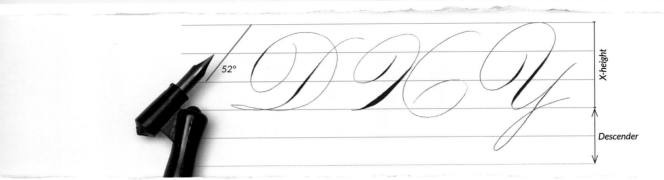

Spencerian Majuscule

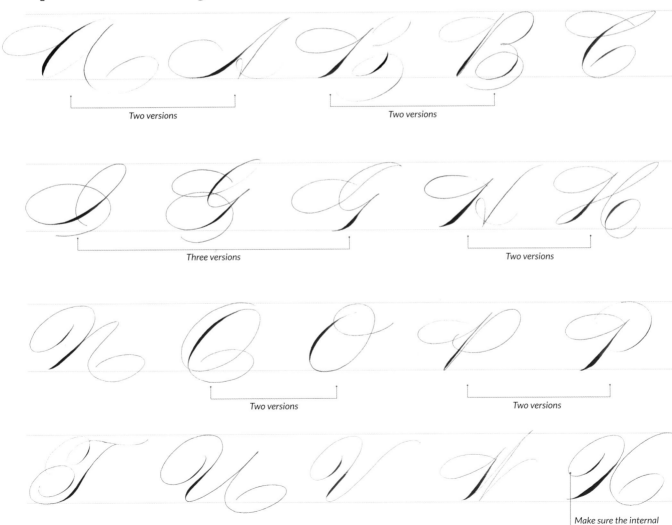

Two versions

Two versions

Three versions

Two versions

Two versions

Two versions

Make sure the internal loop spaces are smaller than the letterform

Warm up

It is vital to warm up adequately to eliminate any shakiness, so the light, airy look of this hand can be achieved.

Write a line of spirals, applying pressure every second curve.

Apply pressure on the downward part of the stroke.

Write the shapes, applying pressure on the downstroke.

Using a pencil, write a letterform. Keep writing over the original letterform as many times as you like. This exercise will help fix the shape of the letter in your mind.

Two versions

Apply pressure to the back curve only

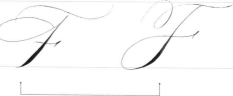

Two versions

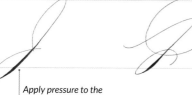

Apply pressure to the end of the downward stroke and then release

Two versions

Two versions

Apply pressure on the inside of the loop

Two versions

Two versions

CLIP 14
Spencerian Majuscule
http://qr.quartobooks.com/cask/clip14.html

Basic structure

Spencerian majuscules developed from their Copperplate counterparts. As there are fewer pressure strokes, the letterforms appear lighter and more elegant. There is no x-height for the majuscules; they are adapted to fit the proportions of the rest of the text. The shape of the letter should be balanced: If flourishes are added to the upper letter, then they should be applied to the lower letter, too.

Pressure is applied to only one stroke within a letter and usually to the bottom half only (see the first family group, below). The letters within the second family group are constructed primarily of both diagonal lines and loops. In the third group, the letters are related to an oval, and the final grouping contains letters that have pressure applied along the diagonal stroke. The pen angle is 52°.

In practice

Capital letters do not have to join the main text; sometimes it can be effective to have a small gap. However, it is key to lead in to the first letter with a hairline upstroke.

IN DETAIL

1 Make sure your pen is at 52°. Start the counterclockwise curve, then sweep down, without applying pressure, forming the smaller top curve of the "E."

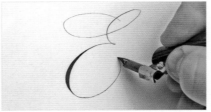

2 Sweep down, applying pressure, release, make the curved downstroke, and begin making the flourish.

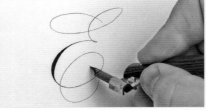

3 End with an inward curve. You can end the flourish line differently, but make sure the letter remains legible.

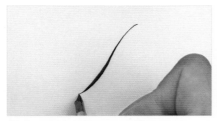

1 Sweep down with pressure applied to the bottom part of the stroke. Make sure your pen is at 52°.

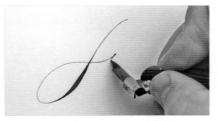

2 Curve up and lead out to cross the first stroke at the halfway point. Make a filled-in dot and lead out with a short hairline stroke.

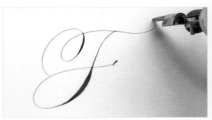

3 Lead in with a loop, applying pressure on the downstroke; sweep up with an oval shape, crossing the stem at 90°, and lead up with a flourished hairline curve.

Note the "T" is flourished on the left-hand side.

Tranquilla

The gap prevents the "T" from appearing too cramped; the hairline lead-in to "r" is an important visual link to the majuscule.

The lead-out helps to balance the word.

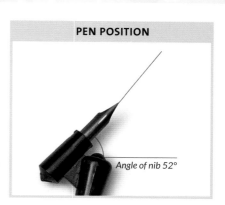

PEN POSITION

Angle of nib 52°

B F H K M N P R T W X

K U V Y

1 Sweep down, applying a little pressure, release, and reapply pressure for the curved downstroke. The pressure is only applied to the bottom half of the stroke.

2 Push back up the stem without applying pressure, branching at the halfway point (where you started to apply the pressure) to form a loop.

3 Push up the stem without any pressure to form the second, slightly lower arch, branching from the halfway point. Lead out with a counterclockwise curve with light pressure for the downstroke.

1 Sweep down using a little pressure, release, and reapply the pressure for the curved downstroke. Only apply pressure to the bottom half of the stroke.

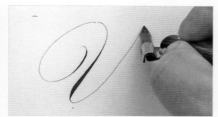

2 Sweep down to form a curve, only applying pressure to the bottom half of the stroke. Sweep up without pressure.

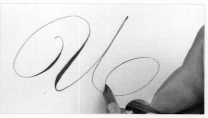

3 Push back down the stem without pressure, branching at the halfway point. Lead out with a counterclockwise curve, applying light pressure for the downstroke.

Foundational Hand *by Jilly Hazeldine*

The Foundational Hand came about through the revival of handmade book arts that resulted from the Arts and Crafts movement of the late nineteenth and early twentieth centuries. It is based on a tenth-century English manuscript and owes its existence to the work of Edward Johnston (1872–1944). It is a beautifully clear and legible formal hand, disciplined, but with a uniform simplicity that employs a natural and consistent pen angle.

History of the hand

Edward Johnston was a British craftsman regarded as the father of modern calligraphy. His involvement in lettering has its origins in the Arts and Crafts movement. Through his intensive research Johnston discovered the methods and principles underlying formal penmanship, and so revived the art of calligraphy and lettering. In Johnston's day the term "calligraphy" was not yet in use; the skill was known as penmanship.

In ninth-century Western Europe, under the driving force of Emperor Charlemagne (742–814 A.D.), a writing style developed known as the Caroline Minuscule. The Carolingian period marks a major development in the evolution of writing, with the emergence of the minuscule (small letter) family of formal scripts.

During the tenth century, particularly fine variations of the Caroline Minuscule were being used in southern England. Of these manuscripts, Edward Johnston considered the Ramsey Psalter (974–986 A.D.) an almost perfect model for formal writing because of its size, clearly made letterforms, and consistent pen angle. Johnston modernized the script to produce the Foundational Hand. The script formed the basis not only of his later teaching but also that of subsequent generations of teachers. It is still considered to be one of the best scripts from which to learn formal writing.

As Johnston said, "The problem before us is very simple, to make good letters and arrange them well."

The blueprint "o"

The "o" is the basis of this script, and its underlying structure is of two overlapping circles written at a precise angle of 30°. This rounded form is reflected in the majority of the letters of the alphabet.

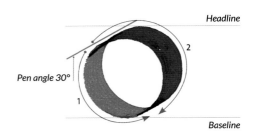

Branching "n"

The arch of "n" is based on a segment of a circle and branches high from the stem. This arch shape also occurs in "h," "m," and "r." The "u" and its related letters are the same as an inverted "n."

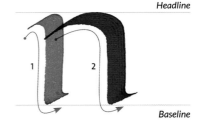

Challenging "g"

The "g" is probably the most complex letter in this script and is composed of four pen strokes. The top bowl is based on the "o," but is about three-quarters of its height, which prevents it from looking top-heavy. The second stroke curves in and back out again to form the elliptical descender, and the bowl should be equally balanced above it.

Drogo Sacramentary (below), Paris, Bibliotheque Nationale de France. Carolingian illuminated manuscript on vellum c.850 A.D.
Written and painted for the personal use of Charlemagne's son Drogo, Bishop of Metz, this manuscript, with its beautiful and legible lettering, is representative of a defining point in the history of writing. The Sacramentary script is cursive in nature with a forward slant. As a bookhand it would have been written quite quickly at a small size. Note also the generously spaced, gilded, and elegantly written Uncials and the marginal Carolingian Versals.

Earthquake (text from Revelation), Susie Leiper
This large canvas piece features abstract imagery and text painted on with brushes in multiple layers. It is a superb example of expressive contemporary calligraphy, using the script in a bold and dramatic way. [Brushes on canvas]

The top of the letter is slightly shorter and the sloping back is reminiscent of Uncial

Both bowls have been left open

Rounded, Uncial form, without the semi-ascender of the modern "t"

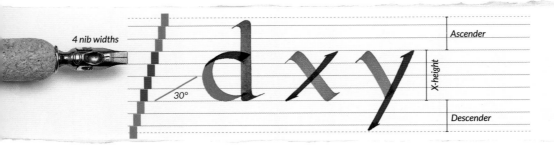

4 nib widths

30°

Ascender

X-height

Descender

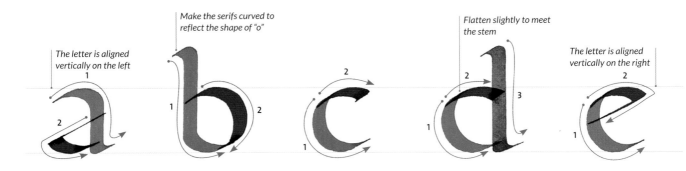

The letter is aligned
vertically on the left
1

2

Make the serifs curved to
reflect the shape of "o"

1

2

2

1

Flatten slightly to meet
the stem

2

3

1

The letter is aligned
vertically on the right

2

1

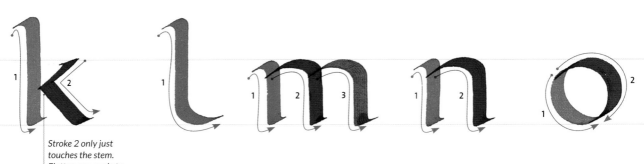

1

2

1

1

2

3

1

2

1

2

Stroke 2 only just
touches the stem.
Flatten pen angle to
about 20° for stroke 2

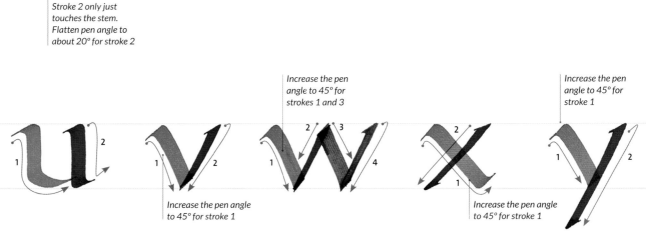

2

1

1

2

Increase the pen
angle to 45° for
strokes 1 and 3

2

1

3

4

Increase the pen
angle to 45° for
stroke 1

2

1

Increase the pen
angle to 45° for
stroke 1

1

2

Increase the pen
angle to 45° for
stroke 1

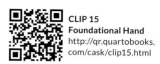

CLIP 15
Foundational Hand
http://qr.quartobooks.
com/cask/clip15.html

The bowl is about three-quarters of the x-height

Note the round arch before the stroke straightens down to the baseline

The descender is an ellipse; at its widest point the width is equal to an "o."

Stroke 3 is flattened slightly

The letter is aligned vertically on the left and right

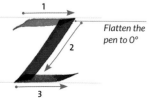

Flatten the pen to 0°

Pleasing curves

It will help the shape of curves if you watch the inside edge of the nib while writing.

Basic structure

The classic simplicity of the Foundational Hand is in its underlying form, which is based on a circle. "O" is formed from two overlapping circles, and this circular form can be seen in the majority of letters. This is especially important for the unity of the script that it is reflected in the arch shapes. The consistent pen angle of 30° is used for all strokes apart from the left–right diagonal strokes, for example "v," "w," "x," and "y," which use a steeper pen angle of 45°. The bottom serifs are generally smaller than those on the top.

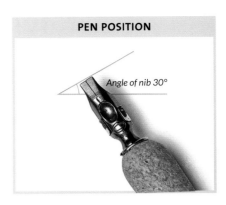

PEN POSITION

Angle of nib 30°

IN DETAIL

bcdegopq

1 Using an angle of 30°, start below the headline, push up and around for a small serif, then pull straight down and through the baseline. Curve counterclockwise to end with a serif.

2 Overlapping stroke 1, push the nib up and around, making a clockwise curve until you reach the thin part of the stroke, then lift the pen.

3 Place the nib on stroke 1.

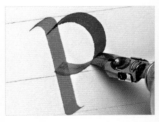

4 Pull down and around to meet the end of stroke 2, overlapping slightly to complete the bowl of the letter.

fjs

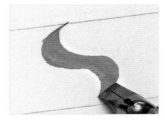

1 Pull the nib at 30° from the headline to the left and turn in a clockwise curve across the width of the letter. Change direction for a curve around to above the baseline.

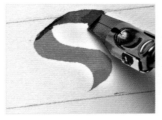

2 Overlap the start of stroke 1, curving up to the headline and across. At the end of the stroke pull in slightly to form a small serif.

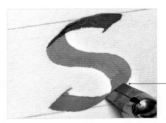

3 Starting to the left of the letter, just above the baseline, make a small round serif, then pull down and across to overlap the end of stroke 1.

The letter should align vertically on the right-hand side, and the top bowl should be slightly smaller than the bottom one.

In practice

This word demonstrates the underpinning shape of a circle in the first stroke of "d" and "e," the clockwise arch of "a," and the counterclockwise arch of "u." Latin has a unique writing rhythm because of the combination of letters in its language, and this is apparent here.

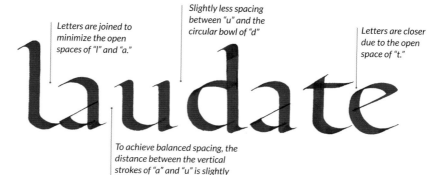

Letters are joined to minimize the open spaces of "l" and "a."

Slightly less spacing between "u" and the circular bowl of "d"

Letters are closer due to the open space of "t."

To achieve balanced spacing, the distance between the vertical strokes of "a" and "u" is slightly less than the counterspace of "u."

ahílmnrtu

1 With pen angle at 30°, start below the headline, push up and around for a small serif, then pull down and through the baseline. Curve counterclockwise to give a serif.

2 Overlap stroke 1 and push up and around until you are level with the start of the arch. Pause and change direction, pull down to the baseline: end with a curved serif.

3 Place the nib on the junction made by the pause in stroke 2, then make an arch as per stroke 2, pause again before pulling down to the baseline: end with a curved serif.

kvwxyz

1 Using an angle of 30°, start above the headline, push up and around for a small circular serif, then pull down to the baseline. Curve counterclockwise to give a serif.

2 Flatten the pen angle to about 20°. Start at the headline, make a small serif, and pull diagonally into the stem.

3 Change direction to make a left–right diagonal to the baseline. Come up from the line slightly at the end of the stroke.

Ruling Pen *by Jilly Hazeldine*

One way to breathe new life into established letterforms is to change the pen used to write them. Calligraphers discovered that ruling pens—a modern tool often part of the school geometry kit—provided possibilities for a more gestural, vigorous, and dynamic style of writing.

The exemplars in this book use a range of pens, as well as a chisel brush, and these all interact differently with the writer's hand, ink, and paper. The writing implement you use strongly influences the marks that are made, and, indeed, the evolution of scripts was led by available materials; the change from reed pen on papyrus to quill pen on calfskin vellum and, eventually, paper has affected the development of writing.

Before advances in computer technology, ruling pens were used for technical drawing in cartography, architecture, and engineering. The German calligraphers Friedrich Poppl and Gottfried Pott are credited with being the innovators of using the pens in calligraphy.

The Ruling Pen minuscule and majuscule are based on the Italic letterform (see pages 98–111), which lends itself well to a freer style of writing.

Speed is a factor in ruling pen writing, there is less control, and it may be harder to be consistent. To some extent, this can be exploited as a particular characteristic of ruling pen writing, which is not possible with different pens. The ruling pen also lends itself well to being used with textured papers.

Type of pen
A folded ruling pen has been used for this chapter (see pages 10–11). They can also be made from aluminum drinks cans or litho plate.

Shallow curved bowl
The bowls of "c," "d," "e," "o," and "q" are constructed in a similar way as for this minuscule "g." The pen is held parallel to and slightly below the headline. It pushes up to the headline then down and out to the left in a shallow curve, making a broad stroke with the center of the blade. Lifted onto the point of the blade, the pen curves up to just below the start of the stroke. Tipping back onto the center of the blade, the descender is formed. About two-thirds of the way down, the blade is turned onto its point, then twisted counterclockwise, pushing to the left and up to complete the descender.

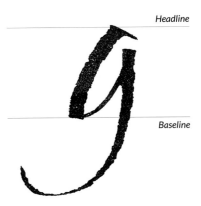

Headline

Baseline

Forming the arch
The arch forms of "h," "m," "n," "p," and "r" are constructed in the same way as for this minuscule "b." The pen is held parallel to and slightly less than the body height above the headline. It is pushed to the left, a little pressure exerted, and then pulled downward, using the natural curve of the hand's movement to make the stroke slightly curved. At the baseline, the pen is tipped onto the point of the blade, making a branching curve up to the headline. The flat of the blade is used to pull down to the baseline, then the point of the blade completes the bowl of the letter.

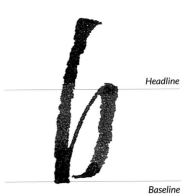

Headline

Baseline

Capital bowl
The letters "B," "D," and "P" are constructed in a similar way to this majuscule "R." The flat of the blade is put on the paper to pull down to the baseline. At the top of the letter, to the left of the main stem, the point of the blade pushes sideways and slightly up. Tilting onto the edge of the blade, from the end of the fine line, a curve forms the bowl. Lifting off the pen, the hand position changes so the blade is along a northeast line and pulls diagonally out and down to the baseline. The letter is completed with a small flick upward using the point of the blade.

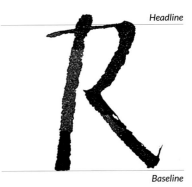

Headline

Baseline

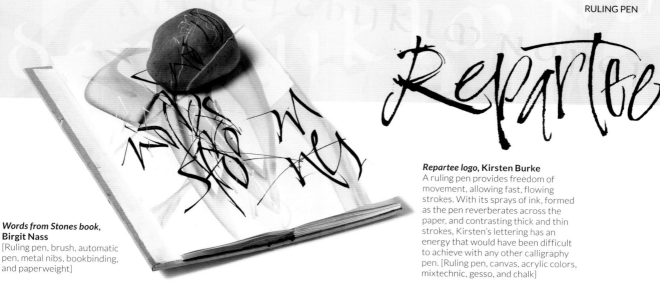

Repartee logo

Words from Stones book, Birgit Nass
[Ruling pen, brush, automatic pen, metal nibs, bookbinding, and paperweight]

***Repartee* logo, Kirsten Burke**
A ruling pen provides freedom of movement, allowing fast, flowing strokes. With its sprays of ink, formed as the pen reverberates across the paper, and contrasting thick and thin strokes, Kirsten's lettering has an energy that would have been difficult to achieve with any other calligraphy pen. [Ruling pen, canvas, acrylic colors, mixtechnic, gesso, and chalk]

A–Zs, Anna Pinto
The "A" and "Z" are very loose, contemporary looking, Lombardic-style capitals. The ruling pen gives them some dimension, thanks to the way that the gouache puddles in unplanned ways. Anna enjoys the gestural quality of the strokes, and the play of thick and thin. [Gouache, colored pencil, ruling pen, pointed pen on Fabriano Ingres paper]

"The stones are all art masterpieces, there aren't two equal," Luca Barcellona
This quote is written freely, without a layout, apparently very fast, and the letters fit in the space, interlocking with each other, never equal one to the other, just like stones. [Broad-edge nib with gouache on cotton paper]

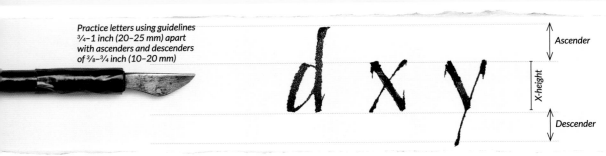

Practice letters using guidelines
¾–1 inch (20–25 mm) apart
with ascenders and descenders
of ⅜–¾ inch (10–20 mm)

Ascender

X-height

Descender

Ruling Pen Minuscule

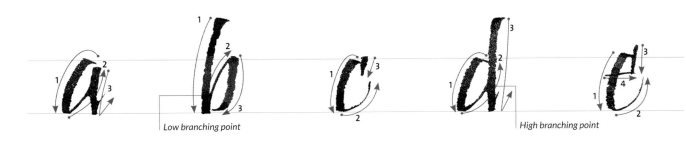

Low branching point

High branching point

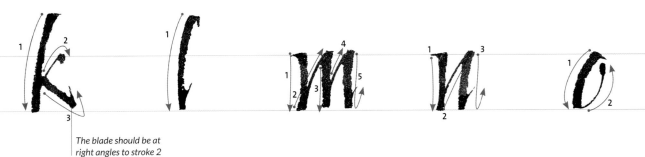

The blade should be at
right angles to stroke 2

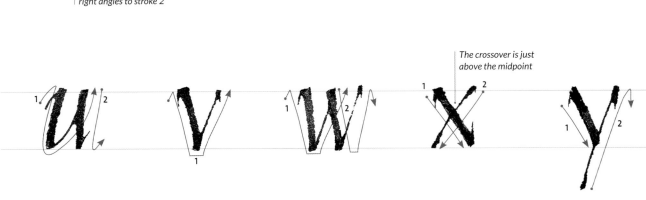

The crossover is just
above the midpoint

*Upward movement
of the crossbar*

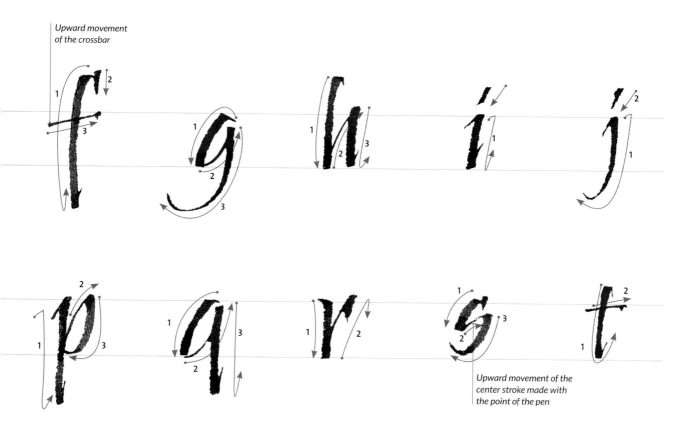

*Upward movement of the
center stroke made with
the point of the pen*

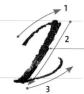

*Use the flat of the blade
to make stroke 2*

Basic structure

The Ruling Pen exemplar has characteristics similar to Italic. The underlying almond shape of "o" and "u" is reflected in many of the other letters. The arches are asymmetric and branch from low down the stems and are made in one movement. Letters have a forward slant. There is extreme contrast between thick and thin strokes.

The blade of the pen is held approximately parallel to the line, and the stroke thickness can be varied by how much of the blade is in contact with the paper. Thin strokes can be made with the point, and as the blade is tipped downward, progressively bolder, thicker strokes are made.

Because the width of the stroke varies depending on how much the side of the ruling pen is in contact with the paper, there is no pen angle. Practice strokes of various thicknesses before attempting the letters.

There is no nib-width ladder either; use guidelines about ¾–1 inch (20–25 mm) apart at first, as it will help to work on a large scale. Ascenders and descenders should be slightly less than the body height.

The ragged edges to the letters are part of the character of Ruling Pen, and in this example the letters have also been written on a slightly textured paper.

IN DETAIL

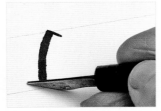

1 Start the letter just below the headline, with the pen making a slight pushed stroke upward, before changing direction to form a diagonal curving broadstroke to the baseline.

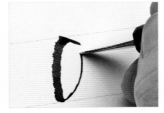

2 Tilt the pen onto its point, then pull it up to just below the headline to form the bowl of the letter.

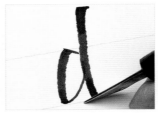

3 Using the blade flat, position the pen slightly less than the body height above the headline, make a short pushed stroke with a little extra pressure, then pull down to the baseline.

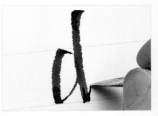

4 Give a slight upward flick at the end of the stroke to form a serif.

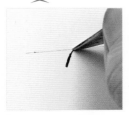

1 Starting just below the headline and using the point of the pen, make a thin stroke up to the headline.

2 Tip the blade onto its edge and pull down below the baseline.

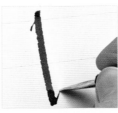

3 Form a serif with a slight upward flick at the end of the stroke.

4 With the blade point on the baseline, make a thin stroke from stroke 1 up to the headline.

5 Tip the blade onto its edge, pulling down and around to form the bowl.

RULING PEN POSITIONS

These marks are of different thicknesses depending on how much of the edge of the pen is in contact with the paper.

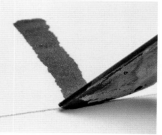

c e o

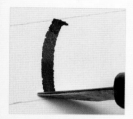
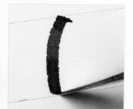

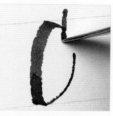
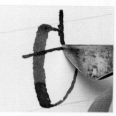

1 Just below the headline, make a slight push stroke upward before forming a curving broadstroke downward to the baseline.

2 Pull slightly down and to the right, tilting the pen onto its point.

3 Pull up toward the headline.

4 Using the point of the blade, make a thin vertical stroke across the beginning of stroke 1.

5 Make a horizontal crossbar using the point of the blade.

f t

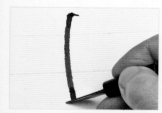
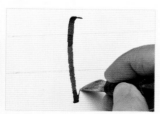
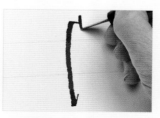
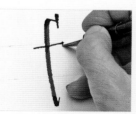

1 Just below the headline, make a slight pushed stroke upward before forming a broadstroke downward to below the baseline.

2 Create a slight upward flick at the end of the stroke to form a serif.

3 Using the point of the blade, make a thin vertical stroke across the beginning of stroke 1.

4 Make a horizontal crossbar using the point of the blade.

CONTINUED NEXT PAGE

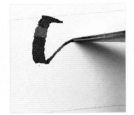

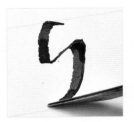

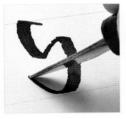

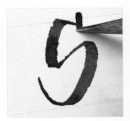

1 Starting just below the headline, push the blade up and then change direction to form a curve to just above half the x-height.

2 Tilt the blade onto its point and make an upward, slightly curved stroke about level with the start of stroke 1.

3 Tilt the blade onto its edge and curve down to the baseline.

4 Tilt onto the point again and make a thin stroke to complete the bottom bowl.

5 Complete the letter with a short vertical stroke across the beginning of stroke 1.

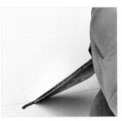

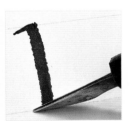

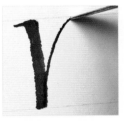

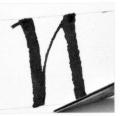

1 Start with the blade flat and make a thin stroke to form a serif.

2 Pull down to the baseline.

3 Tilt the blade onto its point and make a thin, arching stroke up to the headline.

4 Tip the blade again to form a broadstroke and pull it down to the baseline, parallel to stroke 1.

5 Complete the stroke with a slight upward flick.

In practice

The spacing here is similar to that for Italic (see pages 98–105), as the letters have almost straight sides, are of similar width, and can be spaced as approximately equidistant parallels.

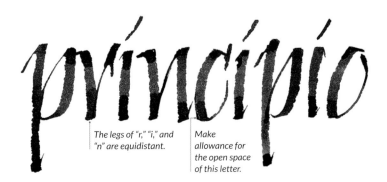

The legs of "r," "i," and "n" are equidistant.

Make allowance for the open space of this letter.

i j k

1 Using the point, position the pen slightly less than the body height above the headline, make a short pushed stroke with a little extra pressure, then pull down to the baseline.

2 Tip the blade onto its point and make a branching stroke from slightly less than halfway up the stem.

3 Use the edge of the blade to make a short vertical stroke across the end of stroke 2.

4 With the blade parallel to stroke 2, place the pen at the point where stroke 2 leaves the stem and make a diagonal stroke to the baseline.

5 A short flick completes the letter.

v w x y z

1 Using the edge of the blade, make a shallow diagonal stroke to the baseline.

2 Add a serif at the top of the stroke using the point of the blade.

3 From the end of stroke 1, using the point of the blade, make a diagonal stroke up to the headline.

4 Using the edge of the blade, make a shallow diagonal stroke to the baseline, parallel to stroke 1. From the end of stroke 3, using the point of the blade, make a diagonal stroke up to the headline parallel to stroke 2.

5 Complete with a serif made with the point of the blade.

Practice letters using guidelines 1⅜–1½ inches (35–40 mm) apart

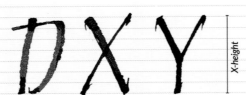

X-height

Ruling Pen Majuscule

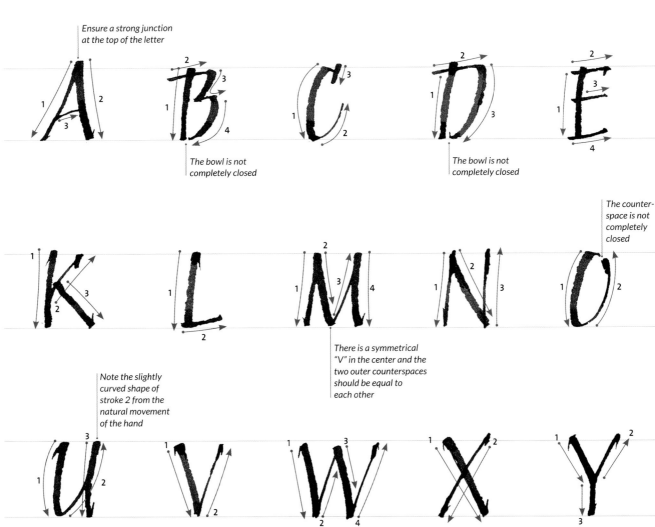

Ensure a strong junction at the top of the letter

The bowl is not completely closed

The bowl is not completely closed

The counter-space is not completely closed

Note the slightly curved shape of stroke 2 from the natural movement of the hand

There is a symmetrical "V" in the center and the two outer counterspaces should be equal to each other

CLIP 17
Ruling Pen Majuscule
http://qr.quartobooks.
com/cask/clip17.html

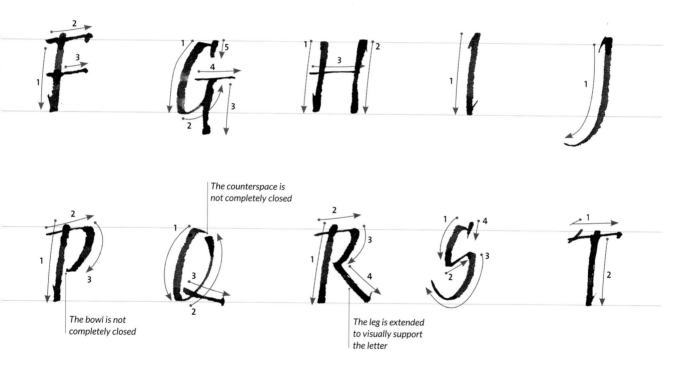

The counterspace is
not completely closed

The bowl is not
completely closed

The leg is extended
to visually support
the letter

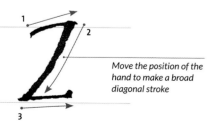

Move the position of the
hand to make a broad
diagonal stroke

Basic structure

The Ruling Pen majuscules are modeled on Italic capitals, having a narrow oval underlying form and a forward slant, while still exploiting the possibilities afforded by the characteristics of the pen.

Many of the strokes required for the majuscules are simply larger versions of the minuscule strokes, for example: "O," "C," "K," "S," "U," "V," "W," and "X." Practice at 1⅜–1½ inches (35–40 mm) high.

IN DETAIL

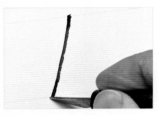

1 With the blade almost on its point, make a diagonal stroke down to the baseline.

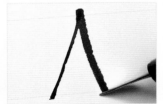

2 Return to the apex of the letter and, with the edge of the blade, pull down to the baseline. This stroke should be heavier than stroke 1.

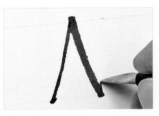

3 Flick up slightly at the end of the stroke to form a serif.

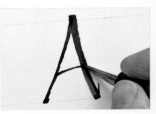

4 Just below half the letter height, draw a crossbar using the point of the blade.

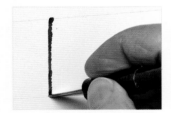

1 With the blade on its point, draw a vertical line down to the baseline.

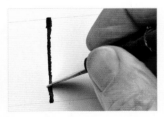

2 Push up slightly at the end of the stroke.

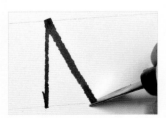

3 Align the blade northeasterly and at the top of stroke 1, then make a diagonal stroke to the baseline.

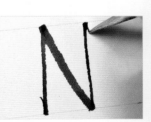

4 With the blade on its point, draw a vertical line from the end of stroke 2 to the top of the letter. Complete the letter with a small serif at the top of the final stroke, using the point of the blade.

BDPR

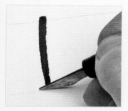

1 With the flat of the blade on the paper, pull down to the baseline.

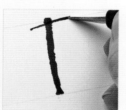

2 At the top of the letter, to the left of the main stem, use the point of the blade to push sideways and slightly up.

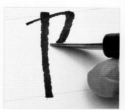

3 Tilt onto the edge of the blade, and from the end of the fine line, curve around to form the top bowl.

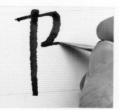

4 Tilt the blade onto its point and pull almost straight out, just past the top bowl.

5 Tilt the blade onto its edge, curving around to form the bottom bowl, which is slightly wider and deeper than the top one.

CGOQU

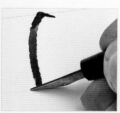

1 Using the edge of the blade, make a slight pushed stroke upward before changing direction to form a shallow, curved stroke to the baseline.

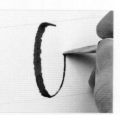

2 Tilt the blade onto its point and continue curving around and up to just above half the letter height.

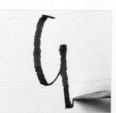

3 Tilt the blade back onto its edge and, starting from the end of stroke 1, pull vertically down to just below the baseline.

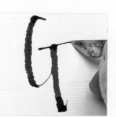

4 Using the point of the blade, make a horizontal stroke across the top of stroke 2.

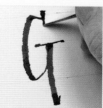

5 Complete the letter with a serif at the beginning of stroke 1 using the point of the blade.

CONTINUED NEXT PAGE ▷

EFL

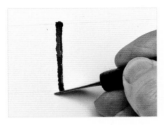

1 With the flat of the blade on the paper, pull down to the baseline.

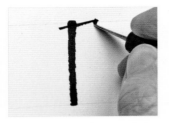

2 At the top of the letter, to the left of the main stem, use the point of the blade to push to the right and slightly up. Use the point of the blade to add a small serif at the end of the stroke.

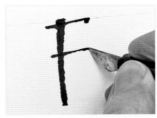

3 Using the point of the blade, make a crossbar just above half the height of the letter.

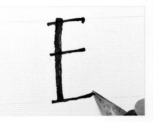

4 Using the point of the blade, draw the foot of the letter and push up slightly at the end of the stroke. This stroke is slightly wider than the other two horizontal strokes.

S

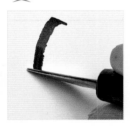

1 Starting just below the headline, push the blade up and then change direction to form a curve to just above half the x-height.

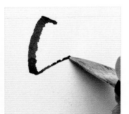

2 Tilt the blade onto its point and make an upward, slightly curved stroke about level with the start of stroke 1.

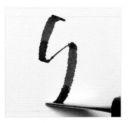

3 Tilt the blade onto its edge and curve down to the baseline.

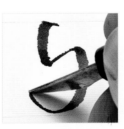

4 Tilt onto the point again and make a thin stroke to complete the bottom bowl.

5 Complete the letter with a short vertical stroke across the beginning of stroke 1.

In practice

Ruling Pen majuscules can be used as a script in their own right, as shown here, where they are also exploiting the textural effects of the pen on a rough paper. The diagonal strokes of "R" and "A" in the word shown here are actually in the counterspaces to avoid there being too big a gap.

LIBERTAS

The distance between adjacent verticals is about the width of "E."

Allowance has been made for the extra space around "T."

HIJKT

1 With the flat of the blade on the paper, pull down to the baseline.

2 Tilt the blade onto its point and flick up and out slightly to thicken the end of the stroke.

3 Repeat for the second leg of the letter.

4 Add a small serif at the top using the point of the blade.

5 Using the point again, draw a crossbar slightly above half the height of the letter.

MVWXYZ

1 With the blade on its point, draw a slight diagonal line down to the baseline, pushing up slightly at the end of the stroke.

2 Align the blade north-easterly and at the top of stroke 1.

3 Make a diagonal stroke to the baseline.

4 With the blade on its point, form the "V" at the center of the letter by drawing a diagonal line from the end of stroke 2 up to the headline. Complete the letter with a slight diagonal down to the baseline using the edge of the blade.

5 Make a small serif at the end of the final stroke, using the point of the blade.

Chisel Brush *by Jilly Hazeldine*

Many of the broad-edge pen scripts can also be written with a chisel brush, which imparts an entirely new dimension to writing. Chisel brushes are available in a wider range of sizes than metal nibs and can also be used on media such as calico, canvas, textured paper, wood, stone, and even walls.

As mentioned in Rustics (see pages 46–53), chisel brushes were used for inscribing notices onto walls. A similar type of brush was likely used to paint classical Roman letters onto stone before cutting with a chisel.

The touch of the brush on a writing surface is delicate and is very different to that of a metal pen. A brush is an extremely flexible instrument and requires sensitivity; however, it is easier to twist and manipulate than the pen is and can produce very pleasing dry-brush effects. Diluted gouache is the best medium to use, or acrylics for non-porous surfaces. It is important to wipe off excess paint and shape the brush each time it is loaded.

As these letters are written slowly and with much manipulation—pivoting and twisting—of the brush, more emphasis has been given here to looking at some sample letters in depth (below).

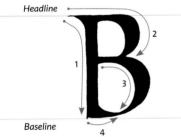

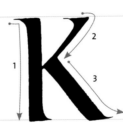

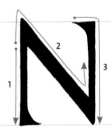

Twisting bowls
The "B" starts with the brush flat to the line. It is then pushed sideways briefly, and then rotated counterclockwise to 50°. It continues down to the line, allowing the left corner of the brush to cut the line. The brush is returned into the stem at the top of the first stroke at 90°. It is rotated quickly clockwise from 90° to 20° as it moves sideways. The top bowl is formed, still at 20°, and then a twist clockwise finishes the stroke with an almost flat angle, leaving a thin. This process is repeated for the lower bowl, covering the end of the previous stroke, around to just above the line at a point halfway on the width of the letter, leaving a thin. The brush is put inside the stem just above the base at 90°. A bit of pressure is exerted on the downward stroke, with a clockwise twist. The angle as you leave the stem should be 20°. A twist to an almost flat angle joins with and overlaps the previous stroke.

Mastering diagonals
As with "B," the "K" starts with the brush flat to the line. The brush is moved to the right, with a pivot onto its right corner, twisting counterclockwise to 50°. It is pulled down almost to the line, slowing down close to it. When the left-hand corner of the brush touches the line, the brush pivots clockwise to a flat angle. A sideways move forms the serif. Stroke 2 also starts with the brush flat to the line. It is pushed to the right to form a small serif, then twisted quickly counter-clockwise to 25°. A diagonal pull touches the stem just above halfway. The brush is placed with its edge on the left side of stroke 2 where it touches the stem. It moves up, twisting clockwise to 50°. Again, movement slows as the brush approaches the baseline. Exerting more pressure and twisting clockwise to a flat angle forms a serif to the right.

Pivoting the brush
The "N" starts with the brush at 60°, just below the top line. The brush is pulled downward, slowing down just before the line. The left corner of the brush is kept on the line as a pivot while twisting counterclockwise to a flat angle and moving sideways to form a serif. The brush is placed at the top of stroke 1, at a right angle, and is aligned with the left-hand edge. Light pressure is applied to push up just through the line before twisting clockwise, increasing the pressure, to about 50°, and making the diagonal stroke almost to the line, twisting counterclockwise as the line cuts the stroke. With a twist to 90°, pressure is lessened and the stroke pushes up, leaving a vertical thin. Moving back to the top, it can be useful to make a small mark on the top line that aligns with the vertical thin. With the brush flat to the line, it is moved slightly to the left of this mark. A push sideways and a counterclockwise pivot on the brush's right corner to 60° begins the second stem, which is then pulled down. The right side of the stroke should align with the vertical thin.

AS WE
EMERGE
FROM THE
DRAD-
NESS OF
WINTER
WE
YEARN
FOR
COLOUR
& ALMOST
ANYTHING
GOES
SO LONG AS
WE CAN
SATE
OURSELVES
WITH IT

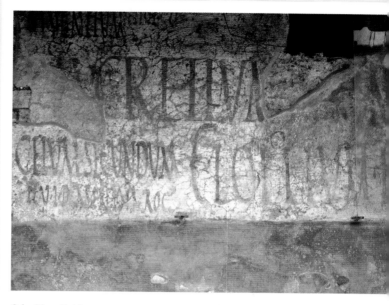

Color, **Mary Noble**
The lettering demonstrates the tactile quality of brush lettering on fabric and the texture-on-texture quality of the dry-brush effect. These occur even where the counterspaces have been filled in, and they have a texture rather than flat, solid blocks of color. [Chisel brush letters in varying weights of an Insular style, gouache on canvas]

Text on walls of Via dell' Abbondanza, Pompeii, Campania, Italy, first century
Historical examples of chisel brush letters are not plentiful. In many cases the brush was used to paint inscriptional letters onto stone before they were incised, and so the brush lettering has been cut away. Letters painted on walls so long ago have not all survived. These letters from Pompeii are Rustic in style rather than the Roman-based letters of the exemplar.

Bookmark, **Tony Curtis**
Letters are based on the same historical source as the chisel brush letters, but are painted with a pointed brush. Tony Curtis is a left-handed scribe. [Printed from original artwork. Letters modeled from Roman Imperial Capitals, drawn and painted]

 EX·LIBRIS

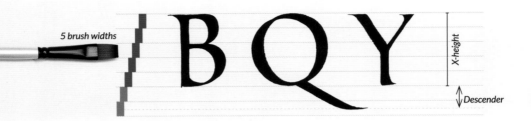

5 brush widths

X-height

Descender

Chisel Brush

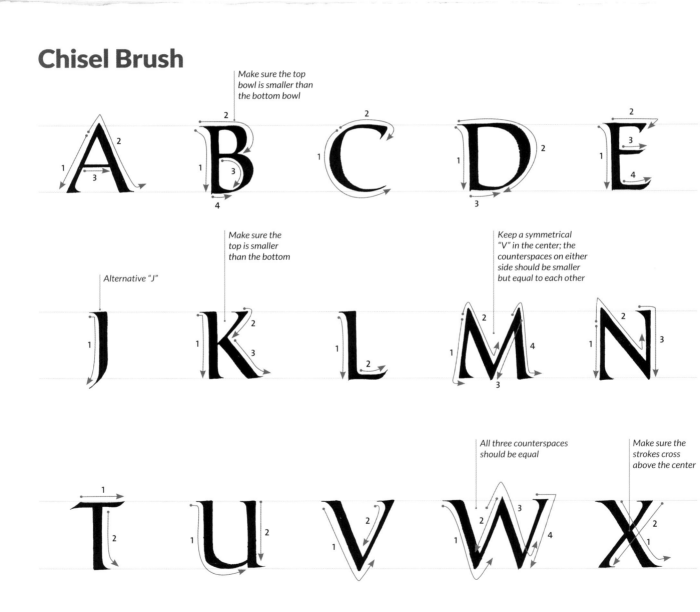

Make sure the top bowl is smaller than the bottom bowl

A B C D E

Make sure the top is smaller than the bottom

Alternative "J"

Keep a symmetrical "V" in the center; the counterspaces on either side should be smaller but equal to each other

J K L M N

All three counterspaces should be equal

Make sure the strokes cross above the center

T U V W X

CLIP 18
Chisel Brush
http://qr.quartobooks.
com/cask/clip18.html

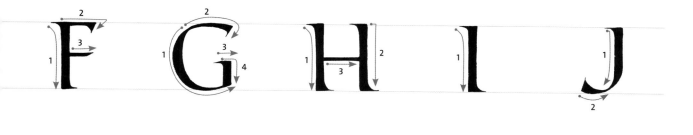

Make sure the top bowl is smaller than the bottom bowl

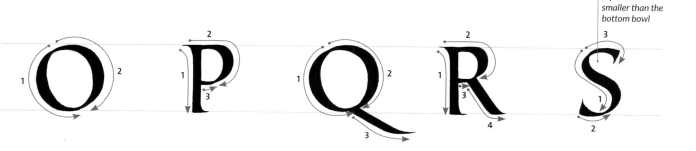

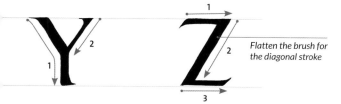

Flatten the brush for the diagonal stroke

Making the letters

The letters shown here are in black ink only because they are written very slowly, with a lot of manipulation, and with gouache rather than ink. A fluent continuity of movement—albeit slow—is needed to execute the letters well.

Basic structure

Brush lettering requires a different technique, and the similarity with a metal nib ends with the chisel shape—the brush is much more sensitive to changes in pressure. The brush is held almost perpendicular to the writing surface, so that the writing comes from its very edge. The writing surface may be better flat or on a slight slope. Hold the brush with your thumb on one side and the first two fingers on the other side, which should make it easier to roll the brush for the manipulated strokes (see "Holding a chisel brush," page 21). Use a whole hand movement and not just the fingers; the larger the writing becomes, the more the movement involves the whole body. Writing on a wall would require the brush to be held at 90° to the wall.

The letters are 5 brush widths high, and the brush angle varies from 0° to 90°.

The proportions of these letters are determined by the letter "O" and are based on Roman inscriptional forms (see pages 38–45). The clockwise and counterclockwise arches and bowls on the letters "B," "C," "D," "G," "P," and "R" will also reflect this shape. The letters are written slowly and carefully.

IN DETAIL

AHNTUVXYZ

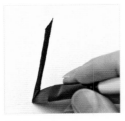

1 Hold the brush perpendicular to the paper, at an angle of 60°, and pull down diagonally right–left to just above the baseline.

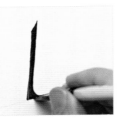

2 Rotate the brush clockwise to a flat angle and pull the brush to the right to form a serif.

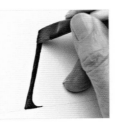

3 Start with the brush at the top of stroke 1.

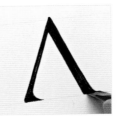

4 Pull down in a left–right diagonal to just above the baseline. Rotate the brush clockwise to a flat angle and pull the brush to the right to form a serif.

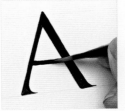

5 With a low angle of about 20°, make a horizontal stroke between the first two strokes, just below half the letter height.

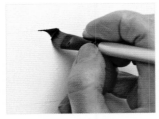

1 Start with the brush flat on the headline and begin rotating the brush counterclockwise.

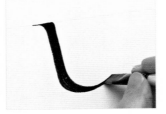

2 Pull the brush straight down to form the bowl. Just after the turn, rotate the brush and complete the bowl.

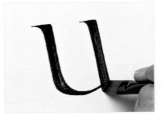

3 With the brush flat on the headline, pull slightly to the right. Rotate the brush quickly while pulling down toward the baseline.

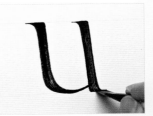

4 Rotate the brush clockwise to a flat angle and pull the brush to the right to form a serif.

BRUSH POSITIONS

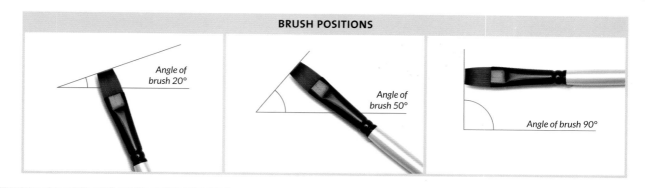

Angle of brush 20°

Angle of brush 50°

Angle of brush 90°

BEFIJJKLPRS

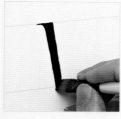

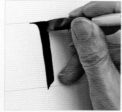

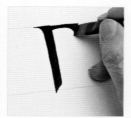

1 Start with the brush flat on the headline, pull to the right, quickly rotate the brush counterclockwise, and pull down to the baseline.

2 Place the brush on top of stroke 1, quickly rotate the brush to a low angle, and pull to the right.

3 Toward the end of the stroke, rotate the brush counterclockwise and pull down slightly to form a serif.

4 Create the crossbar slightly above halfway using a low angle.

5 Starting at the end of stroke 1 at 90°, quickly rotate the brush clockwise to 20°. Pull to the right and up slightly at the end of the stroke.

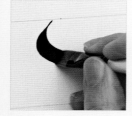

1 With an angle of about 50°, make a counter-clockwise curve.

2 Change direction at approximately half the letter height, making a clockwise curve, lift the brush at the thin.

3 Place the brush just above the baseline, slightly to the left of the bowl, at an angle of 90°.

4 Quickly rotate the brush while pulling down and to the right to meet the end of stroke 1.

5 At the start of stroke 1, rotate the brush clockwise to flatten the angle. Toward the end of the stroke, rotate the brush counterclockwise to 90° and pull down.

CONTINUED NEXT PAGE ▷

CDGOQ

1 Start with the brush flat at the headline. Pull to the right, then quickly rotate counterclockwise to about 50°, then pull down to the baseline.

2 Place the brush on top of stroke 1 at 90°, then quickly rotate it clockwise to 20°.

3 Pull the brush to the right, then make a clockwise curve down to the baseline to a thin.

4 Put the brush on the end of stroke 1 at 90°, then rotate clockwise to about 20°.

5 Pull to the right to join with the end of stroke 2 to complete the bowl.

1 Start with a fairly flat angle, about 30°, then make a clockwise curve ending with a thin.

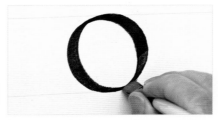

2 Overlap the beginning of stroke 1 with a counterclockwise curve to meet and overlap the end of stroke 1.

3 Add the tail from the thinnest part of the "O" shape. Flatten the brush toward the end of the stroke.

In practice

As with Roman Capitals (see pages 38–45), chisel brush letters demonstrate an underlying geometry based on the square and circle, rather than having a common underlying form as with other scripts such as Foundational or Uncial. The letters in "TABULA" are either half or three-quarters the width of a square.

MW

1 Start with an angle of 60°, just below the headline. Pull down in a right–left shallow diagonal to just above the baseline. Rotate clockwise to a flat angle and pull to the right to form a serif.

2 Place the brush at the top of stroke 1 at 90°, push up slightly, and rotate to 50°.

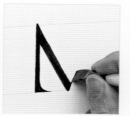

3 Rotate clockwise to about 50°, making a left–right diagonal to the baseline.

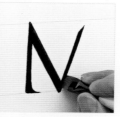

4 Start at the headline at an angle of about 60°. Make a right–left diagonal to join the end of stroke 2. The "V" formed should be symmetrical.

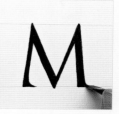

5 Place the brush at the top of stroke 3, matching the angle. Push up slightly and rotate to 30°. Pull down to just above the baseline. Rotate the brush clockwise to a flat angle while pulling to the right to form a serif.

1 Pull a flat brush from the headline across to the right and rotate counterclockwise to 60°. Make a diagonal to the baseline and kick up.

2 Place the brush level with the top of stroke 1. Use an angle of 50° to make a diagonal join with the end of stroke 1.

3 Place the brush at the top of stroke 2, matching the angle. Rotate clockwise to 50°, making a left–right diagonal to the baseline. Kick up from the baseline, as in step 1.

4 Using a flat brush at the headline, pull to the right. Rotate the brush counter-clockwise to 50°, pulling down in a right–left diagonal.

5 Strokes 1 and 3, and 2 and 4 should be of equal weight.

TABULA

The open space of "L" and the diagonal form of "A" make this a difficult combination. The foot of "L" has been shortened to bring it closer to "A."

These spaces need to visually match the area between "U" and "L" and can't be measured. On more advanced scripts, this is something that comes with experience.

The distance between the two uprights is half the letter height, and this provides the benchmark for spacing the rest of the word.

Uncial Variation

As satisfying as it is to replicate the skills of our calligraphic predecessors, the development of scripts can continue much as it always has. Skills no longer required for producing books and religious and legal documents can have new life breathed into them in a more artistic rather than functional way. It is possible to develop variations that retain the essential personality of the original, but that are more expressive and contemporary.

Script variations can be produced by changing systematically the key characteristics of a script (these features are explained in Understanding Letters, pages 14–17). The weight (the ratio of nib width to letter height) of a script can be anywhere between heavy and light. Changing the pen angle will affect the weight distribution, the shape of the underlying form (usually the "o") can be altered, slant introduced, and perhaps a different style of serif used. These changes need to be consistently carried through all the letters of the script.

Roman Capitals, Italic, and Uncial lend themselves particularly well to producing variations, and the Uncial here is in complete contrast to its historical ancestor. It is much lighter in weight, and the weight distribution is different due to the higher pen angle. It is written more cursively, with fewer pen lifts, and has a forward slant, which further increases its less formal appearance. Other variations are possible—the secret is to work methodically without changing too many factors at once.

Retaining the majuscule nature of Uncial means that the interline space can range from very small to much larger. Experimenting with these possibilities creates interesting textural blocks of writing, depending on the desired effect.

An arched "B"
With the nib held at 30°, a small serif is made just below the headline. With a pause followed by a change of direction, a stroke is made down to the baseline that slants at 3° from the vertical. Instead of forming the bowls with a second pen stroke as in the Natural Uncial script (see pages 54–61), the pen travels back up the stroke to form an arch, which curves around to form the two bowls of the letter. The nib is turned onto its left corner to form a thin at the end of the stroke. Note that the top bowl is smaller.

Mirroring strokes
The first stroke of the "M" is a shallow curve starting with the nib at 30° just below the headline, with a small serif at the base. For the second stroke, the nib is placed where the first stroke started and mirrors the shape of the first. There is an option to continue this stroke to the baseline or to about half the x-height. The third stroke overlaps with the second and mirrors the shape of the first, ending with a thin, which just cuts through the baseline. With increased fluency, strokes 1 and 2 could be made in one movement.

Subtle curves
The first stroke of the "N" starts at the headline, with the nib at 30°. There is a slight curve on this stroke down to the baseline. The second stroke is a mirror of the first, and the letter should be about the same width as "O." The third, diagonal stroke overlaps the beginning of the first, travels down it slightly, and then meets the second stroke about two-thirds down. This retains the characteristic shape of the original Uncial "N."

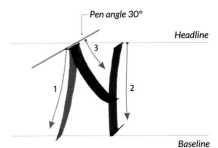

KA MATE! KA MATE! BEGONE O DEATH! BEGONE O DEATH!
KA ORA! KA ORA! AH, 'TIS LIFE! AH, 'TIS LIFE!
TENEI TE TANGATA BEHOLD!! THERE STANDS
PUHURUHURU THE HAIRY MAN
NANA NE TE TIKI MAI WHO WILL CAUSE
I WHAKAWHITI TE RA! THE SUN TO SHINE
UPANE! UPANE! ONE UPWARD STEP, ANOTHER UPWARD STEP,
UPANE! KA UPANE! ONE LAST UPWARD STEP, THEN STEP FORTH!
WHITI TE RA! INTO THE SUN, THE SUN THAT SHINES.

THE HAKA ~ TRANSLATION BY DR. PEI TE HURINUI JONES

WILL YOU GO WITH ME
TO A WONDERFUL LAND
WHERE MUSIC IS?
THE HAIR IS LIKE
THE PRIMROSE TIP THERE
AND THE WHOLE BODY
IS THE COLOUR OF SNOW.

THE RIDGE OF EVERY
MOOR IS PURPLE,
A DELIGHT TO THE EYE
ARE THE BLACKBIRDS EGGS,
THOUGH THE
PLAIN OF IRELAND
IS FAIR TO SEE
IT IS LIKE A DESERT
ONCE YOU KNOW
THE GREAT PLAIN.

Fair Woman, Vivien Lunniss
"Midar's Invitation to the Earthly Paradise,"
a ninth-century poem, has been written in a variation
of Natural Uncial (with a Drawn Uncial heading) using
a centered layout, which works well with the short
lines. The script is a much more delicate and light
version of the original, and some of the letterforms
have been adapted. [Ziller ink, colored pencils, metal
nibs on Fabriano Artistico Hot Press paper]

STRALIAN NATIONAL U
UNIVERSITY OF ADELAI
NIVERSITY OF CAPE TO
UNIVERSITY OF DACCA
DALHOUSIE UNIVERSI
SITY COLLEGE OF THE GO
NIVERSITY OF HONG KO
VERSITY COLLEGE, IBAD

Detail of Uncial Trials, Irene Wellington.
Institute of Commonwealth Studies,
The White House, 1952 (above)
Written over 60 years ago, Irene's
piece has a freshness and vitality that
belies its age. She used a steeper pen
angle than historical Uncial and a slight
slant so the writing appears more
fluent than if she had used the more
formal Roman Capitals. Some of the
letters have also been adapted to look
more contemporary while retaining
the essential personality of a historic
script. (Image © The Irene Wellington
Educational Trust. Reproduced with
permission.)

The Haka, Sue Goldstone (top)
This lightweight compressed
Uncial is balanced by a variation of
Roman Capitals used in a ranged-
right/ranged-left layout, which is
held together by a strong central
axis. The whole piece reflects the
power of the Maori war chant.
[White gouache]

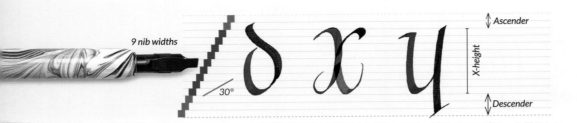

9 nib widths — 30°

Ascender
X-height
Descender

Uncial Variation

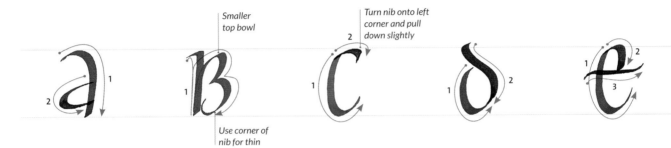

Smaller top bowl

Use corner of nib for thin

Turn nib onto left corner and pull down slightly

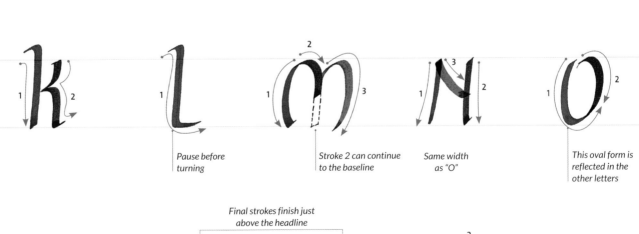

Pause before turning

Stroke 2 can continue to the baseline

Same width as "O"

This oval form is reflected in the other letters

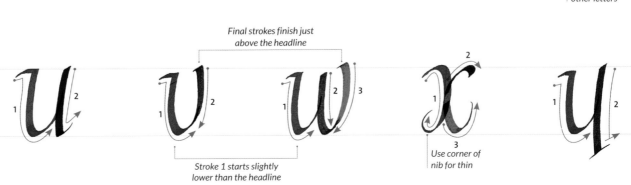

Final strokes finish just above the headline

Stroke 1 starts slightly lower than the headline

Use corner of nib for thin

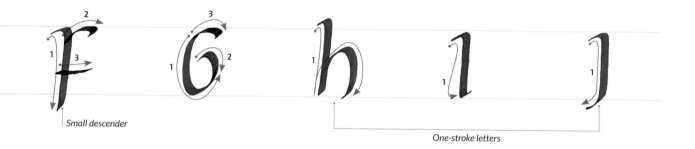

Small descender

One-stroke letters

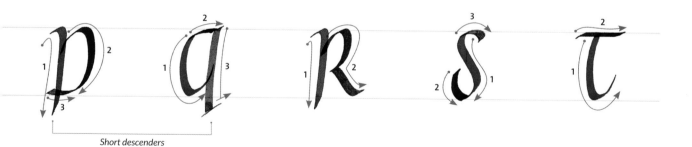

Short descenders

*Flatten pen for
diagonal stroke*

Basic structure

The exemplar is written at 9 nib widths with a pen angle of 30°, which can be used for all the letters except for the diagonal of "z," which is flattened. The letters slant at 3° from the vertical. The family relationship that is so essential to the continuity of any script is retained through the unifying shape of the oval "O," which is reflected in the other letters. This remains a majuscule script, therefore the ascenders of "d," "h," "k," and "l" are only about 1 nib width above the headline. The final strokes of "v" and "w" are just above the headline, and the descenders of "f," "j," "p," and "q" are no more than 2 nib widths below the baseline. The first stroke of "R" also has a short descender.

With increased fluency, and perhaps if writing at a smaller size, some of these letters could be written more cursively with fewer pen lifts, particularly those with branching arches, such as "P" and "R."

IN DETAIL

aBhR

1 With an angle of 30°, start below the headline and make a small hook serif, then pull the pen down to the baseline, cutting through by 1 or 2 nib widths. Then pull it slightly to the left to make a thin.

2 Place the nib on stroke 1 about halfway down. Push the pen up and around, forming the bowl, which is slightly more than half the height of the letter.

3 Change direction and pull the pen diagonally toward the baseline. There should be some space between the angle and the first stroke.

1JFKL

1 With an angle of 30°, start below the headline and make a small hook serif, then pull the pen down to the baseline, cutting through by 1 or 2 nib widths. Then pull it slightly to the left to make a thin.

2 Place the nib on stroke 1, just below the headline. Push the pen up slightly and across, forming a curved stroke. Pull the pen slightly to the left to finish with a thin.

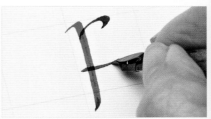

3 Start to the left of stroke 1, about one-third above the baseline, and make the crossbar. Pull the pen horizontally until the stroke aligns with the end of stroke 2.

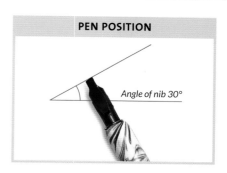
cðeϭoρqτ

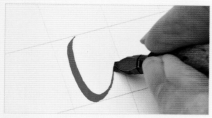

1 Start just below the headline with a pen angle of 30°. Make a counterclockwise oval just touching the baseline and continue upward to a thin.

2 Place the nib on the beginning of stroke 1 and make a small clockwise oval, pulling in slightly at the end, just before halfway.

3 Start to the left of stroke 1 to make the crossbar. Pull the pen horizontally until the stroke aligns with the end of stroke 2, then use the corner of the pen to make a hairline.

1 With an angle of 30°, start below the headline and make a small hook serif, then pull the pen down to the baseline, cutting through by 1 or 2 nib widths. Then pull it slightly to the left to make a thin.

2 Place the nib on stroke 1 about halfway up. Push the pen up and around, forming the bowl, almost reaching the baseline. Then pull in and end with a thin.

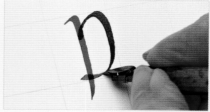

3 Close the bowl by starting slightly to the left of stroke 1. Pull the pen across and up to meet the end of stroke 2.

CONTINUED NEXT PAGE ▷

m u v w y

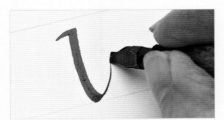

1 Start 2 nib widths below the headline with a horizontal serif. Pause and change direction, pulling a curved stroke down to the baseline. Then curve up and end with a thin.

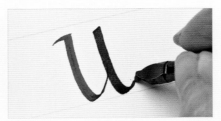

2 Start level with stroke 1. Follow the shape of the first curve, crossing the end of stroke 1, and then rise up from the baseline, ending with a thin.

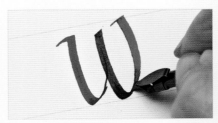

3 Start slightly above the headline with a small serif and mirror the shape of stroke 1, overlapping the end of stroke 2 slightly.

1 Start 2 nib widths below the headline with a horizontal serif. Pause and change direction, pulling a curved stroke down to the baseline. Then curve up and end with a thin using the corner of the nib.

2 Start on the headline, pulling the pen down through to about 2 nib widths below the baseline, overlapping the end of stroke 1. This stroke can have a very slight inward curve.

3 Add a hairline serif to the end of the stroke.

In practice

With a more cursively written script such as this one, it is possible for terminal strokes to connect with the following letter when this occurs naturally (such as the "r" and "p" shown here).

The hairline almost joins to the "m."

Carpe diem

The "c" and "a" combination can present a spacing problem, so the "c" is slightly taller and "a" is partially tucked underneath.

N S X Z

1 This is a narrow, sinuous letter, which should fit inside the "O." Start just below the headline and curve first counterclockwise, then clockwise down to the baseline.

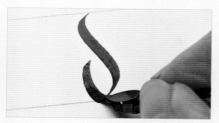

2 Start the second stroke about one-third of the way up from the baseline and close to stroke 1. Make a shallow, counterclockwise curve to meet the end of stroke 1.

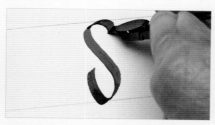

3 Overlap the beginning of stroke 1 slightly and make a clockwise curve, pulling in so that it ends aligned with stroke 1.

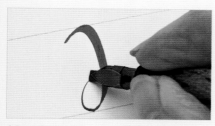

1 Start 2 nib widths below the headline. Make a shallow, counterclockwise curve around and off the baseline. Make a hairline at the end using the corner of the nib.

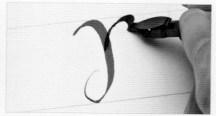

2 Start the second stroke one-third of the way down from the headline, overlapping stroke 1. Mirror the curve at the top of stroke 1, pulling the pen in slightly at the end of the stroke.

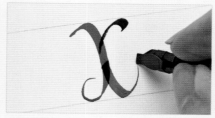

3 Begin the third stroke one-third of the way up from the baseline, overlapping stroke 1. Pull the pen down and off the baseline, making a hairline at the end using the corner of the nib.

Drawn Uncials

The form of these drawn letters is Uncial in character (see page 54), and they are also influenced by the lavishly decorative pages of the *Book of Kells* (c.800 A.D.; see page 177) and the *Lindisfarne Gospels* (c.698 A.D.; see page 62).

For simplicity and as a starting point, the letters for this script are drawn within a rectangle, and the double lines form the equivalent of a pen stroke. Rather than standalone letters, Drawn Uncials are intended to be used to create bands or blocks of text.

Drawn letters invite experimentation, and the keywords for a successful result are "proportion" and "balance." Historical examples of drawn letters exist using networks of interlaced lettering, which have been influenced by Irish artistic traditions. Manuscripts such as the *Book of Kells* and the *Lindisfarne Gospels* incorporated colored bands of letters on the introductory pages to the Gospels and as headings.

Taking it to the next level

The letters featured here came about as the result of a summer school with calligrapher Thomas Ingmire. Calligraphy workshops and summer schools are not only opportunities to share and learn with like-minded people, they are also an excellent way of increasing your skills and exploring new ideas.

Tailoring the exemplar

The rectangle and stroke widths used on the following pages can be altered for design purposes.

These letters are drawn rather than written, so it may be helpful to turn the paper while drawing to keep the lines smooth and flowing. For simplicity, the two lines that are drawn to construct the letter are referred to here as a "stroke."

Celtic inspiration
Keep the width between the drawn lines even in the same way as you might when drawing Celtic interlaced knotwork patterns. There is a slight increase in the width of the stroke on the left- and right-hand sides of the bowl. There is also a slight flaring at each end of the stroke. There are two forms of "b" available to use (see pages 176–177).

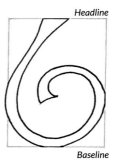

Headline

Baseline

Crossbar positioning
There are two forms of "t" for this script (see page 177): This version can have its crossbar placed at various heights, an option that can be exploited to allow connections to preceding or following letters or the borders of the design.

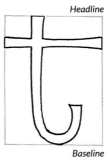

Headline

Baseline

Varying the leg
There are also two forms of "R" (see page 176), the main difference lying in the final leg of the letter, which can connect to the following letter in various ways. The vertical stroke is slightly wider than the strokes that form the bowl and leg of the letter.

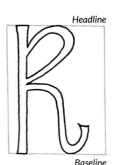

Headline

Baseline

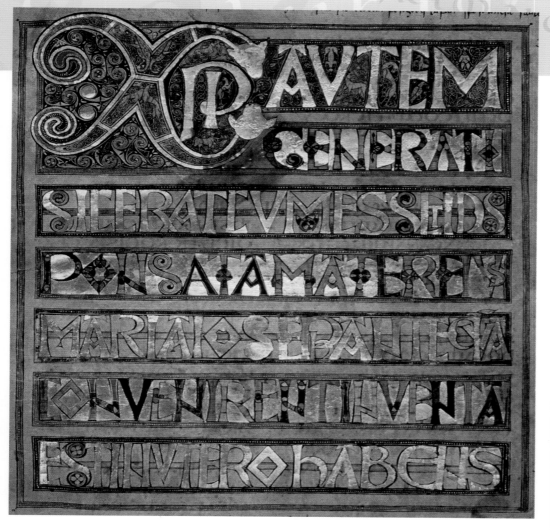

Decorated text from the Gospel of Matthew 1:18, *Stockholm Codex Aureus*, c.750 A.D.
This page of the manuscript begins with the "Chi Rho," which is the oldest known monogram or letter symbol for Christ. The page is a sumptuous display of bands of gilded or decorated intertwined or connecting letters.

Typical of display majuscules seen in the books of Durrow, Kells, and Lindisfarne from the 4th– 6th centuries

Freer in style, the letter is suggested rather than exact and has been adapted to fit the space

Similar to the historical example, but adapted to connect with "a"

The leg has been extended to connect with the surrounding border

Rowan, Vivien Lunniss
This piece is a title from a page from the *Book of Celtic Astrology*. Celtic astrology is concerned with trees, so the word has been drawn vertically. The letters connect with each other and also the border of the panel. [Gouache, colored pencils]

Drawn Uncials

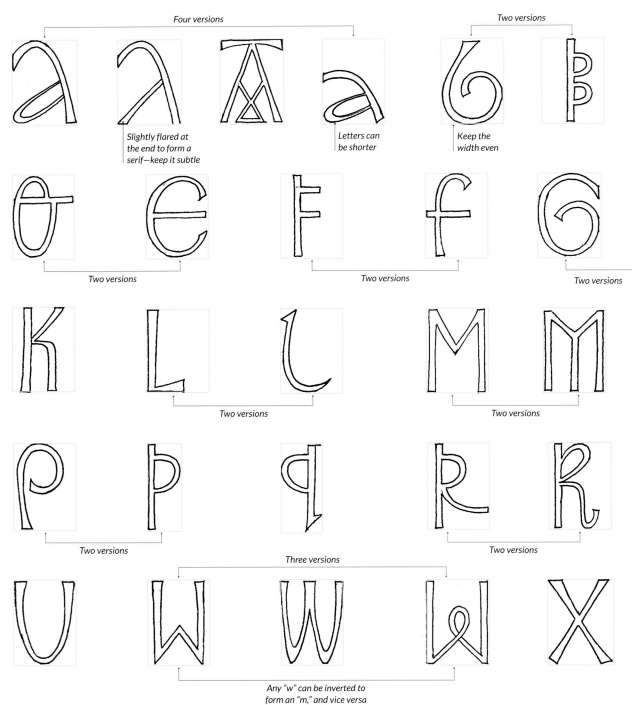

Four versions

Two versions

Slightly flared at the end to form a serif—keep it subtle

Letters can be shorter

Keep the width even

Two versions

Two versions

Two versions

Two versions

Two versions

Two versions

Two versions

Three versions

Any "w" can be inverted to form an "m," and vice versa

 CLIP 20
Drawn Uncials
http://qr.quartobooks.
com/cask/clip20.html

Letters can be narrower than box width

Ascenders can be shorter

Four versions

 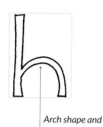

Arch shape and height can vary

Two versions

Two versions

Two versions

Height of crossbar can vary

Two versions

Two versions

Three versions

Letter variations

It is useful to have variations for some letters so that when planning calligraphy panels (such as those shown on pages 178–179), there is an opportunity to experiment with different forms in order to arrive at the best result for your piece.

Basic structure

The size of the rectangle and the double lines forming the letters are well proportioned here, but present only a starting point and can be changed.

These letters are based on Uncial forms (see pages 54–61) and are first drawn in pencil, which allows changes to be made. Once the design is complete and the outline has been redrawn with a technical pen, the pencil can be erased. The intention is to form panels of interlaced letters, so some trial and error is involved. Letters can overlap, share strokes, or be joined together to move naturally across the page. The border surrounding the lettering can follow a separate line or become part of the letters, or there can be no border at all.

The balance between the lines that form the letters and the negative space around them sometimes presents the viewer with an intentional, interesting conundrum. This balance can be altered.

IN DETAIL

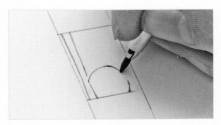

1 Using a sharp pencil, start with the vertical stroke, which is slightly wider at its top and bottom than in the middle. Draw the inside shape of the arch first, then add the outside.

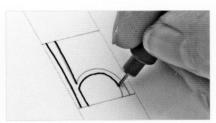

2 When you are happy with the shape of the letter, redraw the outline using a technical pen. (If you are going to be using a water-based medium on the design, be sure to use a waterproof technical pen or drawing ink.)

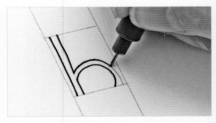

3 Complete the letter.

1 Using a sharp pencil, draw the serif and the descender followed by the inside shape of the bowl, then add the outer lines.

2 Redraw the outline using a technical pen.

3 Complete the letter.

Ornamental text from St Mark's Gospel in *The Book of Kells*; Irish, late eighth century
The ornate initial letter with its complex knotwork decoration introducing bands of the runic-style Angular letters and richly colored counterspaces are typical of the period.

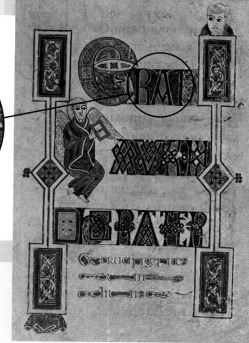

ᛒᚳᛞᛖᚩᛈᛊᚱ

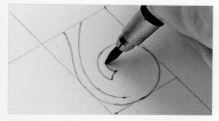

1 Using a sharp pencil, draw the outside shape of the letter using the full width of the rectangle. Make the top and bottom of the stroke slightly wider than its stem.

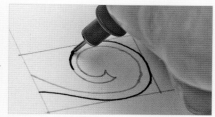

2 Redraw the outline using a technical pen. Curves are often easier to draw if you turn the paper.

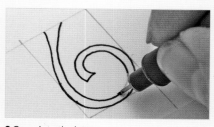

3 Complete the letter.

1 Using a sharp pencil, start with the vertical stroke, which is slightly wider at its top and bottom. Draw the leg of the letter to the edge of the rectangle. Draw the inside of the bowl.

2 Redraw the outline using a technical pen.

3 Complete the letter.

CONTINUED NEXT PAGE ▷

FSXZ *(Ungrouped)*

1 Using a sharp pencil, start with the flared vertical stroke. Add the arms of the letter: the top arm below the top of the rectangle; the bottom arm above the midpoint.

2 Redraw the outline using a technical pen.

3 Complete the letter.

1 The top bowl of this "S" is rounded while the bottom bowl is more angular. Using a sharp pencil, draw the inside shapes first. The ends of the strokes are slightly wider than the stem.

2 Redraw the outline using a technical pen.

3 Complete the letter.

In practice

Drawn Uncials are most effective when used to create blocks or bands of text, and very different effects are possible between the positive and negative versions. Parts of the letters connect with the border surrounding them, which is the same width as the letters.

"Pax et amor" ("Peace and love")

The "e" and "t" are joined by a shared crossbar.

The letters "P," "a," and "x" run into each other naturally.

A small form of "o" has been used so that it can circle the leg of "M" and connect to the "R."

1 Start with the vertical stroke in the center of the rectangle, making it wider at its top. Curve around to form the inside shape of the bowl. The crossbar can touch both sides of the rectangle.

2 Redraw the outline using a technical pen.

3 Complete the letter.

1 Draw the inside shape, making the strokes wider at the top, then add the outside shape. There are subtle curves on the strokes, which stop the letter from looking too rigid.

2 Redraw the outline using a technical pen.

3 Complete the letter.

The letters "S" and "e," and "m" and "p" share a stroke. These are known as conjoined letters.

"d" and "e" also share a stroke.

"semper fidelis" ("always faithful"): Positive variation

The back of "e" passes through the bowl of "p."

The means of adding color, either to the letters or to the spaces, has a profound effect.

Negative variation

Arabic Script

Although Arabic scripts are based on a different system than the Latin-based alphabet used in the West, and are also written in the opposite direction, the Arabic-inspired script featured here was developed so that it could be used with the Western alphabet while retaining characteristics that would give it an Eastern flavor.

Developing a script can be a demanding process, calling on all your experience and vision as a calligrapher, but it is, ultimately, very rewarding. In developing this script, the nature of the subject was one of the sources of inspiration.

The Bedouin legend about "The Horse" could have used a flourished Italic and perhaps wavy lines to represent the undulating nature of desert sands. However, a less literal, and perhaps less gimmicky approach would be to visit original sources for creative ideas, which for the version of "The Horse" shown opposite was the lettering in Arabic manuscripts.

This interpretation

For the Arabic-inspired script featured here, the pen strokes are made with a steep pen angle and have flicks on the terminations of the strokes rather than serifs. It can be very helpful to use a sketchbook to map, record, and organize your ideas and resources.

Open bowl
This letter "a" is made in one stroke that starts just below the headline, forming an arch. Then the pen is turned onto its left corner, forming a second arch moving right to left. The bowl is left open.

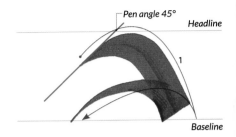

Tall ascender
With the first stroke, the bowl of the "d" is formed. The second stroke curves from 4½ nib widths above the headline to meet the end of the first stroke.

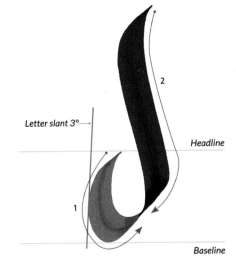

Balancing the small bowl
To borrow a typographic term, this letter is based on a double-story, looptail "g." The bowl of the letter is small and only occupies about half of the x-height. The first stroke forms a sweeping "s" shape that ends below the baseline. The second stroke starts to the left of this and moves from left to right to join to the first stroke. The bowl of the "g" is formed with the third stroke. A short "ear," left to right, for stroke 4 serves to balance the letter.

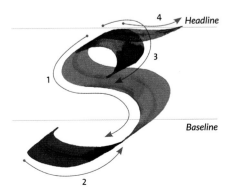

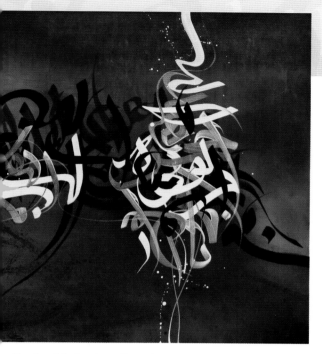

Chamber of the Sun, Sasan Nasernia
Experimenting with scripts is clearly not just the province of Western calligraphers, as this stunning work shows. Sometimes it is possible to appreciate the imagination and drama that has been invested without necessarily being able to understand what it says. Visually, this piece works on several planes, with the white writing in the foreground and the dark layer and shadow behind. [Acrylic on canvas]

The Horse, Vivien Lunniss
This script was designed especially to write the Bedouin Legend, as Western scripts were not aesthetically appropriate. Arabic letters haven't been copied, but the intention was to capture their essence by using tall ascenders written at steep pen angles and to pull out horizontal strokes and some abstract shapes that could be adapted into Western letterforms. [Walnut ink, metal pens on Khadi paper]

Page from a 1224 Arabic edition of _De Materia Medica_ by the Greek physician, pharmacologist, and botanist Pedanius Dioscorides (40–90 A.D.)
Arabic scripts are written from right to left, and have several forms, much like Western lettering. As a scientific treatise this book will have been written in a functional and legible style to be used for reference.

When God decided to create the horse, he spoke to the south wind and said "I wish to create from you a being who shall be the glory of my faithful and the terror of my enemies" the wind answered "Lord, I listen and obey". Then God took a handful of wind and fashioned from it a chestnut horse.

BEDOUIN LEGEND

Lo I have created the horse

I have moulded it from the wind
I have tied Good Fortune to its mane; it will fly without wings
It will be the noblest of animals; equal in pursuit or aversion
It will carry those who will praise and glorify my name
God then blessed the horse with the sign of glory and happiness
marking its forehead with a star

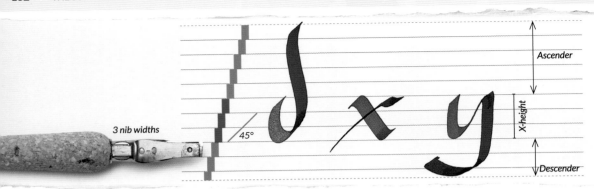

3 nib widths

45°

Ascender

X-height

Descender

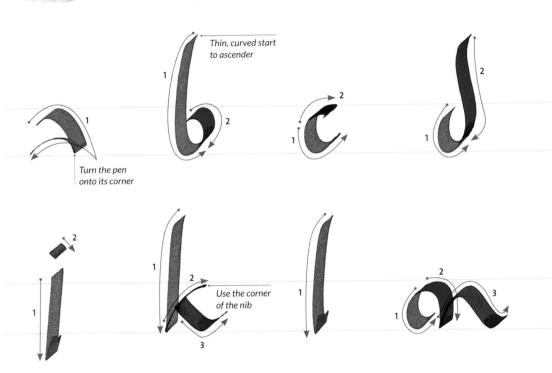

Thin, curved start
to ascender

Turn the pen
onto its corner

Use the corner
of the nib

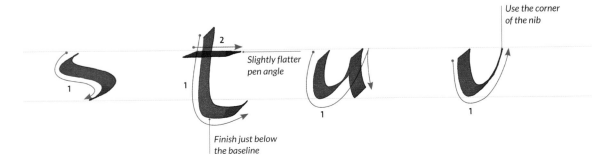

Use the corner
of the nib

Slightly flatter
pen angle

Finish just below
the baseline

Slightly flatter pen angle for final stroke

Rhombic dot

Flick the nib back up the stem to form a serif

Make a round corner

Finish just below the baseline

Use the corner of the nib for thins

Use the corner of the nib

Basic structure

The letters are written at 3 nib widths, ascenders at 5 nib widths, and descenders shorter, also 3 nib widths. The letters "t," "e," and "g" have smaller descenders, at 2 nib widths. The pen angle is 45°; the pen is slightly flattened for the final strokes of "t" and "g." The letters slant about 3° from the vertical.

The shape of "o" is reflected in the related letters "b," "c," "d," "g," "m," and "q." Clockwise arches are shallow and can connect to the following letter when this occurs naturally.

There is minimal use of serifs, with slight upward flicks of the pen at the terminals of the strokes in the letters "f," "j," "l," "p," and "q" and thin, curved starts to the ascenders such as in "b" and "h." There is some use of the corner of the nib for the letters "a," "k," "v," "w," "x," and "y."

IN DETAIL

shanuvwy

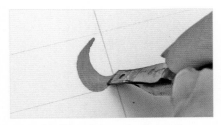

1 With the nib at 45°, start just below the headline and curve counterclockwise around and just up from the baseline.

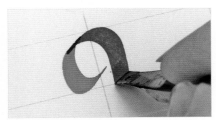

2 Place the nib on the start of stroke 1, curve up to the headline, then pull straight down to the baseline.

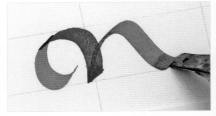

3 Overlap the end of stroke 2 with the nib on its left corner, then push up and roll the pen so that the full width is on the paper, making a clockwise curve up to the headline. Pull diagonally down to the baseline.

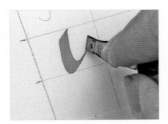

1 Using a pen angle of 45 °, start on the headline and pull the nib down to the baseline, making a sharp turn toward the headline.

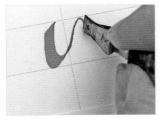

2 Roll the nib onto its left corner, push up to the headline, and make another sharp turn toward the baseline.

3 Place the nib at the headline, over the end of stroke 1, and pull down through the baseline, pulling to the left at the end of the stroke.

4 Start stroke 3 to the left of the bowl of the letter, then pull down and across to overlap the end of stroke 2.

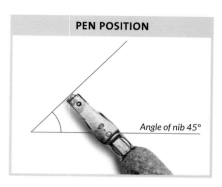

PEN POSITION

Angle of nib 45°

bcdsopq

1 With the pen on the headline at an angle of 45°, make a sweeping "s" shape that ends below the baseline.

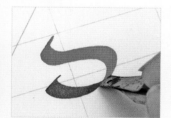

2 Start stroke 2 to the left of the bowl of the letter, then pull down and across to overlap the end of stroke 1.

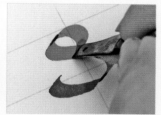

3 Placing the nib on the start of stroke 1, curve around to meet the first stroke.

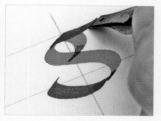

4 Using a flatter pen angle, place the nib on top of stroke 3 and pull along the headline, ending with a slight upward movement.

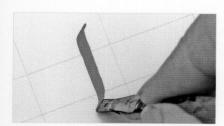

1 Starting about 2 nib widths above the headline at an angle of 45°, pull the pen down and to the left, then straight down through the baseline, pulling to the left again at the end of the stroke.

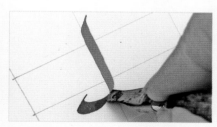

2 Start stroke 2 to the left of the upright, and pull down and across to overlap the end of stroke 1.

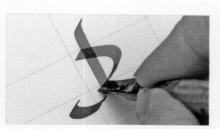

3 Start stroke 3 to the left of the upright, just under the headline, move out and down, then move back into and just across the upright again, forming the bowl of the letter.

CONTINUED NEXT PAGE ▷

fliki

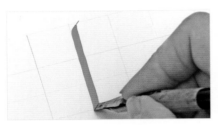

1 Starting 5 nib widths above the headline at 45°, pull the pen down and to the left, then straight down through the baseline.

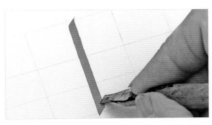

2 At the end of the stroke, flick the pen back up and out of the stem to form a serif.

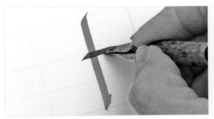

3 Using a flatter pen angle, place the nib on top of and to the left of stroke 1 and pull along the headline, ending with a slight upward movement.

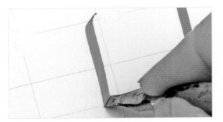

1 Start about 5 nib widths above the headline at an angle of 45°, pull the pen down and to the left, and then pull straight down to the baseline.

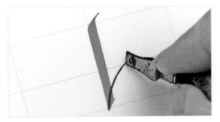

2 Using the corner of the nib, start at the baseline and push the pen in an upward curve to the headline.

3 Place the nib onto stroke 2 and pull down diagonally to the baseline. Finish by curving up from the baseline slightly.

In practice

Writing words is different to practicing individual letters, and the descenders here are longer than suggested, to suit the word. It is important to be consistent with any changes that you make. The dot on the "i" is heavy, to resemble the rhombic dot used in Arabic calligraphy.

1 Start with the nib just below the headline at an angle of 45° and make a shallow clockwise curve to about 1 nib width above the baseline.

2 Place the nib on the end of stroke 1 and echo the shape of the first curve, but make it larger, stopping just below the baseline.

3 Start stroke 3 to the left of the letter and pull down and across to overlap the end of stroke 2.

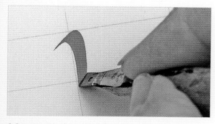

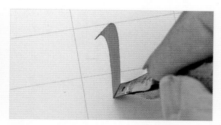

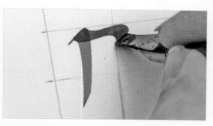

1 Start with the nib just below the headline at an angle of 45°, make a curved serif, and then pull straight down.

2 Continue to 1 to 2 nib widths below the baseline. Twist the pen toward the end to taper the stroke.

3 Overlapping stroke 1, pull the pen along the headline, dipping the stroke, and then pull the nib down again to finish with a serif.

The shallow arch of "h" flows naturally into the open bowl of "a."

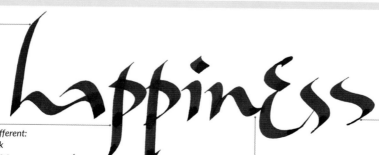

The "p" letters are deliberately different: two curved descenders could look cluttered, so the second letter has a straight descender.

The "n" just meets the back of "e."

The second "s" has been given a more pronounced curve.

Resources

The International Association of Master Penman, Engrossers and Teachers of Handwriting (IAMPETH)
www.iampeth.com

Cyberscribes, an Internet calligraphy discussion group
www.calligraph.com/cyberscribes

For a list of groups and everything related to calligraphy:
www.cynscribe.com

Calligraphy and Lettering Arts Society (CLAS)
www.clas.co.uk

Society of Scribes and Illuminators (SSI)
www.calligraphyonline.org

Suppliers: Scribblers, who provided the materials for this book
www.scribblers.co.uk

Index

Credits

Author acknowledgments

I would like to thank my fellow calligraphers whose skills have helped to make this book what it is. Also the artists whose wonderful work is featured throughout the book. We mustn't forget the many nameless scribes of years ago who provided the foundations for all that calligraphy is now.

Quarto would like to thank the following artists and agencies for supplying images for inclusion in this book:

Key: t = top, b = bottom, l = left, c = center, r = right

- © British Library Board. All Rights Reserved/ Bridgeman Images, p.63t
- © Ivan Vdovin/Alamy, pp.36bc, 39t
- © Look and Learn/Bridgeman Images, p.55b
- © The Art Archive/Alamy, p.36tc
- © The Art Archive/Alamy, p.47t
- © V&A Images/Alamy, p.85
- © The Irene Wellington Educational Trust. Reproduced with permission, p.165br
- © Photo Researchers/Mary Evans Picture Library, p.181tr

- *A Book of Celtic Astrology*: Dynamo House Pty. Ltd., Melbourne, Australia, p.55t

- Alldred, Barbara, p.34b
- Association Internationala de Bibliophilie, 2009, p.99t
- Barcellona, Luca, Calligraphy and lettering arts, www.lucabarcellona.com, pp.4t, 9t, 32t, 143br
- Burke, Kirsten, www.kirstenburke.co.uk, pp.35r, 36cl, 143tr
- *Colour For Adventurous Gardeners* by Christopher Lloyd, edited by Erica Hunningher. Published by BBC Books and reproduced by permission of The Random House Group Ltd., p.157l
- Colvin, Brian, p.113bl
- Creative Commons, p.137bl
- Curtis, Tony, FSSI, p.157b
- De Agostini Picture Library/G. Dagli Orti/ Bridgeman Images, p.157r
- Dover, p.177tr
- Fukaya, Yukiko, www.yukikofukaya.com, pp.27cr, 35t
- Garavaglia, Rosella, Calligrapher and Lettering Artist, www.calligraphy-london.co.uk, p.31br
- Goffe, Gaynor, pp.27t, 33bl, 37br
- Goldstone, Sue, p.165t
- Gunn, Sue, FFSI, www.suegunncalligraphy.co.uk, pp.2tl, 31bl, 32br
- Jamieson, Anne, p.27c
- Kespersaks, Veiko, p.111
- Lehtinen, Anja, www.alfabet.fi, p.71l
- Leiper, Susie, www.susieleiper.com, pp.2b, 9b, 137t
- Massoudy, www.massoudy.net, p.33br

- McClelland, Janice, pp.36tl, 47t, 77l
- Nasernia, Sasan, www.nasernia.com, p.181tl
- Nass, Birgit, www.birgitnass.de, pp.8bc, 33tr, 143tl
- Noble, Mary, www.marynoble.co.uk, pp.99b, 157l
- Orriss, Michael, p.31tc
- Photo Pierpont Morgan Library/Art Resource/ Scala, Florence, p.71tr
- Pickett, Jan (HFCLAS/FSSI), www.janpickett.com, pp.32bl, 34t
- Pinto, Anna, www.annapintocalligraphy.com, pp.34bl, 143cl
- Royal Library, Stockholm, Sweden/ Bridgeman Images, pp.8tc, 173
- Seahorsetwo, Shutterstock.com, p.11b
- Stevens, John, www.johnstevensdesign.com, p.127tl
- UPPA/Photoshot All Rights Reserved, p.37
- Vitolo, Joseph M., www.zanerian.com, p.127b
- Wellington, Irene, p.165br
- Wikipedia, p.113t
- Winchester Cathedral, Hampshire, UK/ Bridgeman Images, p.77br

All step-by-step and other images are the copyright of Quarto Publishing plc. While every effort has been made to credit contributors, Quarto would like to apologize should there have been any omissions or errors, and would be pleased to make the appropriate correction for future editions of the book.